into the sunset

PHOTOGRAPHY'S IMAGE OF THE AMERICAN WEST

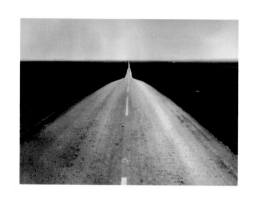

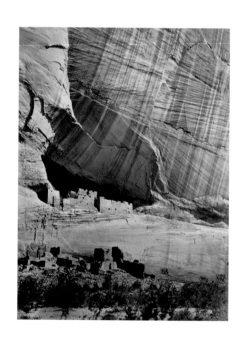

into the sunset
PHOTOGRAPHY'S IMAGE OF THE AMERICAN WEST

EVA RESPINI

THE MUSEUM OF MODERN ART, NEW YORK

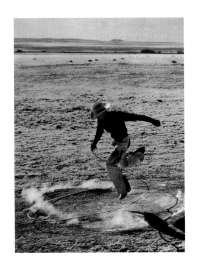

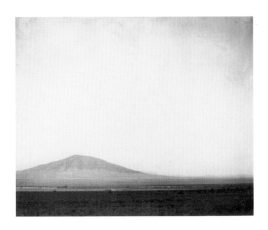

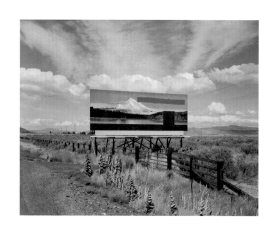

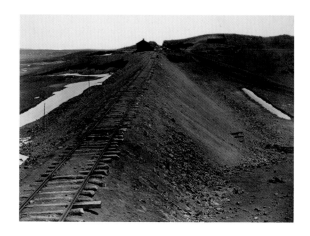

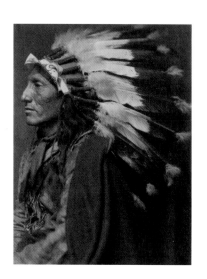

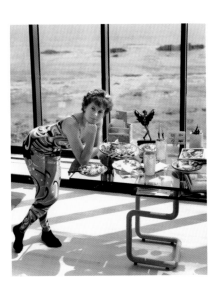

Published on the occasion of the exhibition *Into the Sunset: Photography's Image of the American West*, March 29 to June 8, 2009, at The Museum of Modern Art, New York, and February 25 to May 23, 2010, at the Seattle Art Museum, organized by Eva Respini, Assistant Curator, Department of Photography, The Museum of Modern Art

Produced by the Department of Publications,
The Museum of Modern Art, New York

Edited by Rebecca Roberts
Designed by Pascale Willi
Production by Christina Grillo
Color separations by Martin Senn
Typeset in District
Printed and bound by Graphicom, Vicenza, Italy
Printed on 170 gsm Lumisilk

Library of Congress Control Number: 2008941399
ISBN: 978-0-87070-749-0
Published by The Museum of Modern Art
11 West 53 Street
New York, New York 10019-5497
www.moma.org

Distributed in the United States and Canada by D.A.P./Distributed Art Publishers
155 Sixth Avenue, Second Floor
New York, New York 10013
www.artbook.com

Distributed outside the United States and Canada by Thames & Hudson, Ltd
181 High Holborn
London, U.K. WC1V 7QX
www.thamesandhudson.com

Printed in Italy

Front cover: Joel Sternfeld, *After a Flash Flood, Rancho Mirage, California* (detail) (plate 61)

Back cover: Cindy Sherman, *Untitled Film Still #43* (detail) (plate 122)

Pages 2–3 (left to right): Dorothea Lange, *The Road West, New Mexico* (plate 29);
Timothy O'Sullivan, *Ancient Ruins in the Cañon de Chelle* (plate 25); Richard Prince,
Untitled (Cowboy) (plate 118); Laura Gilpin, *Sunrise on the Desert* (plate 16)

Pages 4–5 (left to right): Stephen Shore, *U.S. 97, South of Klamath Falls, Oregon* (plate 3);
Gertrude Käsebier, *American Indian Portrait* (plate 91); Andrew J. Russell, *Granite Cañon,
from the Water Tank* (plate 30); Joel Sternfeld, *A Woman at Home After Exercising,
Malibu, California* (plate 77); Robert Adams, *East from Flagstaff Mountain, Boulder County,
Colorado* (plate 22)

Pages 6–7: John Divola, *N34°10.744'W116°07.973'* (detail) (plate 14)

Pages 32–33: Geoffrey James, *Looking Towards Mexico, Otay Mesa* (detail) (plate 71)

Pages 90–91: Philip-Lorca diCorcia, *Major Tom; Kansas City, Kansas; S20* (detail) (plate 128)

Endpapers: Edward Ruscha, *Every Building on the Sunset Strip* (detail) (plate 24)

contents

foreword

The American West has been a fertile subject for photographers since
the development of the medium. *Into the Sunset: Photography's Image
of the American West* explores how photography has shaped and
transformed the West in the collective imagination, from 1850 to today.
This investigation includes a broad range of styles and sensibilities, from
nineteenth-century works made a few years after the invention of
photography to iconic images of the twentieth century to pictures made
as recently as 2008. About sixty percent of the photographs in this volume
and the exhibition that it accompanies are drawn from the collection of
The Museum of Modern Art. The Museum has a rich history of presenting
thematic exhibitions in which the art of the present engages with the art
of the past, and Eva Respini's lively and persuasive selection of photographs
and her thoughtful essay exemplify the Museum's commitment to this
history and to presenting the collection in new ways. I am deeply grateful
to the institutions and individuals who have generously lent indispensable
artworks to this important exhibition.

Glenn D. Lowry
Director, The Museum of Modern Art, New York

discoverers, dreamers, and drifters

EVA RESPINI

The American West occupies about two million square miles of land, extending from the Mississippi River to the Pacific Ocean, from the forests of the Northwest to the Rio Grande. This region of incredible geographic richness has been occupied for thousands of years by peoples of different ethnicities, languages, and cultures, from Comanche to Lakota to the first Europeans in the 1500s. It was named the West by the most recent people to settle there: Americans.

Photography and the American West came of age together. The exploration of a large part of the West by European Americans coincided with the invention of photography, and the two have been bedfellows ever since. The first photographic process was announced in France in 1839, and the medium quickly came into use in the United States. Although explorers traveled west after the Louisiana Purchase of 1803, it was not until the 1840s that Americans began exploring and settling the West in earnest. In 1848 the Mexican Cession—California, Nevada, and Utah, as well as parts of what are now Arizona, Colorado, and New Mexico—introduced Spanish culture and expanded the region. Spurred by reports of gold, silver, arable land, and other abundant natural resources, some 350,000 people migrated beyond the frontier between 1841 and 1865, and many more followed after the Civil War. Photographs provided a vivid and tangible image of this unknown land, paving the way for travelers, industrialists, settlers, and tourists.

The West was a blank slate on which new stories could be written. From the very beginning, photographs of the West were tied to national identity and supported an image of the West that promised independence, faith in progress, and rejection of old-world values. The West symbolized America as a whole, and photography, representing technological progress, was the perfect medium with which to construct an American identity. This relationship has resulted in a complex association that shapes the perception of the West's social and physical landscape to this day.

The West of the popular imagination is easily visualized—big skies, windswept plains, soaring mountains, deep canyons, sublime natural formations, and sprawling cities, sometimes victimized by natural disasters. The West's inhabitants are just as iconic—Native Americans, miners, cowboys, homesteaders, outlaws, starlets, cult members, hippies, suburbanites, and drifters and others on the margins. These archetypes have been made

popular through film, painting, writing, and, especially, photography. Photography's ability to describe the world in rich detail has made it an ideal medium for recording the Western land and people. A photograph, of course, is also a fiction created by the photographer. Historian Martha A. Sandweiss accounts for this in her summation of the significance of the image of the American West, and ties it to present-day national attitudes. "The popular legend of the West," she has written, "should properly be discounted as good history, but it should not be disregarded as a good story that continues to have a direct impact on American behavior and national beliefs."[1]

Into the Sunset: Photography's Image of the American West examines how photography has established and transformed the image of the West, from 1850 to the present. This volume and the exhibition it accompanies chart the West's complex, fantastic, seductive, rich, and often extremely persuasive mythology. They also explore how prevailing social, political, and cultural attitudes have influenced the pictures photographers have framed. The book is organized thematically, in two sections: Land and People. Photographs of the land range from grand depictions of the "unspoiled paradise" found by early American explorers to pictures that showcase man's effects on the land, including images of industrial development, personal pictures taken on the road, and prosaic urban and suburban scenes. Photographs of the people of the West represent a diversity of occupations, lifestyles, and archetypes: gold miners, lumberjacks, Native Americans, cowboys, suburbanites, city dwellers, and hard-edged down-and-outers. Each of these photographs—of people or of the land—is one facet of photography's image of the West. It is with these pictures that the grand narratives of the West have been spun.

Westward the Course of Empire

Before the advent of photography, the Western landscape was depicted, and often mythologized, in paintings, prints, drawings, and the writings of explorers and other travelers. In the nineteenth century, the philosophy of Manifest Destiny—the belief that the United States has a God-given right to explore, conquer, and claim new territories—justified American expansion and the eradication of native populations in the West. Spectacular Western landscapes on large canvases by Thomas Moran and Albert Bierstadt (fig. 1) translate the pervasive concept of nature as God's sublime revelation to man into transcendental depictions of the land. Painting and photography pictured the West as free for the taking, justifying the occupation of territory that had in fact been populated for millennia. Photography, however, was the more powerful promotional tool, as it purported to provide an accurate record of fabled Western wonders—even if many photographs were carefully constructed to adhere to predetermined ideas.

The tradition of American landscape photography began in the West. There were a few isolated practitioners, but there was no firmly established school until photographers began making pictures in the West in the 1860s.[2] Some of the earliest and best photographs of the West were made under government patronage after the Civil War. Four "Great Surveys" were launched in the late 1860s and early 1870s to study the geography and geology of new Western territories, and each included a photographer in its party.[3] Their collective mission was to plot maps, measure natural resources, categorize flora and fauna, claim land, and publicize transport routes and the wealth of resources for government agencies, investors, and the general public. Photographs made on these surveys include general views of the land, details of geological formations and geographic sites of

1. Albert Bierstadt (American, born Germany. 1830–1902). **Sunrise, Yosemite Valley**. c. 1870. Oil on canvas, 36 1/2 x 52 3/8" (92.7 x 133 cm). Amon Carter Museum, Fort Worth, Texas

interest, and pictures of mines, railroads, ancient ruins, and Native Americans and their settlements.

The Great Surveys explored different geographic areas, and each survey leader had his own particular background and interest—Clarence King was a scientist and geologist, Major John Wesley Powell was fascinated with Native American cultures, Ferdinand Vandeveer Hayden was a conservationist who hoped to harness the power of publicity for his cause, and Lieutenant George Wheeler was a military leader who believed that the army could bring law and order to the West. Each survey photographer— half "scientific technician" and half "publicist"[4]—had a different way of approaching and interpreting what he came across, and they all were given leeway in choosing their subjects and in how they photographed them. Their pictures were made into lithographs for inclusion in official reports, mass produced for public consumption in the form of stereographs and large photographs, exhibited internationally, and selected and grouped in albums given to government officials as records of the survey projects. As they circulated in the public, the photographs shaped an image of the West as territory ripe for settlement and industrialization and helped define an American photographic landscape tradition that would endure for generations.

Timothy O'Sullivan, perhaps the most celebrated of these photographers, was employed by the King and Wheeler surveys. O'Sullivan had learned his trade in the renowned Washington, D.C., studio of Mathew Brady, but it was his experience in the field during the Civil War that trained him for the arduous task of photographing in remote Western areas.[5] Picture making itself is the subject of his 1867 picture *Desert Sand Hills near Sink of Carson, Nevada* (plate 15), made on the King survey. Footprints lead from O'Sullivan's wagon (his darkroom) to the slightly elevated position of the camera. The vacated wagon and forlorn horses underscore the insignificance of humans in the windswept, arid landscape. Similar in character is his striking 1873 photograph of Canyon de Chelly (plate 25), made on the Wheeler survey, in which ancient cliff dwellings are dwarfed by an immense rock face. In O'Sullivan's photographs, the West is wild and austere, even uninhabitable, while other survey photographers, such as William Henry Jackson, adhered to more picturesque visions of the land. The importance of the survey images to Americans' experience of the West is evident in an 1883 photograph by Jackson (plate 4), made years after he participated in the Hayden survey. In this photograph, sold to tourists, the small figures surveying the land embody the optimism that defined Manifest Destiny; this posed image is a nostalgic reenactment of the survey spirit.

Virgin Land

Before and during the surveys, independent photographers celebrated the natural magnificence of the West's landscape. In their images, Yosemite Valley is a supreme symbol of unclaimed bounty, although until 1851 the region was inhabited by Ahwaneechee Indians (a mix of the Northern Paiute, Southern Sierra Miwok, and other Native American tribes). The indigenous people were driven out by military force, and by 1856 a hotel and railroad had been constructed, opening the floodgates for Eastern tourism and commerce. Yosemite quickly became a national icon, and it has been photographed by countless professionals and amateurs ever since.

The first known photographs of Yosemite were made by Charles Weed, who visited the valley in 1859. Carleton E. Watkins made his first pictures there in 1861, with an 18-by-22-inch "mammoth" plate camera, and returned four years later to make more. The large size of Watkins's prints is well suited to images celebrating the grandeur of Yosemite.

His pictures are very detailed and sharp; he sometimes combined two or more to create a sweeping panorama of the valley, capturing in great detail both the foreground and the vistas beyond (plate 12). Weed and Watkins were joined by American photographers such as George Fiske and James Fennemore, as well as British photographer Eadweard J. Muybridge, who first visited Yosemite in 1867 and began making mammoth plate photographs there in 1872 (plate 7).

Watkins was, arguably, the West's first renowned landscape photographer. While Watkins made many excellent pictures of San Francisco, the Mariposa estate (plate 6), the Columbia River, mining settlements (plate 20), and agricultural developments (on commission for the California State Geological Survey and other clients), the pictures he made in the 1860s in Yosemite are among his best, at once rich in detail and simple in composition. Muybridge's equally handsome views of Yosemite tend toward more elaborate and ornate compositions. He often framed his vistas with branches in the foreground and superimposed separate negatives of clouds on a landscape (a standard practice at the time) to create images of greater drama. Watkins's photographs of the valley helped persuade Congress to establish it as the first national park in 1864, when Abraham Lincoln signed a bill designating Yosemite "for public use, resort, and recreation . . . inalienable for all time."[6] A similar course protected Yellowstone; William Henry Jackson's photographs and Thomas Moran's sketches made on the Hayden survey led to 1872 legislation preserving it as a national park. These photographers' pictures popularized the West as a magnificent land of plenty, but they also contributed to the preservation of areas of wilderness in a time of rapid settlement.

In 1888 George Eastman introduced the Kodak camera, profoundly affecting the photographic profession. Now that everybody could make their own snapshots of the land, the photographer-as-artist emerged as a distinct identity from the amateur and the commercial professional. Lyricism dominated photographic language at the turn of the century, and in pictures by Laura Gilpin, Anne W. Brigman, Alvin Langdon Coburn, and Minor White, the image of the West began to take on new forms. Coburn's soft-focus picture of Yosemite taken around 1911 (plate 10) emphasizes poetry, while others create a sense of myth and eternal time—such as Gilpin's 1921 photograph of a sunrise over the desert (plate 16). Gilpin, a student of Clarence H. White, was inspired by the physical and cultural geography of the Southwest, where, she said, she could feel the "deep roots of long past cultures."[7] In her quest to create timeless visions of the land and its people, she made photographs that do not reveal the realities of modern life, but instead reflect an image of the West as primeval.

The most famous artist to photograph Yosemite in the twentieth century was Ansel Adams. Adams's vision of the West is deeply personal, almost mystical, and it celebrates the West's stunning details and vistas alike. Of Yosemite, in 1960 he wrote, "I know of no sculpture, painting, or music that exceeds the compelling spiritual command of the soaring shape of granite cliff and dome, of patina of light on rock and forest, and of the thunder and whispering of the falling, flowing waters."[8] Adams's commitment to expression through precise description is seen in his photograph *Mount Williamson, Sierra Nevada, from Manzanar, California* (plate 2), in which light dramatically breaks through clouds, illuminating a rocky landscape in a modern interpretation of the sublime. With his photographs, Adams carried on the image established by Watkins, Muybridge, Gilpin, Coburn, and others, of the West as a natural paradise.

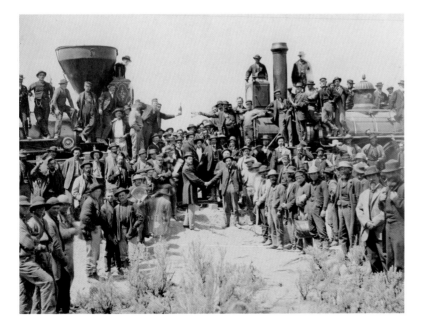

2. Andrew J. Russell (American, 1830–1902). **East and West Shaking Hands at Laying Last Rail**. 1869. Albumen silver print, 11 1/8 x 14" (28.2 x 35.5 cm). The Yale Collection of Western Americana, Beinecke Rare Book and Manuscript Library

Paving Paradise

Distance is a defining characteristic of the West, and the development of transportation technology is directly related to the pace of the region's settlement. The much-anticipated transcontinental railway was completed on May 10, 1869, when the Union Pacific and Central Pacific railroads met in Promontory Summit, Utah, an event symbolized by the driving of a golden spike into the last tie. Three photographers recorded the event: Alfred A. Hart, Andrew J. Russell (fig. 2), and Charles Savage.[9] Russell's famous picture of the event de-emphasizes the enormous labor it took to blast and level the land to lay the rails. Chinese laborers made up about ninety percent of the construction force but are omitted from the pictorial "record." Instead, the photograph applauds the exuberant westward progress sanctioned by Manifest Destiny.

With the completion of the transcontinental railway, the West opened to large-scale development, settlement, industrialization, and tourism. Russell was commissioned by the Union Pacific Railroad Company to document its entire line, from Omaha, Nebraska, to its meeting point with the Central Pacific, and the result is the lavish leather-bound volume *The Great West illustrated*, of 1869 (plate 30). When Russell was hired, much of the track had already been laid. His pictures, as stated in the album's preface, were "calculated to interest all classes of people, and to excite the admiration of all reflecting minds as the colossal grandeur of the agricultural, mineral, and commercial resources of the West are brought to view."[10] They commodify the land, demonstrating the richness of its natural resources, creating a spectacle, and encapsulating the promise that lay newly within reach.

Other photographers were hired by railway companies to make pictures. In William Henry Jackson's 1875 picture of Upper Twin Lake in Colorado, made for the Denver and Rio Grande Railway (plate 8), the still lake peacefully and picturesquely reflects the mountainscape. Jackson's photographs for the Denver and Rio Grande were meant to entice tourists. Like many contemporaneous pictures, they provided viewers with "a complete fantasy of escape, from complexity to simplicity, from urban chaos to natural order, from the protective closed parlor to the protected open spaces of the West."[11]

The development of the automobile has deeply affected how people experience the Western landscape. The Federal Highways Acts of 1916 and 1921 provided financial aid to states, launching an explosion in highway building that coincided with the growing affordability of cars. For photographers and other tourists, in the 1920s and 1930s the automobile became the preferred vantage point from which to experience America. Ansel Adams's and Edward Weston's road-trip photographs of California appeared in the periodical *Touring Topics* in 1931 and 1930, respectively, and in 1939 the Automobile Club of Southern California published the photography book *Seeing California with Edward Weston*.[12] These pictures were compelling advertisements for the great outdoors, although with the advent of the car true wilderness became increasingly harder to come by.

In 1937 Weston was awarded the first Guggenheim Foundation Fellowship for photography, and he used the money to travel throughout the West by car, with his future wife, Charis, as chauffeur. The scope of Weston's previously tightly cropped images widened to take in the large Western vistas dotted with telephone poles, cars, and road signs. The pictures—such as the ironic and surreal *Hot Coffee, Mojave Desert* (plate 34)—are at once witty and sober. Through these photographs, the highway became an inescapable element of the image of the West.

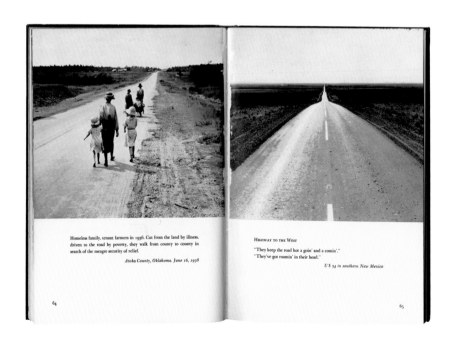

3. Spread from **An American Exodus: A Record of Human Erosion**, by Dorothea Lange and Paul Taylor (New York: Reynal & Hitchcock, 1939). The Museum of Modern Art Library

4. Rudy Burckhardt (American, born Switzerland. 1914–1999). **Untitled** from the album **An Afternoon in Astoria**. 1935. Gelatin silver print, 6 1/2 x 9 3/8" (16.6 x 23.8 cm). The Museum of Modern Art, New York. Gift of CameraWorks, Inc., and purchase

5. Edward Ruscha (American, born 1937). **Standard Station**. 1966. Screenprint, 19 5/8 x 36 15/16" (49.6 x 93.8 cm). Publisher: Audrey Sabol, Villanova, Penn. Printer: Art Krebs, Screen Studio, Los Angeles. Edition: 50. The Museum of Modern Art, New York. John B. Turner Fund

In 1939 photographer Dorothea Lange collaborated with sociologist Paul Taylor (her husband) on *An American Exodus: A Record of Human Erosion*, a book that traces migration westward from the Cotton Belt, Mississippi Delta, and Dust Bowl to California (fig. 3). "For three centuries," they wrote, "an ever-receding western frontier has drawn white men like a magnet. This tradition still draws distressed, dislodged, determined Americans to our last West, hard against the waters of the Pacific."[13] This association of the West with hope is reflected in Lange's 1938 photograph *The Road West, New Mexico* (plate 29)—in it the desolate U.S. Route 54 shimmers in the sunlight, its median lines pointing westward, a symbol of new opportunities and a better future. Lange's photographs in *An American Exodus* evoke, in near-biblical terms, hardship and devastation combined with an unwavering faith in the human spirit.

The post–World War II economic boom and the introduction of the interstate freeway system cemented the automobile's preeminence in the United States. Advertisements, billboards, storefronts, and signage associated with car travel had been fertile iconography in the 1930s and 1940s for photographers such as Walker Evans, Russell Lee, and Rudy Burckhardt (fig. 4). In the next three decades, Robert Frank, Lee Friedlander, Dennis Hopper, Stephen Shore, and Henry Wessel, Jr., followed in their wake, exploiting the windshield and rearview mirror as framing devices (plates 33 and 38), billboard imagery (plate 3), and the elegance of a single telephone pole at the side of the highway (plate 28). The car-bound perspective increasingly came to typify pictures of the West.

The road trip, especially via the legendary U.S. Route 66 (Chicago to Los Angeles), became an American rite of passage and a staple for many photographers working in the West. Robert Frank's influential book *The Americans* (published in 1959 in the United States) includes photographs of highways, gas stations, bars, luncheonettes, motels, big city and small town life, and the everyday rituals he encountered while driving across the country in 1955 and 1956. Jack Kerouac, author of the ultimate American road-trip novel, *On the Road* (1957), wrote the introduction to the United States edition of *The Americans*, casting the book as a pictorial equivalent to his own influential narrative. In Frank's pictures there is humor, sadness, and outrage, and his fleeting observations evoke the rhythm of the road. His 1955 photograph of a deserted gas station in Santa Fe, New Mexico (plate 36), is an image of the West tinged with despair.

In 1956, while Frank was making pictures for *The Americans*, Edward Ruscha drove Route 66 from his native Oklahoma City to Los Angeles. This trip was the basis for his 1963 book *Twentysix Gasoline Stations*, the first in a series of artist's books. It is composed of twenty-six black-and-white photographs of gas stations on Route 66, a recurring motif in the artist's paintings, drawings, and prints (fig. 5). The detached and deadpan approach in *Twentysix Gasoline Stations* and Ruscha's 1967 book *Thirtyfour Parking Lots* (plates 41–46) is the spiritual opposite of Frank's personal engagement in *The Americans*. Ruscha's most ambitious book is *Every Building on the Sunset Strip* (1966) (plate 24), a twenty-seven-foot-long panorama of a two-mile stretch of Sunset Boulevard in Los Angeles between Crescent Heights Boulevard and Doheny Drive, encompassing apartment buildings, gas stations, and warehouses as well as landmarks such as Whisky a Go Go. In the book, the Sunset Strip is pictured from the vantage of a car, and the street-level facades reveal little of the sprawl that extends behind them. Ruscha embraced the commercial vernacular of the road and the strip as a uniquely Western (and specifically Californian) cultural language. The strip was also the subject of the influential 1968 study *Learning from Las Vegas: The Forgotten Symbolism of Architectural Form*,

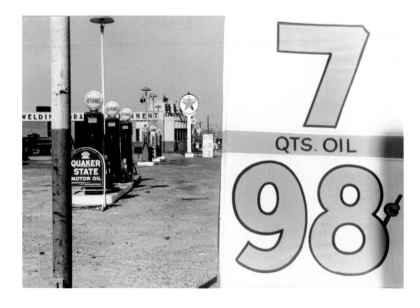

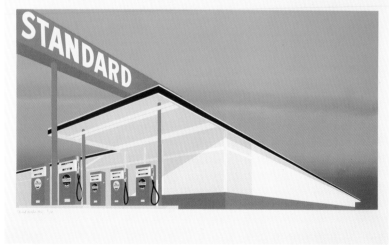

by architects Robert Venturi, Denise Scott Brown, and Steven Izenour, who cite Ruscha's book as an inspiration (fig. 6).

Andy Warhol remarked of his road trip to Los Angeles in 1963, "The farther West we drove, the more Pop everything looked on the highways."[14] Warhol was an Easterner who consumed images of the West through film and mass media, and his comment demonstrates that people increasingly thought of the West as a place of highways, overpasses, billboards, and strip malls. Stephen Shore, who shared with Warhol an interest in the commercial language of the road, made color pictures of signs, billboards, and gas stations while on multiple cross-country journeys in the 1970s. On an early road trip, in 1971, Shore made photographic postcards of Amarillo, Texas, which he distributed across America in postcard racks at road stops and gas stations. The photographs he made a few years later are more diaristic and include pictures of half-eaten meals, slept-in motel beds, and the numerous gas stations that he passed through (plate 39). The relationship between nature and artifice is a recurring motif; in *U.S. 97, South of Klamath Falls, Oregon* (plate 3), a painted billboard competes with the drama of the Western sky.

Manufacturing Civilization

In his influential 1893 essay "The Significance of the Frontier in American History," historian Frederick Jackson Turner pronounced the westward-moving American frontier—"the meeting point between savagery and civilization"[15]—as all but gone, establishing the general understanding in the last decade of the nineteenth century that the age of settlement and development had begun in earnest. His theory proposed that the moving frontier had been a significant factor in forming the American national character, and its closing marked an equally significant moment in the nation's history.

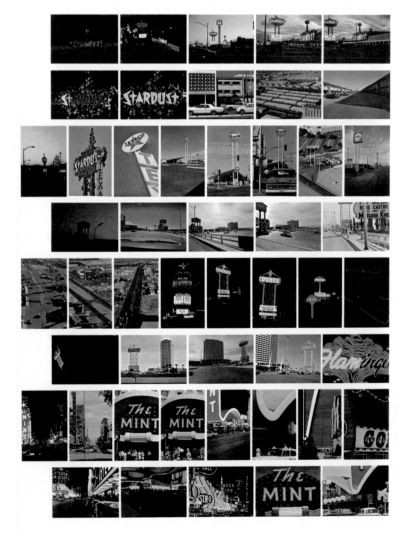

6. Page from **Learning from Las Vegas: The Forgotten Symbolism of Architectural Form**, by Robert Venturi, Denise Scott Brown, and Steven Izenour (Cambridge, Mass.: MIT Press, 1972). The Museum of Modern Art Library

Between 1870 and 1900, Americans settled more land than they had during the previous three centuries, and photographers explored its new conditions. San Francisco had been the subject of at least fifty photographic panoramas by 1877,[16] the year that Eadweard J. Muybridge made his 360-degree image of the city from an elevated vantage point on California Street Hill (plate 23). He combined the photographs into eight-foot-long bound books for sale for ten dollars and a variant presented in eleven albumen prints individually mounted on boudoir cards. In 1878 he returned to the same site to make eleven mammoth plate photographs that together are over seventeen feet in length.[17] His panoramas celebrate the metropolis's astonishing growth, its importance, and its affluence, and reflect the unwavering faith in progress of the late nineteenth century and the optimism about development justified by Manifest Destiny.[18]

In the economic boom after World War II, suburbs emerged outside existing cities to accommodate new demands for housing. Built in California in the 1950s, Lakewood was one of the largest planned communities in the West, comprising over 17,000 homes laid out in a grid on 3,500 acres of land. Families were attracted to new developments like Lakewood, where, it seemed, they could fulfill the American dream of self-sufficiency and economic upward mobility. In 1950 William A. Garnett was hired to make photographs of the construction of the Lakewood development to record the efficiency of mass-produced housing (plates 47–52). Taken from an airplane, the photographs are devoid of people and focus on the progress of construction over large areas of land. In his memoir of growing up in Lakewood, the writer D. J. Waldie describes Garnett's pictures: "The photographs celebrate house frames precise as cells in a hive and stucco walls fragile as an unearthed bone. Seen from above, the grid is beautiful and terrible."[19] Garnett's pictures, commissioned to promote the new

development, were enlarged and bound in presentation books for perusal by potential buyers. Subsequently, however, they came to represent all that was wrong with suburban development in the eyes of its critics. Peter Blake included Garnett's Lakewood pictures in his influential 1964 book *God's Own Junkyard: The Planned Deterioration of America's Landscape*, in which he describes suburbs as "interminable wastelands dotted with millions of monotonous little houses on monotonous little lots."[20]

In Garry Winogrand's 1957 photograph *New Mexico* (plate 56), a toddler stands in the driveway of a suburban house in an austere desert landscape. Such dispassionate views of the land were familiar territory for many photographers in the 1960s and early 1970s, and in 1975 the exhibition *New Topographics: Photographs of a Man-Altered Landscape*, at George Eastman House in Rochester, New York, defined such images as part of a new genre of landscape photography. Broadly speaking, New Topographics photographs are stark, black-and-white depictions of man-made structures in the land. These photographs have in common an economy of description, a clarity of detail, and a studied attempt to remain detached, seemingly objective. In Robert Adams's pictures of new subdivisions in Colorado—such as *Colorado Springs, Colorado* (plate 57)—people, when they appear, are isolated. The tension between promise and ruin is present in his work, but Adams was interested in ambiguous representations in which critique is mixed with empathy for the aspiration to the better life the suburbs promised. In the foreword to Adams's seminal 1974 book *The New West: Landscapes along the Colorado Front Range*, curator John Szarkowski wrote that the photographer had "discovered in these dumb and artless agglomerations of the boring buildings the suggestions of redeeming virtue. He has made them look not beautiful, but important, as the relics

of an ancient civilization look important. He has even made them look, in an unsparing way, natural."[21]

In 1978 Joel Sternfeld began making color photographs while traveling across the United States. The result is *American Prospects*, a series of photographs and a book that reveal the complexity of rural, urban, and suburban life in America. Like New Topographics artists, Sternfeld was interested in the suburbs, industrial parks, theme parks, and highways that increasingly populated the American landscape. Using 8-by-10-inch color negatives, he made detailed pictures with a painterly, even cinematic use of color, finding beauty in the unraveling American social fabric of the late 1970s and early 1980s (plate 13). A similar theme is embodied in John Divola's color photographs made in the late 1970s of an abandoned beach house in Zuma Beach, California (plate 58). The artist added to the existing spray-painted and deteriorated interiors and photographed them in contrast with the natural spectacle of the setting sun, seen through blown-out windows. In his later series Isolated Houses (plate 14), photographs of small dwellings at the edge of civilization in the vast emptiness of the California desert picture the West as a place of marginalized extremes.

Paradise Lost

Photography has played a key role in celebrating the "taming" of the West, influencing attitudes about land use and its impact. The discovery of gold in 1848 in California set into motion one of the largest westward migrations in the United States, and the mining of gold and other materials took hold as a major Western industry. The scope of this discovery is astonishing—within seven years, about $300 million in gold had been excavated from the

ground[22]—and its economic and social impact solidified the notion of the West as a land of opportunity. Mining towns became cities, and photography flourished in their centers. Virginia City, Nevada, the site of the lucrative Comstock Lode, was the subject of photographs by Timothy O'Sullivan in 1868, including some of the first pictures made in mine shafts (plate 89). Pictures celebrating new mechanized mining technologies were popular, and like Wilfred R. Humphries's promotional 1904 panorama of Bisbee, Arizona (plate 63), these pictures endorsed the promise of technological progress. The development of oil fields in the 1890s fueled another economic boom, and cities—Los Angeles and Houston, for example—developed in areas where oil was plentiful. A photograph of oil gushing from a derrick in Maricopa, California (plate 64), taken by an unknown photographer around 1905, demonstrates that natural resources in the West seemed limitless.

Another of the West's lucrative industries was logging. In the southern Sierras in 1890, a large tree cost $1,500 and its lumber sold for $2,500, yielding a gross profit of $1,000 per tree for the lumber companies.[23] Darius Kinsey's celebratory photographs of loggers standing proudly by massive fallen trees focus on the arduous and dangerous conditions under which these men worked at the turn of the twentieth century (plate 75). Kinsey also photographed vast swaths of razed forests (plate 68) and the complex transportation system that moved timber from the woods to the mines, factories, and cities where it was consumed. His pictures laud the heroism of the loggers, but for twenty-first-century viewers they also compose a devastating image of environmental destruction.

With the development of large-scale irrigation systems, agriculture operations grew exponentially. In 1926 Hugo Summerville, a San Antonio–based photographer specializing in panoramas, created a sweeping image of a Texas fig farm that benefited from modern irrigation technology but

7. Robert Smithson (American, 1938–1973). **Spiral Jetty**. April 1970. Great Salt Lake, Utah. Black rock, salt crystals, earth, and red water (algae), 3 ½ x 15 x 1,500′ (1.1 x 4.6 x 457 m). Collection DIA Center for the Arts, New York. Photograph by Gianfranco Gorgoni

8. Christo Vladimir Javacheff (American, born Bulgaria 1935). Jeanne-Claude Denat de Guillebon (American, born France 1935). **Running Fence, Sonoma and Marin Counties, California, 1972–76**. 1976. Photograph by Wolfgang Volz

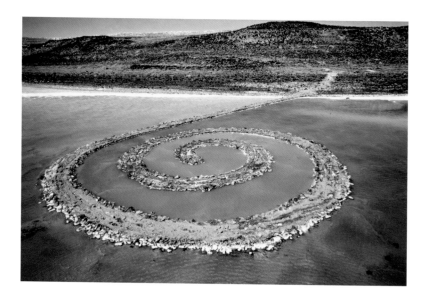

had not yet been fully mechanized (plate 60). Like Kinsey's photographs and many others, this picture celebrates the West's bounty and reinforces the image of Western settlement as a continually glorious march toward a predetermined destiny.

After World War II the effects of settlement on the environment became a major subject for artists. Among those interacting with the landscape in new ways was Robert Smithson, who created large-scale earthworks in some of the most inhospitable areas of the West, including the Great Salt Lake in Utah, where in 1970 he executed *Spiral Jetty* (fig. 7), his best-known work. Smithson believed that "the processes of heavy construction have a devastating kind of primordial grandeur," and he maintained that there was potential for beauty in man-made interventions in nature, such as his own projects.[24] Photographers of Smithson's generation shared his view of the Western landscape. Lewis Baltz turned his lens toward man-made detritus in his twenty-five-part photographic work *San Quentin Point* (plate 67). In this grid of photographs, the imprint of humans is evident in the form of plastic bags, bottles, and other trash. In his tightly cropped pictures, "the man-made, the cultural, and the natural are entropically merged," Baltz has said.[25]

Increasingly, photographers made images that spoke to the failure of the West's promised bounty, including the impact of natural disasters, from Joel Sternfeld's 1979 picture of a suburban landslide (plate 61), where neutral tones camouflage the extent of the destruction, to Frank Gohlke's image of the aftermath of the eruption of Mount St. Helens in 1980 (plate 66), in which the devastated area is ten miles in radius. These images, while beautiful, evoke the wrath of nature that is absent in the celebratory images of the nineteenth and early twentieth centuries.

Other visions of the West carry a decidedly more urgent message about the degradation of land. David T Hanson's 1986 photograph of hazardous waste in Leadville, Colorado (plate 70), depicts, in vividly acidic colors, the extent of the contamination of the California Gulch from lead, silver, zinc, copper, and gold mining in the nineteenth and early twentieth centuries, while Robert Dawson examines the intensive over-farming of Western terrain in black-and-white photographs also made in the mid-1980s (plate 73). Richard Misrach has been photographing the desert of the Southwest for over thirty years; his moody 1983 image of a desert fire evokes a post-apocalyptic land (plate 9). And in Karin Apollonia Müller's hazy 1997 picture of downtown Los Angeles (plate 69), the modern city is a littered wasteland riddled with freeways and populated with anonymous glass towers. While these images address the degradation of the environment, they, too, are highly aestheticized constructions, different only in content from the pictures of an unspoiled paradise that dominated representations of the West in the nineteenth and early twentieth centuries.

Contemporary images of the West reflect current events and politics, just as nineteenth-century ideologies, such as Manifest Destiny, affected how nineteenth-century photographers framed their pictures and how these pictures were received and interpreted. Geoffrey James's 1997 photograph of the border fence built between Mexico and the United States by the United States Army Corps of Engineers in 1994 (plate 71) depicts a land unnaturally divided. The title of his series, Running Fence, recalls a 1976 work of the same title by artists Christo and Jeanne-Claude. Their *Running Fence* (fig. 8) was a twenty-four-mile-long, eighteen-foot-high white nylon fence that snaked across the rolling hills of California's Sonoma and Marin counties for two weeks. Unlike the permanent structure in James's picture, the temporary fence enhanced the beauty of the landscape and was in harmony with its

natural topography. In contrast, James's photograph pictures a land scarred by politics and likely to remain so. An-My Lê's crisp black-and-white pictures taken in the Mojave desert in 2003–04 record military exercises performed in preparation for war in Iraq (plate 62). Just as European landscape emulates the West in Spaghetti Western films, here the California desert is a stand-in for hostile Middle Eastern terrain. Lê's detailed photograph, made with a large-format camera, underscores the vital role landscape plays in war. Together these cautionary contemporary visions of the land have come to influence how we imagine the future of the West.

Native Americans

Pictures of people symbolize the face of the West, and images of Native Americans are among the most recognizable Western icons. The earliest pictures of Native Americans in the West were made by white photographers, and they reflect their makers' attitudes toward the noble warriors or uncivilized heathens they considered their subjects to be. Their photographs are ethnographic documents or romanticized and symbolic artistic statements; they rarely are straightforward records. The first known photograph of a Native American, made in about 1845 in Great Britain by the Scottish photographers David Octavius Hill and Robert Adamson, pictures Reverend Peter Jones (Kahkewaquonaby) (fig. 9). Although Reverend Jones hailed from the Eastern Ojibwa tribe, this is a picture of *the* Native American—singular regardless of culture or affiliation—an archetype that has become a potent, if misconstrued, symbol of the American West.

Before the advent of photography, expeditionary painters such as George Caitlin and Karl Bodmer depicted Native Americans and their ways of life, and some of the post–Civil War government surveys included photographs of indigenous people and their settlements. An early photographic example includes a portrait attributed to Edric L. Eaton of the Pawnee Tirawahut Resaru, or Sky Chief (plate 74), a picture previously attributed to William Henry Jackson, who had purchased Eaton's commercial studio and its contents. Tirawahut Resaru is dressed in a mixture of traditional clothing and United States military issue; with the American government he had found a common enemy in the Dakota. Like gold miners and loggers in their portraits of the mid-nineteenth century, he posed with the instruments that defined him. A U.S. peace medal hangs around his neck, and he holds a tomahawk pipe, a symbol of both war and peace.

In the latter part of the nineteenth century, when most native populations had been driven off their land and relegated to reservations, many white Americans became interested in indigenous cultures. The Bureau of Ethnology (later renamed the Bureau of American Ethnology) was established in 1879 by an act of Congress to study native cultures under founding director Major John Wesley Powell (fig. 10). Powell developed and professionalized the nascent field of anthropology with ethnographic, archeological, and linguistic field research, and photography played a pivotal role in his studies. John K. Hillers, photographer on Powell's survey expedition down the Colorado River in the early 1870s, was appointed the bureau's official photographer. Hillers photographed Pueblo Indians extensively in New Mexico and Arizona, making overall views of their settlements (plate 21) as well as portraits. In his 1879 photograph of two Moki (Hopi) girls, their distinctive hairstyles and cornmeal-covered faces signify their unmarried status (plate 82). In keeping with the bureau's mission, this portrait and other pictures like it are tributes to fast-disappearing traditional Native American lifestyles, reflecting mainstream nostalgia for a culture that had

9. David Octavius Hill (British, 1802–1870). Robert Adamson (British, 1821–1848). **Rev. Peter Jones (Kahkewaquonaby) [The Waving Plume]**. c. 1845. Calotype, 7 7/8 x 5 13/16" (20 x 14.8 cm). Amon Carter Museum, Fort Worth, Texas

10. John K. Hillers (American, 1843–1925). **Tau-Gu, Great Chief of the Pai-Utes, with Major John Wesley Powell**. c. 1900. Two albumen silver prints, each: 4 3/8 x 3" (11.1 x 7.6 cm). The Museum of Modern Art, New York. Purchase

been deliberately destroyed. In the same year, Wells Moses Sawyer photographed Chief Joseph (Hinmaton-Yalakit), the great Nez Perce leader known for his resistance to the United States government's attempts to force his people onto reservations. Sawyer's photograph of Joseph in traditional dress with his nephew in modern-day garb is a compelling image of generational transition and cultural assimilation (plate 123).

Between 1895 and 1904, amateur photographer and bookseller Adam Clark Vroman traveled throughout the Southwest photographing among the Hopi and Navajo. Vroman's photographs are neither romantic, nostalgic, nor ethnographic but are straightforward and respectful descriptions of the communities and families he met during his travels (plate 95). His well-made platinum prints are rich in description and tone, but he did not exhibit his photographs or think of himself as an artist, but rather, in his words, a "general 'wanting to see' fellow."[26] He photographed in order to better understand Native American culture, language, dress, and ritual, and his pictures reflect a more impartial point of view than those of his contemporary Edward Sheriff Curtis. Curtis's ambitious photographic project *The North American Indian* (1907–30), underwritten by J. Pierpoint Morgan, comprises a limited-edition book of twenty volumes containing over two thousand photographs of indigenous people from across North America as well as Edison wax cylinder sound recordings. In his preface to Volume I, President Theodore Roosevelt wrote, "The Indian as he has hitherto been is on the point of passing away. . . . It would be a veritable calamity if a vivid and truthful record of these conditions were not kept."[27] While the intent of the project was preservation, prevailing racial stereotypes and his own nostalgia for the "vanishing race" determined the content of many of Curtis's photographs.[28] He frequently took liberties in staging them, sometimes asking his subjects to change

into traditional dress and retouching his negatives to erase traces of the modern world. Curtis found opportunities for the picturesque in his images: In his 1904 photograph taken in Canyon de Chelly (plate 26), small Navajo figures cross the barren land on horseback, as at the beginning or the end of a mythic tale.

Gertrude Käsebier's photographs of Native Americans echo Curtis's. Käsebier, who tended to cast her subjects as symbols, photographed Sioux cast members of Buffalo Bill's Wild West Show in her East Coast studio around the turn of the twentieth century. Käsebier, raised on the Great Plains, expressed genuine respect for Native Americans; she created artistic images that celebrated them, but only as heroic, wise, exotic, or mysterious. Her picture of Whirling Horse (plate 91), whom she photographed in profile to better describe his spectacular headdress, is an artistic representation rather than an insightful psychological portrait of an individual. Pictures such as these perpetuate the romantic cliché of Native Americans as deeply spiritual, naturally in tune with the land, and unfettered by modern-day concerns and technology.

Many Native Americans saw photography, a tool of white colonists, as a threat to the sanctity of their rituals and ceremonies. For this reason the Hopi banned photography at their events in 1915 (other Pueblo tribes soon followed suit), and individuals such as the Lakota leader Crazy Horse refused to be photographed. Although the majority of early photographs of Native Americans were made by white Americans, there were indigenous professional photographers, such as Benjamin and Henry Haldane and Thomas Easton (all Tsimshian), working in the nineteenth century, and George Johnston (Tlingit), Murray McKenzie (Cree), and Lee Marmon (Laguna Pueblo), in the twentieth century.[29] The Kiowa photographer Horace Poolaw, a recognized practicioner in his day, began taking

pictures of his family, friends, and community members in the 1920s. Poolaw's pictures—exemplified by a delicate hand-colored photograph of his sister and her son (plate 90)—describe traditional rituals, festivals, and dress as well as the integration of Native Americans into modern American life. Poolaw and other Native American photographers came into mainstream public consciousness through exhibitions and books on the subject in the 1980s and 1990s, around the same time that identity politics and postcolonial theory became widespread subjects of contemporary art.[30]

Lois Conner's photographs taken in the 1990s on the Navajo reservation in the Four Corners area—the meeting point of Arizona, Colorado, New Mexico, and Utah—exemplify recent photographs of Native Americans. Conner (whose grandmother was Cree) pictures her subjects going about their lives—hanging out with family or driving around (plate 109). Artists have also used the medium to more openly examine preconceptions about Native American image and identity. James Luna, an artist of Pooyukitchum/ Luiseño ancestry, makes installations, performance-based videos, and photographs that speak to his cultural background and his experiences on the La Jolla reservation in California, where he was born and raised. His tongue-in-cheek 1991 self-portrait *Half Indian/Half Mexican* (plate 92) recalls an identity photograph or mug shot. These recent photographs provide a counterpoint to the tokenized portrayals of Native Americans so pervasive in the nineteenth and twentieth centuries.

Land of Opportunity

Most of the earliest photographs made in the West are portraits, and the pursuit of opportunity is tangible in pictures of the migrants who settled there. The discovery of gold in 1848 near Sacramento, California, precipitated an influx of immigrants to that state and favorably influenced the local economy. Portrait studios in Sacramento, San Francisco, and nearby mining towns such as Stockton did a brisk business with newly wealthy miners. In these pictures miners hold the tools of their trade or golden nuggets, identifying themselves by their occupation and ambition (plate 81). The miners' poses, their outfits, and the tools that define their hazardous occupation have contributed to the rough-and-tumble hero persona that is prevalent in the legends of the West. The frontiersman holding a gun in a hand-colored ambrotype is forging a new life (plate 88), as are the loggers, photographed by Darius Kinsey in the Northwest, who proudly demonstrate their conquest of majestic arboreal giants by cutting them open and lying deep in their trunks for the camera (plate 75). These aspirational photographs forge an image of the West's people that omits the hardship, violence, and economic distress that was the reality for many frontier-era migrants.

Although they were barred from many occupations and segregated into ghettos, Chinese immigrants were essential to the building of the West, from the transcontinental railway to mining operations. Isaac Wallace Baker made the earliest known photograph of a Chinese person in California a few years after the gold rush, while traveling through mining camps with his mobile daguerreotype wagon peddling portraits to workers (fig. 11). Carleton E. Watkins's Montgomery Street studio was located near the heart of San Francisco's Chinatown, and during the 1870s and 1880s he made photographs of the neighborhood's inhabitants. Watkins's Chinese darkroom assistant, Ah Fue, may have provided him with access to the Chinese community. His portrait of a Chinese actor (plate 83), made in the late 1870s, is an image of elegance, grace, and nobility that, while respectful, does exoticize its subject.

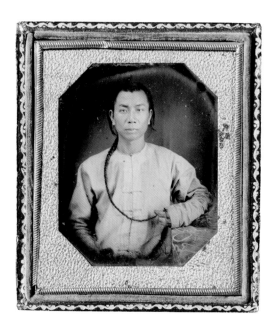

11. Isaac Wallace Baker (American, 1810–c. 1862). **Portrait of a Chinese Man**. c. 1851. Daguerreotype, 3 1/4 x 3 1/4" (8.3 x 8.3 cm). Oakland Museum of California

12. Frederick Remington (American, 1861–1909). **The Bronco Buster**. 1895. Bronze, 32 1/2 x 19 1/2 x 12 3/4" (82.6 x 49.5 x 32.4 cm). Amon Carter Museum, Fort Worth, Texas

13. Unknown artist. **Buffalo Bill's Wild West and Pioneer Exhibition (Summit Springs Rescue)**. c. 1907. Color lithograph, 28 1/8 x 38 1/4" (71.4 x 97.2 cm). Printer: Strobridge Lithograph Co. Buffalo Bill Historical Center, Cody, Wyoming (1.69.2033)

Arnold Genthe's turn-of-the-century photographs focus on the vitality of the street life of San Francisco's Chinatown (plate 96). Unlike his East Coast counterparts Lewis Hine and Jacob Riis, Genthe (a frustrated draftsman and painter) was not a social documentarian—he saw his photographs as means of visual expression. He wrote, "My inmost desire to be an artist had never really left me. In the camera, I saw a new and exciting art medium—one by which I could interpret life after my own manner in terms of light and shade."[31] In his photographs he projects poetry and exoticism onto his Chinese subjects, and they are not dissimilar to Edward Sheriff Curtis's romanticized views of Native Americans. By highlighting immigrants to the West—whether miners, loggers, actors, or railroad workers—these early pictures forged an image of the region as a land of opportunity and its settlers as successful strivers for the golden dream.

Studs on the Range

Embodying qualities of self-sufficiency and independence, the cowboy endures as one of the West's most prominent symbols. The cowboy of popular culture possesses supreme skills in roping, shooting, and riding and is a rugged, solitary individual (almost always a man) of strength and action. The heyday of the historical cowboy—whose daily life related very little to his legend—was between the 1860s and 1880s, before the introduction of barbed wire and the transcontinental railroad made his skills at long trail drives redundant. Even though the "classic" cowboy began to disappear in real life over one hundred years ago, as an icon he is still instantly recognizable by his swagger and his clothes. See, for example, a clearly constructed portrait made in the 1850s (plate 116). The sitter's clothes, worn like a costume, highlight how the symbolism of dress, regardless of its utility

in the working world of ranch hands, can make for a powerful image. In the late 1800s, Charles D. Kirkland became known for photographs of Wyoming cowboys and straightforward descriptions of ranch life. But even his direct and frank pictures show cowboys in their dress clothes (plate 87), helping to mythologize them as heroic figures.

One of the most well-known artists to celebrate the legend of the Old West was Frederick Remington, a cowboy, sheep rancher, and gold prospector who made bronze sculptures of Western heroes. The drama of ranch life was the focus of his work. In his 1895 sculpture *The Bronco Buster* (fig. 12), a horse's straining muscles are clearly defined as it struggles to overpower the cowboy who is trying to master it. Depictions of cowboys at work make up the entire oeuvre of Texan Erwin E. Smith, who photographed at the beginning of the twentieth century (plate 121). Like Remington, Smith constructed images of life on the open range during a period in which it was already in sharp decline.

Buffalo Bill's Wild West Show was one of the most important influences on narratives of interactions between cowboys and Native Americans before the advent of film. The traveling show was a popular spectacle staged by the indefatigable William "Buffalo Bill" Cody throughout the United States and abroad between 1883 and 1917 (fig. 13). It featured bronco riding, roping, fancy shooting, and other theatrics, as well as entertaining but inaccurate re-enactments of battles between white settlers and Native Americans. The cast included live animals, cowboys and cowgirls (including the famous Annie Oakley), and over one hundred Native Americans (including noted leaders Iron Trail and Sitting Bull), some of whom are pictured in the six-foot-long panorama taken of the troupe in Brooklyn, New York, in 1909 (plate 115). Although Cody's show played into white stereotypes of Native Americans, the spectacle brought to a wider

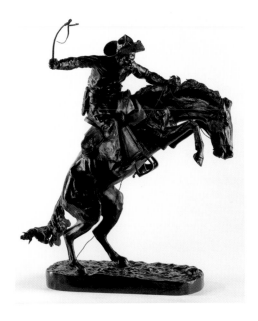

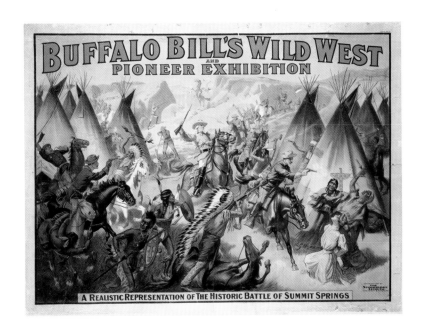

consciousness the Native American traditions and rituals that have shaped many representations of the West. Buffalo Bill's Wild West Show (and others like it) gave birth to the modern rodeo, and the rodeo's pageantry and showmanship reflect its roots. In the 1970s Garry Winogrand made photographs at the Fort Worth Fat Stock Show and Rodeo, focusing on the moments between events and on the rodeo's audience, as demonstrated in his photograph of three fun-loving female spectators (plate 102), familiar Texan characters in popular culture.

The Marlboro Man was conceived by advertising executive Leo Burnett in 1954 for a campaign for Marlboro cigarettes. Burnett's creation, characterized by rugged masculinity, is recognized around the world as a timeless representation of the United States and is for many the defining image of the American West. For his Cowboy series, begun in 1980, Richard Prince has rephotographed Marlboro advertisements, cutting out the texts, cropping the images, and enlarging them (plate 118). Prince began rephotographing the ads in the 1990s, as Philip Morris increasingly came under attack for its products and two Marlboro Man models, Wayne McLaren and David McLean, died of lung cancer. By singling out the Marlboro Man for scrutiny, Prince has highlighted the artifice of the virile image of the cowboy and its potency as a deeply ingrained figure in American mythology.

A Man Who Lives by His Own Code

In John Ford's 1962 classic Western movie *The Man Who Shot Liberty Valance*, Tom Doniphon (played by John Wayne) declares of the West, "Out here a man settles his own problems." This creed could caption many images of the West's inhabitants, from the outlaw to those living "off the grid." The outlaw is a crucial character in legends of the Wild West, and gunslinging

bandits—Jesse James, Billy the Kid, Butch Cassidy, and Cherokee Bill—have been immortalized in pulp novels and on the silver screen by actors such as Robert Redford and Clint Eastwood. Before the advent of film, photography played a role in popularizing these colorful characters, and pictures of them circulated in the media and were reproduced on "wanted" posters. An unknown photographer made a rare picture of five members of the legendary outlaw gang the Wild Bunch at the height of their infamy (plate 100). The leaders of the Wild Bunch were Butch Cassidy and Kid Curry (pictured at top left), and together they robbed stagecoaches, trains, and banks in the late nineteenth century. In the picture the gang members, dressed in their city best, fall short of their reputations as feared gunslingers and murderers.

Even in the modern West, the man who lives by his own code thrives in popular culture. The spirit of the frontier outlaw is evoked in *Easy Rider* (1969), starring Peter Fonda, Jack Nicholson, and director Dennis Hopper (fig. 14). In the film the promise of freedom on the road, in drugs, and in sex is haunted by violence and death. The motorcycle (or "steel horse") is a powerful symbol of rebellion in popular culture, and The Hells Angels Motorcycle Club, founded in 1948 in the San Bernardino area of California, is often characterized as a violent gang of outlaws. In the mid-1960s Hells Angel Birney Jarvis described fellow club members as "pure animals." "They'd be animals in any society," he told writer Hunter S. Thompson. "These guys are outlaw types who should have been born a hundred years ago—then they would have been gunfighters."[32] Irving Penn's 1967 studio portrait of seven Hells Angels (plate 98) shows a group tied together by look, attitude, and lifestyle. In Penn's picture the bikers are elegantly draped over their motorcycles, exhibiting the confidence and toughness they are associated with but not the violence for which they have become known.

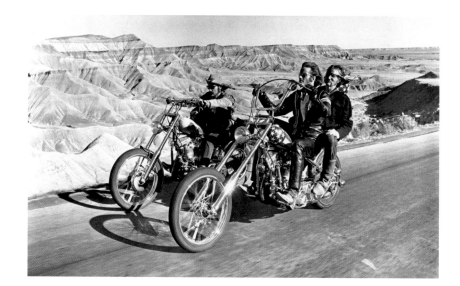

14. Dennis Hopper (American, born 1936). **Easy Rider**. 1969. USA. 35mm print, color, sound, 95 min.
The Museum of Modern Art Film Stills Archive

Notorious gangs have shaped the perception of the modern-day West, especially of California. Graciela Iturbide, a Mexican photographer who studied with Manuel Alvarez Bravo, traveled to East Los Angeles in 1986 and photographed members of the White Fence gang. Centered in the barrio of Boyle Heights, the gang has created its own cultural and ethnic identity, fusing American and Mexican attributes. In her picture of women standing in front of a mural of figures from Mexican history (Benito Juárez, Emiliano Zapata, Pancho Villa), the *cholas* pose self-consciously, their tight jeans, tank tops, and heavy makeup signifying their group identity (plate 101). This picture by Iturbide and Penn's Hells Angels portrait reveal the importance of dress and posturing in creating the image of some of the most well-known gangs of the West.

The West's reputation as the originator of counterculture in the United States—including the feminist, gay rights, black pride, anti–Vietnam War, and Chicano movements and the "turn on, tune in, drop out" hippie philosophy—still prevails. While these ideas flourished across the country and around the world in the 1960s and 1970s, they were embodied by the West—by California, to be exact. In the late 1960s, San Francisco was the central meeting point for hippies, who, like their predecessors (cowboys and outlaws), thrived on creating a distinct identity outside of the mainstream. In 1966 and 1967 William Gedney photographed disaffected youth in the Haight-Ashbury district of San Francisco, recording communal living, concerts in the park (plate 76), and the general daily goings-on of kids in the area. Writer Joan Didion also spent a year in the Haight, and in her 1967 essay "Slouching Towards Bethlehem" she describes what she experienced as a society unraveling from within: "The center was not holding. It was a country of bankruptcy notices and public auction announcements and commonplace reports of casual killings and misplaced children and abandoned homes and

vandals who misspelled even the four-letter words they scrawled."[33] This sentiment is mirrored in Gedney's photograph of a rundown celebrity worshipper whose ambitions have been replaced by the dark specter of violence, drug abuse, and self-destruction (plate 131). More extreme countercultures include communes, religious cults, and militias, many of which thrive in the open spaces of the West. Made ten years before the well-publicized 1993 FBI siege of a Branch Davidian compound in Waco, Texas, Joel Sternfeld's photograph of a member of the Texan Christ Family religious sect (plate 80), whose vegetarian followers wear white robes and advocate nonviolence, has a strange off-kilter effect, as the subject is half underground. Like Gedney's pictures, Sternfeld's image speaks to the decline and corruption of utopian ideals in the West.

The Lifestyle

Land ownership has always been one of the promises of the West, and as such it is the subject of many photographs. The 1862 Homestead Act granted ownership of 160-acre parcels of public land to those settlers who resided on them for five years in every Western state except Colorado. Families flocked to the West to realize their dreams of home and land ownership, and by 1895 more than 430,000 settlers had filed homestead claims. Homesteaders faced difficult financial and environmental conditions. Clashes took place between the new arrivals and ranchers, who claimed the open range for their cattle, and Native Americans, whose ancestral hunting grounds were destroyed by the parceling process. The homesteader Solomon D. Butcher made nearly 1,500 photographs of families and their sod houses in Custer County, Nebraska, creating a record of homesteading at its height. Andrew J. Russell's 1869 picture taken in Utah (plate 103)

and Butcher's photograph of around 1888 (plate 107) are typical images of Western settler families of that era.

As the frontier era ended near the close of the nineteenth century, mass settlement of the West began. People converged in some of the fastest-growing towns of the West—San Francisco, Denver, Salt Lake City, Los Angeles—where gainful employment in manufacturing and other industry could be had. It wasn't until the economic boom of World War II that Americans migrated outside urban centers en masse. With government home-ownership incentives, new technology that facilitated the mass production of houses, and the introduction of the interstate highway system, America—especially the Western states with their ample land—was ripe for a suburban building boom.

In suburban communities, the verticality of life in the city was replaced by a horizontal milieu of backyard pools and quiet cul-de-sacs. Photographers expressed interest not only in the architecture of suburbia but also in the promise of its lifestyle. Bill Owens's Suburbia photographs, of family dinners, Tupperware parties, and garage sales, are accompanied by matter-of-fact commentary by his subjects. Owens, a photographer for a newspaper in Livermore, California, lived and worked in the suburbs, and his pictures provide an insider's point of view on dreams of home ownership. In his 1972 photograph *We Are Really Happy* (plate 108), a young couple feeds their baby in an archetypical image of suburban bliss. Behind the beaming pair, however, a tangle of industrial power lines and pylons is visible through a window, exposing their home's less than ideal location.

Larry Sultan has chronicled his family's suburban Californian lifestyle in his photographs and books. For one project he isolated stills from his family's home movies of 1943 to 1972 and made photographs

of them. These pictures feature backyard barbeques, family get-togethers, and golf outings, activities that epitomize suburban life (plate 110). However, unease lurks beneath the surfaces of these familiar images; cropped and grainy, they resemble surveillance or evidence photographs. In Homeland, his 2008 series of staged photographs of day laborers, Sultan explores the delicate structures and fraught sociopolitical tensions that sustain the suburban lifestyle (plate 125).

The commodification of modern home ownership accompanied the new suburban lifestyle. It is probably best exemplified by Julius Shulman's well-known 1960 photograph of a house designed by architect Pierre Koenig in 1958 as part of the Case Study House program (plate 59). In the image, Koenig's glass house is perched almost impossibly in empty space, overlooking the twinkling city below, while inside two elegant women sit chatting in the living room in a picture-perfect scene of modern living. Shulman's widely published images promote the chic elegance and cool glamour of an idealized lifestyle, and they continue to resonate today. This template is updated in Joel Sternfeld's 1988 photograph of a woman posing with her light lunch after exercising in her Malibu home (plate 77). In a caricature of a healthy California lifestyle, Sternfeld's subject shows off her trim figure in a Pucci outfit without a trace of sweat.

Silver Screen

The Great Train Robbery, filmed in 1903 in New Jersey, is one of the earliest Western films. Directed by former Thomas Edison cameraman Edwin S. Porter, the eleven-minute silent film was inspired by the events of August 29, 1900, when members of Butch Cassidy's gang robbed a Union Pacific train in Wyoming. A scene of a bandit firing his gun at the camera

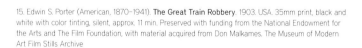

15. Edwin S. Porter (American, 1870–1941). **The Great Train Robbery**. 1903. USA. 35mm print, black and white with color tinting, silent, approx. 11 min. Preserved with funding from the National Endowment for the Arts and The Film Foundation, with material acquired from Don Malkames. The Museum of Modern Art Film Stills Archive

16. John Ford (American, 1894–1973). **Stagecoach**. 1939. USA. 35mm print, black and white, sound, 93 min. Preserved with funding from Celeste Bartos, from material acquired from AFP Exchange. The Museum of Modern Art Film Stills Archive

17. Andy Warhol (American, 1928–1987). **Double Elvis**. 1963. Silkscreen ink on synthetic polymer paint on canvas, 6' 11" x 53" (210.8 x 134.6 cm). The Museum of Modern Art, New York. Gift of the Jerry and Emily Spiegel Family Foundation in honor of Kirk Varnedoe

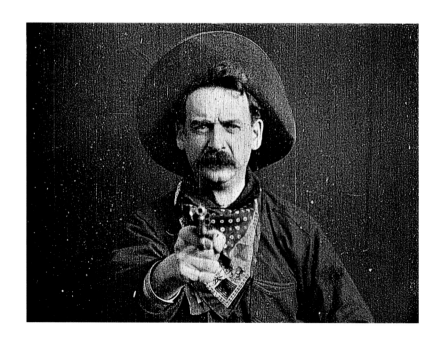

(which could be shown at the movie's beginning or end) had a profound effect on audiences (fig. 15). Extremely popular and commercially successful, *The Great Train Robbery* created one of the most enduring genres of American film.

While on a cross-country trip in the late 1980s, French cultural theorist Jean Baudrillard remarked, "It is not the least of America's charms that even outside the movie theaters, the whole country is cinematic. The desert you pass through is like the set of a Western, the city a screen of signs and formulas."[34] Indeed, the region is indelibly linked to the world presented in films. Many visitors cannot experience Monument Valley, the imposing and primeval basin situated on the Arizona-Utah border, without thinking of John Ford classics such as *Stagecoach* (1939) (fig. 16) and *The Searchers* (1956), and it's hard not to conjure the Spaghetti Westerns of Sergio Leone when passing through dusty border towns. Films in other genres have also contributed to imagery of the West and its people, including the life on the road epitomized in *Easy Rider*; civic corruption, scandal, and intrigue in Los Angeles in *Chinatown* (1974), directed by Roman Polanski; and the counterculture hero celebrated in Michelangelo Antonioni's *Zabriskie Point* (1970). Television, too, has had a powerful impact in bringing a certain image of the West to the masses—in 1959 seven of the top ten television shows in America were Westerns.[35] The recent resurgence of the genre in American entertainment—*Brokeback Mountain* (2005), *There Will be Blood* (2007), *No Country for Old Men* (2007), the remake of the 1957 classic *3:10 to Yuma* (2007), and the popular HBO series *Deadwood* (2004–06)—points to the continued interest of viewers in cinematic narratives of the West.

The stories told by Western films diverge greatly from the true history of the West, and the cinematic vision of the region's land and heroes and heroines has provided fodder for artists interested in how the spectacle of film has shaped conceptions of the West. Andy Warhol glorifies a hero of the silver screen in his seminal 1963 painting *Double Elvis* (fig. 17), derived from a publicity photograph for the movie *Flaming Star* (1960). In this image, two American pop icons—Elvis Presley and the gunslinger—merge, heightening the work's impact. Warhol was a predecessor of artists such as John Baldessari, Cindy Sherman, and Richard Prince, who looked to mass media, film, and consumer culture for inspiration in the 1970s and 1980s. Baldessari often borrows imagery from film and mass media in his photographs and paintings. In his 1984 work *Black and White Decision* (plate 120), he has flanked a film still of a woman with a still from a Western movie of two men on horseback. At the top is a third still of two men playing chess, their faces cropped out of the frame almost entirely. The result is an equally fascinating and puzzling montage that underscores film's vibrancy in popular culture.

The iconography of Hollywood B movies of the 1950s and 1960s was the inspiration for Cindy Sherman's Untitled Film Stills (1977–80). To make this seminal series of photographs, the artist donned costumes, wigs, makeup, and other props and enacted archetypal film characters: a smartly dressed career girl in the big city; a sex kitten posing on crumpled sheets; a woman running down a set of stairs looking furtively over her shoulder. The photographs, though not based on specific films, are recognizably cinematic and evoke numerous narrative possibilities. Sherman refers to Western films in her images of a lonesome woman waiting at a deserted train station in Flagstaff, Arizona, and a country girl posing on a tree at Monument Valley (plate 122). In this latter picture, taken in 1979 during a family vacation, Sherman tried to "make use of the Western environment," she has said.[36] Monument Valley was made famous by John Ford in the numerous Westerns that he shot there, from the 1930s to the 1960s (*Stagecoach, My Darling*

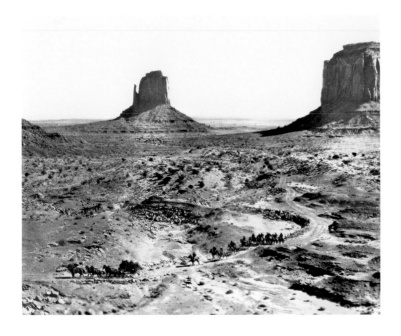

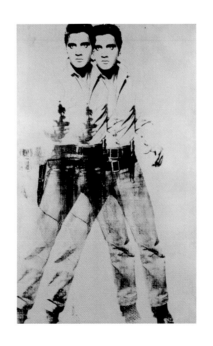

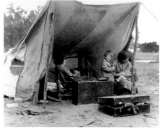

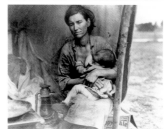

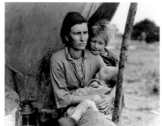

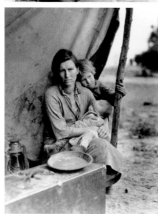

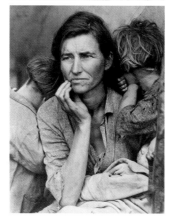

Clementine, She Wore a Yellow Ribbon, Wagon Master, The Searchers, and *Cheyenne Autumn*). By choosing one of the most hallowed locations in American cinema, Sherman has created an image that is deeply associated with the West in film. In a series of photographs executed in 2000, Sherman takes on the guises of a variety of women that seem plucked from the West Coast—an aging hippie, a fading beauty queen, and a tough woman in braids and flannel shirt who would be at home in the mountains of the Northwest or on the Oklahoma plains (plate 113). With these photographs, Sherman both critiques and reinforces the image of the West created through film.

As Hollywood has played an increasingly large role in American life, photographers have engaged with the image culture that supports the film industry. Lee Friedlander explores this culture of artifice in his photographs of signs and shop windows, including a 1965 picture-within-a-picture of a movie cowboy (plate 111). More recently, artists have fabricated and photographed sets that recall Hollywood's version of the West, as in James Casebere's 1985 photograph of toppled wagons (plate 119) and David Levinthal's 1989 soft-focus color photographs of toy cowboys (plate 117). Like Sherman's fictive film stills, these photographs both replicate and critique the image of the West as it appears in films and are themselves contributions to the ever-growing mass of representations of the region.

The underbelly of the film industry is the subject of Larry Sultan's series The Valley, made in middle-class suburban homes in the San Fernando Valley that were rented as sets for pornographic movies. Sultan's pictures do not engage in a moral debate about pornography, and in many cases the subjects of the photographs, like the suburbs themselves, are banal. Instead of picturing erotic exploits, Sultan focuses on the realities of the industry—setting up, waiting, applying makeup. The series includes portraits of the films' stars, such as *Tasha's Third Film* (plate 112), a 1998 picture in

18. Dorothea Lange (American, 1895–1965). Six variants of **Migrant Mother, Nipomo, California**. 1936. Gelatin silver prints, dimensions variable. Oakland Museum of California (from top, 1–5) and The Museum of Modern Art, New York. Purchase (6)

which a blond woman in curlers is seated tentatively on a couch waiting for her scene, while in the background a sliver of tanned legs and a hunched cameraman indicate the action. These photographs provide a less than idealized image of film culture and address the implications of suburbia as a backdrop for the construction of fantasy.

Failure of Possibility

Western migration promised a better future, but for some migrants hope gave way to despair. The anguish of dashed dreams is strongly evoked in one of the most well-known images of the twentieth century, Dorothea Lange's 1936 photograph *Migrant Mother, Nipomo, California* (originally titled *Human Erosion in California/Facing Starvation*) (plate 124). When she made this seminal picture, Lange was employed by the Farm Security Administration to document conditions in rural areas of the country during the Great Depression. Her photographs tend to have a humanist or moral purpose, and they helped put a face to the hardships of the Depression, particularly those experienced by displaced farmers. In the 1970s Florence Owens Thompson identified herself as the formerly anonymous subject of Lange's image. Lange had photographed Thompson, then a thirty-two-year-old mother of seven, in a camp for pea pickers in Nipomo, California. She made six exposures of Thompson and her family (fig. 18) but it's the iconic close-up of her weathered face etched with worry lines that is the poster image not only for President Franklin D. Roosevelt's New Deal, but also for the failure of the promise of the West.[37] The photograph was made the same year that *Life* magazine was launched, and the picture was quickly co-opted by the booming mass media. It has been reproduced countless times in magazines and is the image on a United States postage stamp issued in 1998.

The psychology of the disenfranchised has been a rich subject for photographers throughout the history of the medium, but it became an especially ripe topic for photographers in the wake of the major cultural and ideological shifts of the 1960s and 1970s. In 1978 the Amon Carter Museum in Forth Worth, Texas, commissioned Richard Avedon to make portraits throughout the West, a project that resulted in the book and exhibition *In the American West*. Avedon, one of the most successful fashion and celebrity photographers of the twentieth century, found his new subjects in mining towns and at stockyards, fairs, truck stops, and rodeos, and they included coal miners, drifters, and other marginalized or uncelebrated Americans—like Carl Hoefert, an unemployed blackjack dealer Avedon met in Reno, Nevada (plate 133). When these frontal, almost confrontational photographs were published, they generated intense debate about Western stereotypes and the nature of portraiture. One critic speculated that, in opposition to other constructions of the region, Avedon wanted "to portray the whole American West as a blighted culture that spews out casualties by the bucket: misfits, drifters, degenerates, crackups and prisoners—entrapped either literally or by debasing work."[38] In his fashion work Avedon created seductive images of the rich and famous, and he recognized the power of photography in spinning myth. Regarding *In the American West* he said, "This is a fictional West. I don't think the West of these portraits is any more conclusive than the West of John Wayne."[39]

In 1990 Philip-Lorca diCorcia began a series of photographs made on or near Santa Monica Boulevard in Hollywood. DiCorcia chose an area populated by hustlers, drug addicts, and drifters and sought out the men who frequented this strip. Each picture is titled with the subject's name, age, and place of birth and the amount the artist paid to photograph him. Made at the same time as Gus Van Sant's 1991 film about male hustlers in

the Northwest, *My Own Private Idaho*, starring River Phoenix and Keanu Reeves, and presaging the "heroin chic" of the later 1990s, diCorcia's photographs revel in the seedy glamour of Hollywood. With dramatic lighting and expressive posing, diCorcia stages his photographs to evoke a cinematic narrative, although viewers are required to fill in the details of the plot. His picture of "Major Tom" lying on fabled Hollywood Boulevard keeping vigil over John Lennon's star (plate 128) is an image of melancholy lament for crushed dreams and evokes the seduction and violence that can accompany celebrity worship.

Katy Grannan recently completed a series of photographs of "new pioneers"—individuals struggling to define themselves in the West today. In one image, "Nicole," whom Grannan befriended after her own move to San Francisco in 2005, poses seductively on a gravel parking lot in one of her many guises (plate 132). Her makeup-streaked face and the harsh light allude to her perilous existence on the fringes. In relation to these photographs and to her own experience, Grannan has remarked, "Many of us are still looking for whatever it is we believe the West offers— reinvention, escape. We believe it will be easier here; it will be different."[40]

In the past few years, Justine Kurland has been photographing train jumpers throughout the West. Although the landscape in her photographs is familiar from Andrew J. Russell's sweeping views of the 1860s, Kurland's images of transient life are a far cry from the promise embedded in his pictures. An endless freight train in the background of one photograph frames an assorted bunch—"Cuervo," riding a burro, followed by more burros and a wolf (plate 127). Together these photographs compose a decisively foreboding image of the West in which aspiration and disappointment go hand in hand.

*

The images of land and people explored here do not all picture the West from the same point of view or even, perhaps, picture the same West. Rather, each is one part in a continually shifting and evolving composite image of a region that has itself been growing and changing since the opening of the frontier. Their incredible variety illustrates the fascination the West has had for photographers since the invention of the medium over 150 years ago. Moreover, these pictures reflect the images of the West that have lived in the minds of the men and women who created them (and the individuals who commissioned them), and they transmit and sometimes critique those images while stimulating others in the imaginations of those who view them.

Historian Clyde A. Milner has said of the West that it is "an idea that became a place."[41] Photography, with its ability to construct persuasive and seductive narratives, has been the ultimate vehicle for creating and perpetuating that idea through images of people and places that together mythologize a region of America—and reflect a nation's image of itself.

Notes

1. Martha A. Sandweiss, "Interpretation," in *The Oxford History of the American West*, ed. Clyde A. Milner, Carol A. O'Connor, and Sandweiss (New York and Oxford: Oxford University Press, 1994), 672.

2. Until the 1860s, when the wet-collodion process was developed, most photographs were made indoors; daguerreotype technology, with its long exposure times and labor-intensive process, required the photographer to have control over light, temperature, movement, and subject. Weston J. Naef and James N. Wood discuss early American landscape photography in the exhibition catalogue *Era of Exploration: The Rise of Landscape Photography in the American West, 1860–1885* (Buffalo, N.Y: Albright-Knox Art Gallery, and New York: The Metropolitan Museum of Art, 1975).

3. The four surveys were Clarence King's United States Geological Exploration of the Fortieth Parallel (begun in 1867), which employed Timothy O'Sullivan; Ferdinand Vandeveer Hayden's United States Geological and Geographical Survey of the Territories (begun in 1867), which employed William Henry Jackson; Major John Wesley Powell's United States Geological and Geographical Survey of the Rocky Mountain Region (begun in 1870), which employed E. O. Beaman and John K. Hillers; and Lieutenant George Wheeler's United States Geographical Surveys West of the One Hundredth Meridian (begun in 1871), which employed William Bell and Timothy O'Sullivan.

4. John Szarkowski uses these terms to describe Timothy O'Sullivan's role as a survey photographer in the exhibition catalogue *American Landscapes: Photographs from the Collection of The Museum of Modern Art* (New York: The Museum of Modern Art, 1981), 7.

5. O'Sullivan and his contemporaries used the wet-collodion process to photograph outdoors. Photographs were made on glass plates that were coated and sensitized prior to being fitted into the camera. After the plate was exposed to light through the photographic aperture, it was developed and fixed immediately, in an on-site darkroom. The transport of large cameras, darkroom equipment, chemicals, and fragile glass plates required a large travel crew.

6. U.S. Congress. *Congressional Globe*, 38th Cong., 1st sess., pt. 3:2300–01, 2695, pt 4:3378, 3388–89, 3444; appendix: 240; "An Act Authorizing a grant to the State of California of the 'Yo Semite Valley' and of the land embracing the 'Mariposa Big Tree Grove,' approved June 30, 1864." For a detailed account of the role of Watkins's photographs in the passage of the bill, see "Evolving Together: Photography and the National Park Idea" in *American Photographers and the National Parks*, by Robert Cahn and Robert Glenn Ketchum (New York: Viking Press, 1981).

7. Martha A. Sandweiss quotes Gilpin in her exhibition catalogue *Laura Gilpin: An Enduring Grace* (Forth Worth, Tex.: Amon Carter Museum, 1986), 12.

8. Ansel Adams, *The Portfolios of Ansel Adams* (Boston: New York Graphic Society, 1981), n.p.

9. Andrew J. Russell was the official photographer for the Union Pacific Railroad Company (which laid track west from Omaha) and Andrew A. Hart for the Central Pacific Railroad Company (which laid track east from Sacramento), and Charles Savage was a commercial photographer based in nearby Salt Lake City.

10. Andrew J. Russell, *The Great West illustrated in a series of photographic views across the continent taken along the line of the Union Pacific Railroad west from Omaha, Nebraska* (New York: Union Pacific Railroad Company, 1869), n.p.

11. Peter B. Hales describes them thus in *William Henry Jackson and the Transformation of the American Landscape* (Philadelphia: Temple University Press, 1988), 162.

12. For an in-depth discussion of California's role in the development of car culture, see "Landscapes of Consumption: Auto Tourism and Visual Culture in California, 1920–1940," by John Ott, in *Reading California: Art, Image, and Identity, 1900–2000*, ed. Stephanie Barron, Sheri Bernstein, and Ilene Susan Fort (Los Angeles: University of California Press, 2001).

13. Dorothea Lange and Paul Taylor, *An American Exodus: A Record of Human Erosion* (New York: Reynal and Hitchcock, 1939), 107.

14. Andy Warhol and Pat Hackett, *Popism: The Warhol '60s* (London: Hutchinson, 1981), 39.

15. Frederick Jackson Turner, *The Frontier in American History* (New York: H. Holt: 1920), 3.

16. For a discussion of the history of panoramas in Western photography, see *The Great Wide Open: Panoramic Photographs of the American West*, by Jennifer A. Watts and Claudia Bohn-Spector (London: Merrell Publishers, 2001).

17. For a detailed analysis of all three versions of this panorama, see *Eadweard Muybridge and the Photographic Panorama of San Francisco, 1850–1880*, ed. David Harris (Montreal: Canadian Centre for Architecture, 1993), 116–23.

18. In 1990 Mark Klett remade Muybridge's panorama of San Francisco as closely as possible (new buildings blocked the original view), cementing the city's image as one of the West's most vital. Klett participated in The Rephotographic Survey Project (launched in 1977), which replicated over 120 nineteenth-century photographs made by William Henry Jackson, Muybridge, Timothy O'Sullivan, and Andrew J. Russell, among others. Photographers Rick Dingus and JoAnn Verburg and art historian Ellen Manchester also worked on the project.

19. D. J. Waldie, *Holy Land: A Suburban Memoir* (New York: W. W. Norton & Company), 5.

20. Peter Blake, *God's Own Junkyard: The Planned Deterioration of America's Landscape* (New York: Holt, Rinehart and Winston, 1964), 8.

21. John Szarkowski, foreword to *The New West: Landscapes along the Colorado Front Range*, by Robert Adams (Boulder, Colo.: Colorado Associated University Press, 1974), viii.

22. Keith Davis cites this figure in his exhibition catalogue *The Origins of American Photography 1839–1885, from Daguerreotype to Dry-Plate* (Kansas City, Mo.: Nelson-Atkins Museum of Art, 2007), 137.

23. Ralph W. Andrews cites these figures in *"This Was Logging!" Selected Photographs of Darius Kinsey* (Seattle: Superior Publishing Company, 1954), 40.

24. Robert Smithson, "A Sedimentation of the Mind: Earth Projects," in *The Writings of Robert Smithson* (New York: New York University Press, 1979), 38.

25. Lewis Baltz, interview in *Camera Austria* 11/12 (1983), n.p.

26. In *Adam Clark Vroman: Platinum Prints, 1895–1904* (Los Angeles: Michael Dawson Gallery, and Santa Fe, N.Mex: Andrew Smith Gallery, 2005) (p. 5), Andrew Smith and Jennifer A. Watts cite this journal text by Vroman inscribed on the back of a photograph (photCL86 [103]) in the collection of the Huntington Library, Art Collections, and Botanical Gardens, in San Marino, California.

27. Theodore Roosevelt, preface to *The North American Indian: The Complete Portfolios*, by Edward S. Curtis (Cologne, Germany: Taschen, 1997), 32.

28. "Vanishing race" refers to the popular notion at the turn of the twentieth century that Native American cultures were facing extinction.

29. Further south, Martin Chambi, a Peruvian of Indian-Mestizo ancestry, photographed his own and neighboring mountain villages, archaeological sites, and peoples around Cuzco from the 1920s until his death in the 1970s. Although many of his images of Machu Picchu and indigenous communities are romanticized, Chambi received significant artistic and international acclaim in his lifetime.

30. Some books on the subject published in the 1990s are the exhibition catalogues *The Photograph and The American Indian*, by Alfred L. Bush and Lee Clark Mitchell (Princeton, N.J.: Princeton University Press, 1994) and *Spirit Capture: Photographs from the National Museum of The American Indian*, ed. Tim Johnson (Washington, D.C.: Smithsonian Institution Press/National Museum of the American Indian, 1998), as well as *Strong Hearts: Native American Visions and Voices* (New York: Aperture, 1995) and *Grand Endeavors of American Indian Photography*, by Paula Richardson Fleming and Judith Lynn Luskey (Washington, D.C.: Smithsonian Institution Press, 1993).

31. Arnold Genthe, *Genthe's Photographs of San Francisco's Old Chinatown*, text by John Kuo Wei Tchen (New York: Dover, 1984), 15.

32. Hunter S. Thompson, *Hell's Angels: A Strange and Terrible Saga* (New York: Ballantine Books, 1996), 4.

33. Joan Didion, "Slouching Towards Bethlehem," in *Slouching Towards Bethlehem* (New York: Farrar, Straus and Giroux, 1990), 84.

34. Jean Baudrillard, *America*, trans. Chris Turner (New York: Verso, 1988), 56.

35. Milner, O'Connor, and Sandweiss, *Oxford History of the American West*, 673.

36. Cindy Sherman, *The Complete Untitled Film Stills* (New York: The Museum of Modern Art, 2003), 14.

37. For an extensive analysis of the sequence of six exposures, see *Dorothea Lange: The Heart and Mind of a Photographer*, by Pierre Bornham (New York: Bulfinch Press, 2002), 190.

38. Max Kozloff, "Through Eastern Eyes," *Art In America* (January 1987): 91.

39. Richard Avedon, *In the American West: 1979–1984* (New York: Harry N. Abrams, 1985), n.p.

40. Katy Grannan, *The Westerns* (San Francisco: Fraenkel Gallery, and New York: Greenberg van Doren Gallery and Salon 94 Freemans, 2007), n.p.

41. Clyde A. Milner, "America, Only More So," introduction to Milner, O'Connor, and Sandweiss, *Oxford History of the American West*, 3.

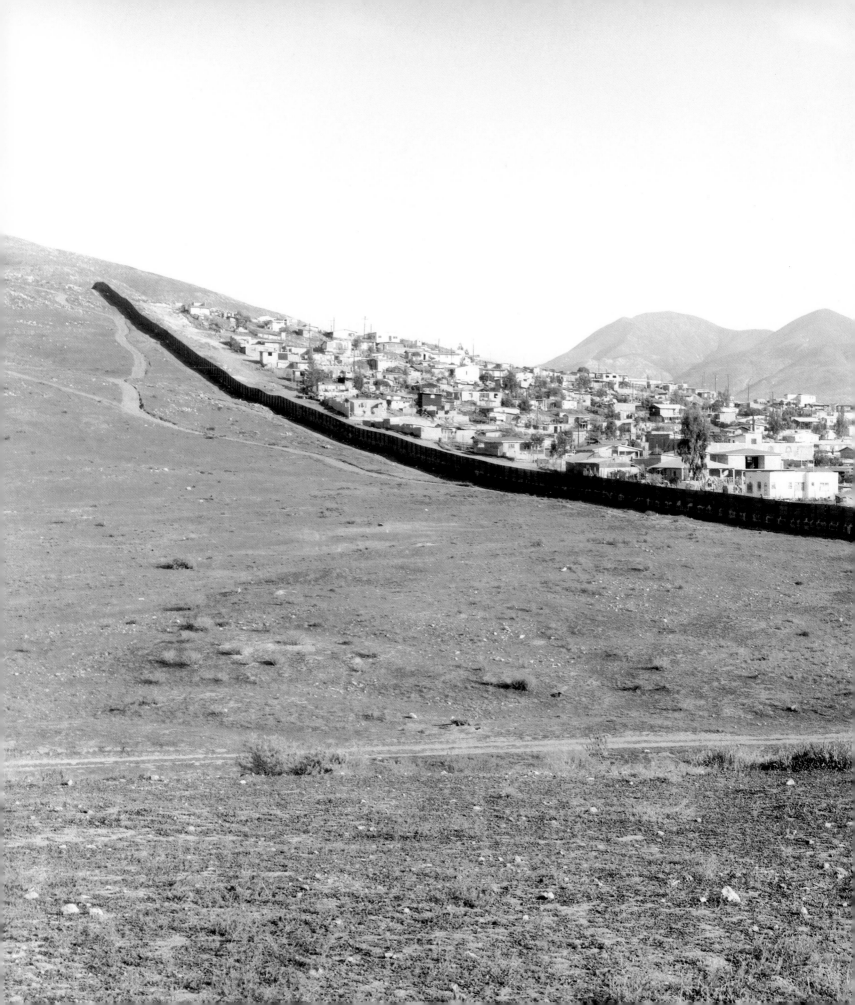

land

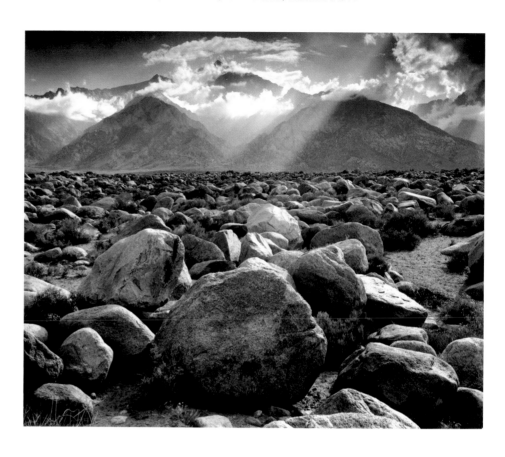

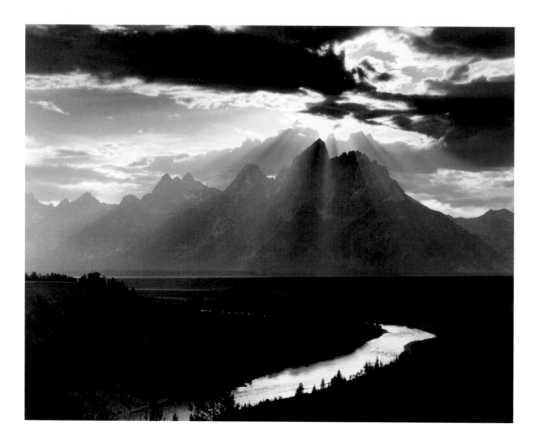

1. **Minor White**. Grand Tetons. 1959

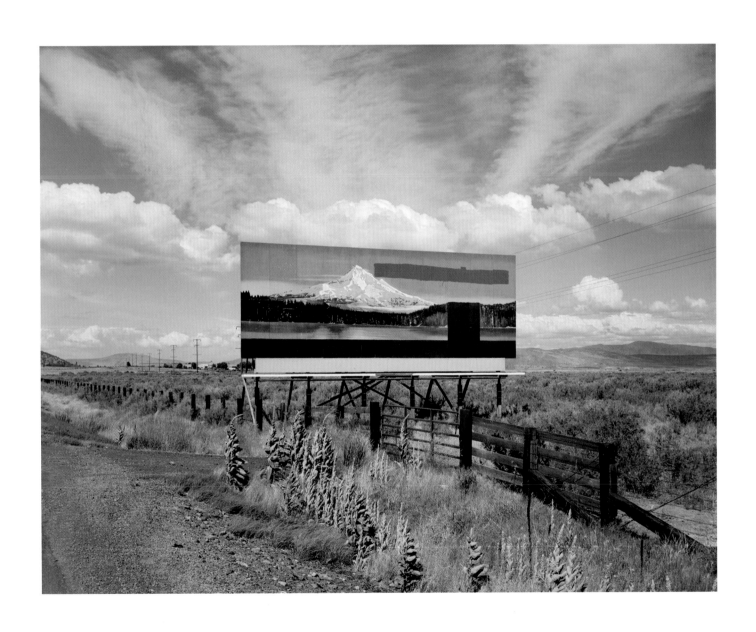

3. **Stephen Shore**. U.S. 97, South of Klamath Falls, Oregon. July 21, 1973

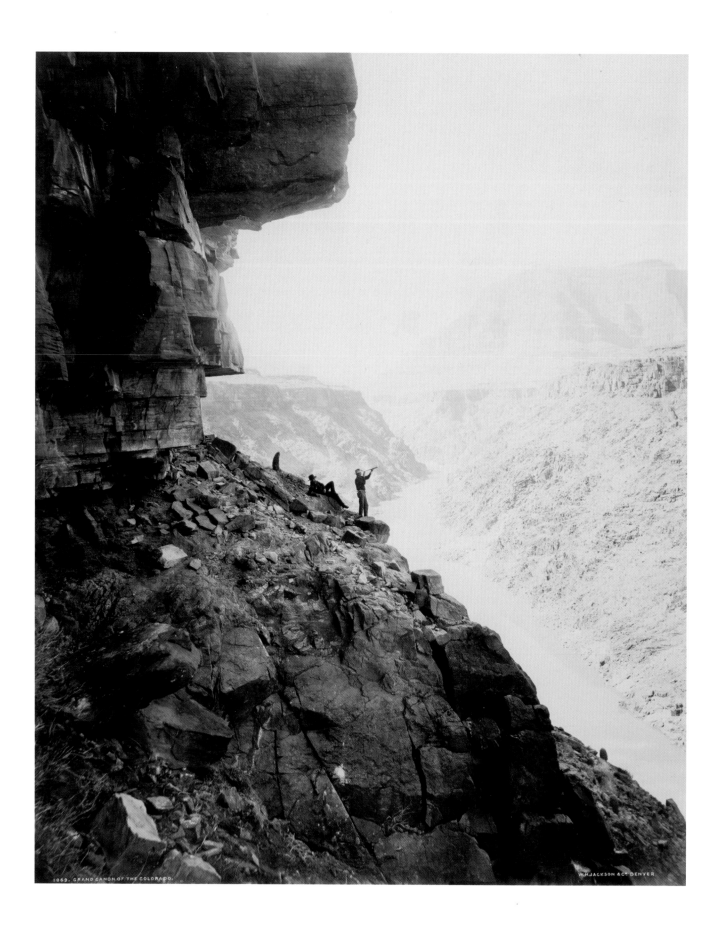

4. **William Henry Jackson**. Grand Canyon of the Colorado River. 1883

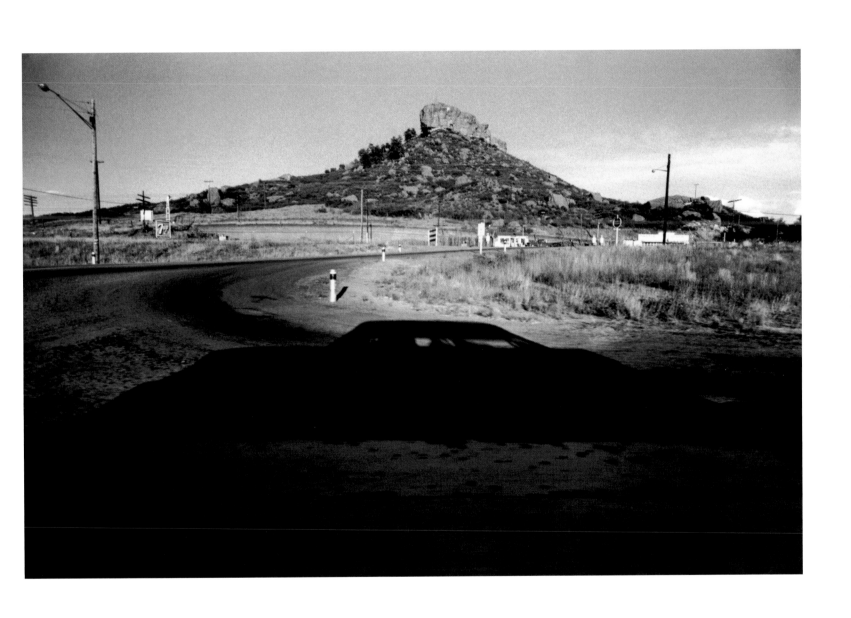

Garry Winogrand. Castle Rock, Colorado. 1959

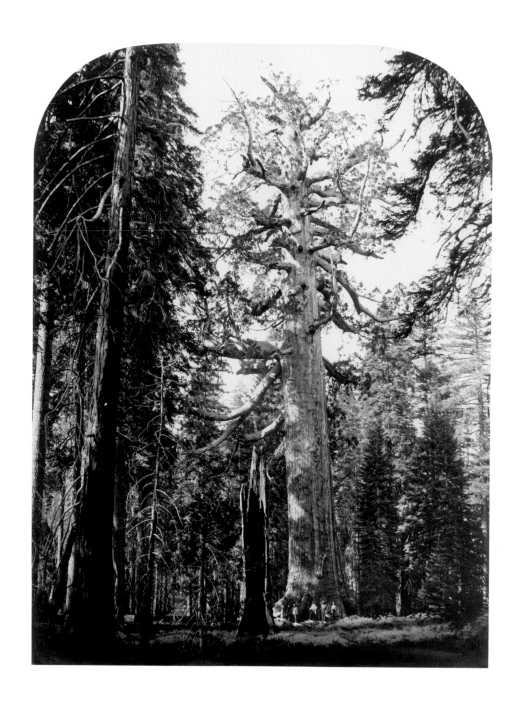

6. **Carleton E. Watkins**. Grizzly Giant, Mariposa Grove. 1861

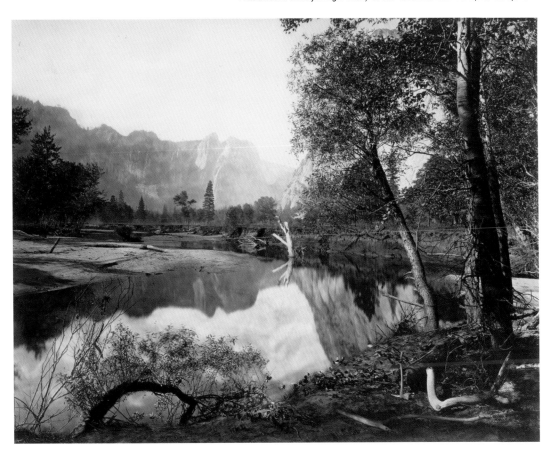

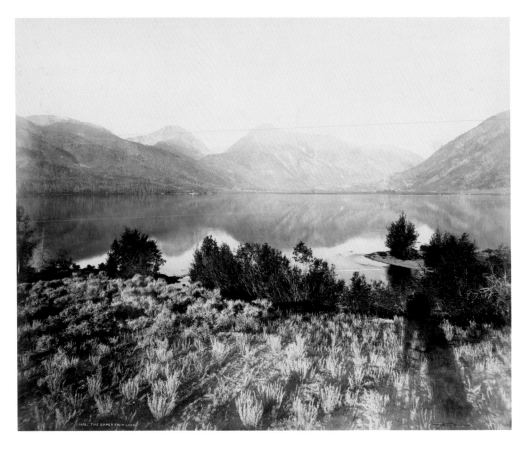

8. **William Henry Jackson**. Upper Twin Lake, Colorado. 1875

9. **Richard Misrach**. Desert Fire Number 43. 1983

11. **Ansel Adams**. Moonrise, Hernandez, New Mexico. 1941

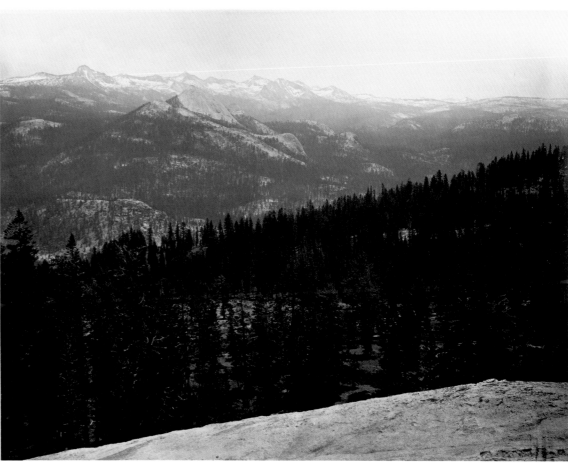

12. **Carleton E. Watkins**. View from the Sentinel Dome, Yosemite. 1865–66

13. **Joel Sternfeld**. Abandoned Uranium Refinery near Tuba City, Arizona, Navajo Nation. 1982

14. **John Divola.** N34°10.744' W116°07.973'. 1995–98

15. **Timothy O'Sullivan**. Desert Sand Hills near Sink of Carson, Nevada. 1867

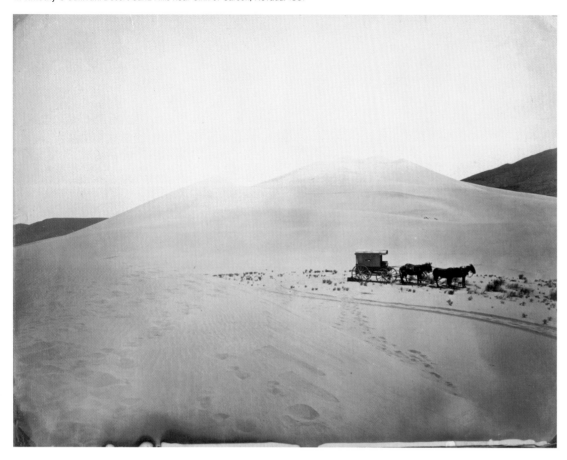

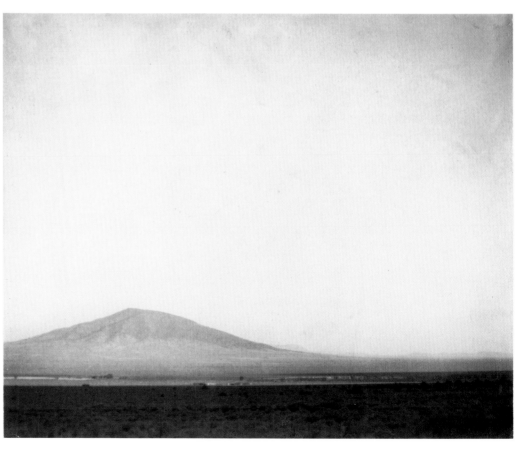

16. **Laura Gilpin**. Sunrise on the Desert. 1921

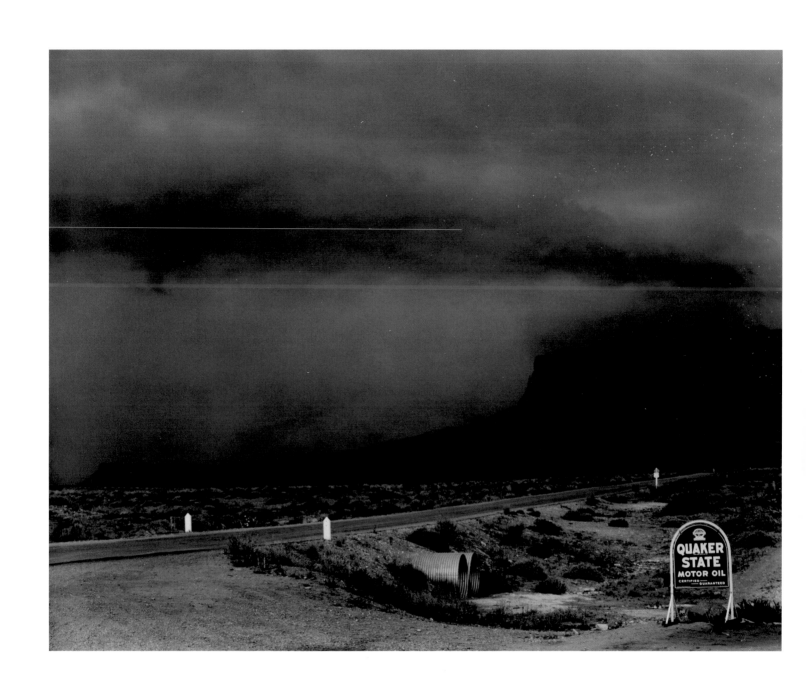

17. **Edward Weston**. Quaker State Oil, Arizona. 1941

18. **Frederick Sommer**. Arizona Landscape. 1943

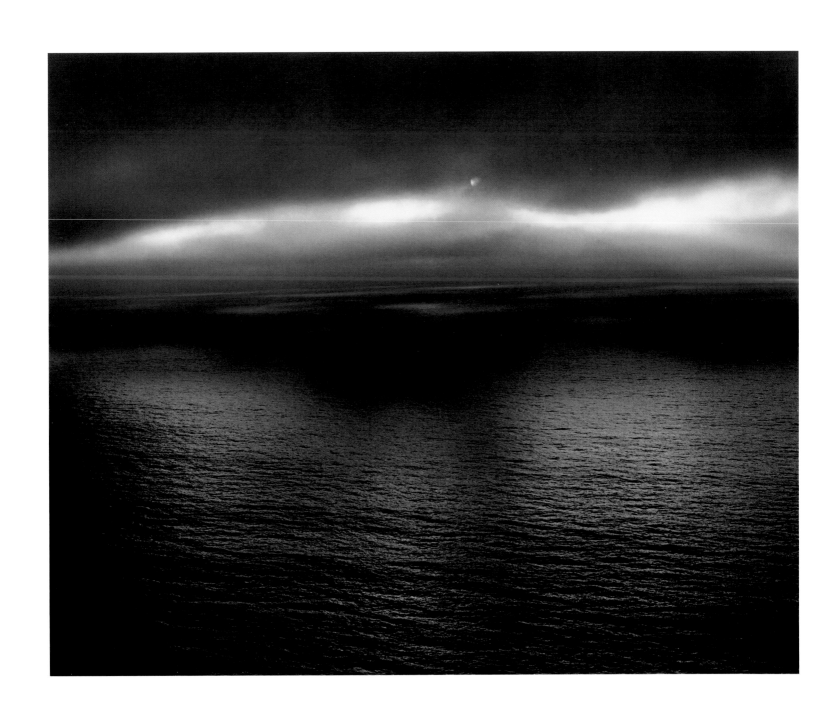

19. **Minor White**. Devil's Slide, San Mateo County, California. 1948

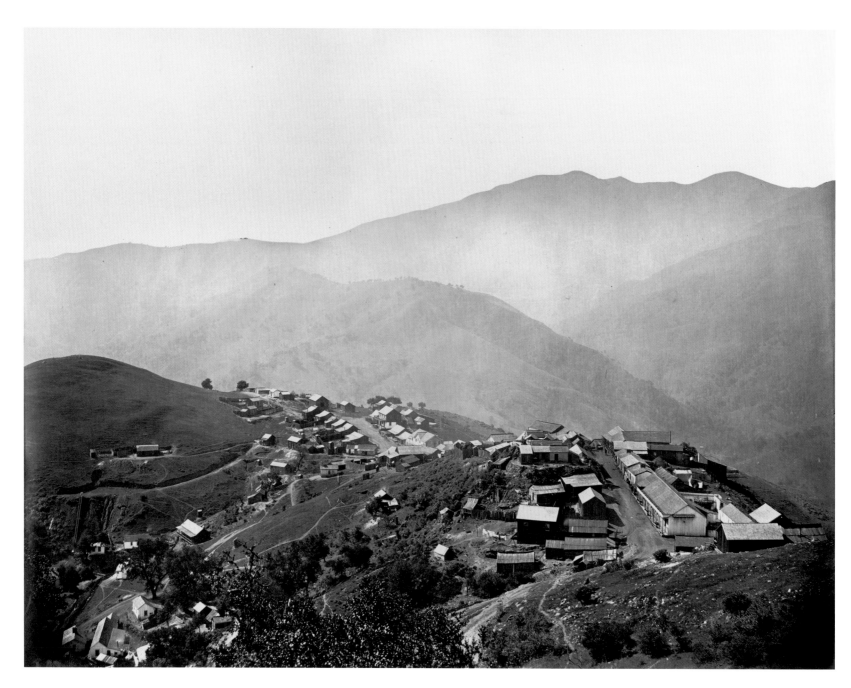

20. **Carleton E. Watkins**. The Town on the Hill, New Almaden. 1863

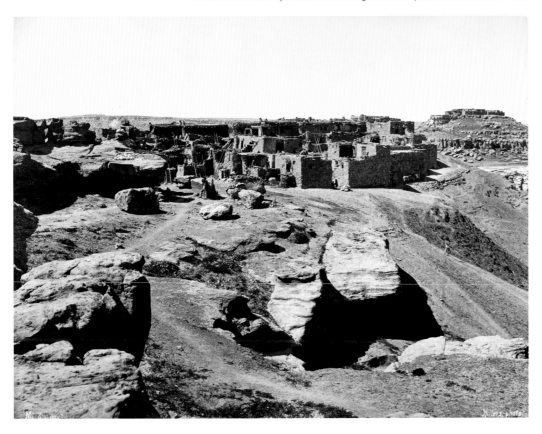

22. **Robert Adams**. East from Flagstaff Mountain, Boulder County, Colorado. 1976

23. **Eadweard J. Muybridge**. Panorama of San Francisco, from California–St. Hill. 1877

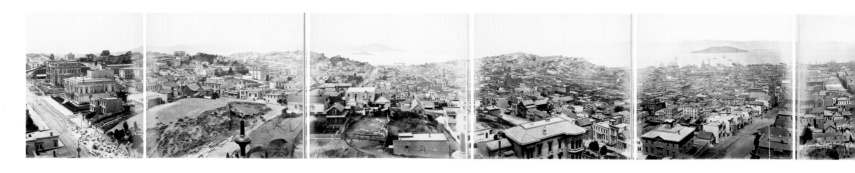

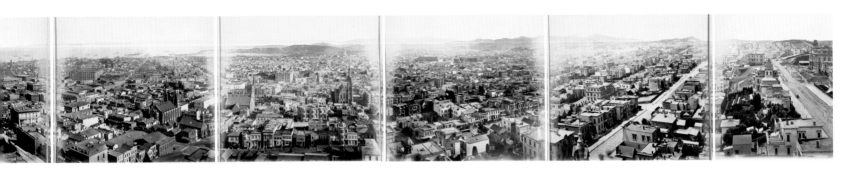

8876 8882 Clark 8900 8912 8920 Hilldale 8958 8960

24. **Edward Ruscha**. Every Building on the Sunset Strip (detail). 1966

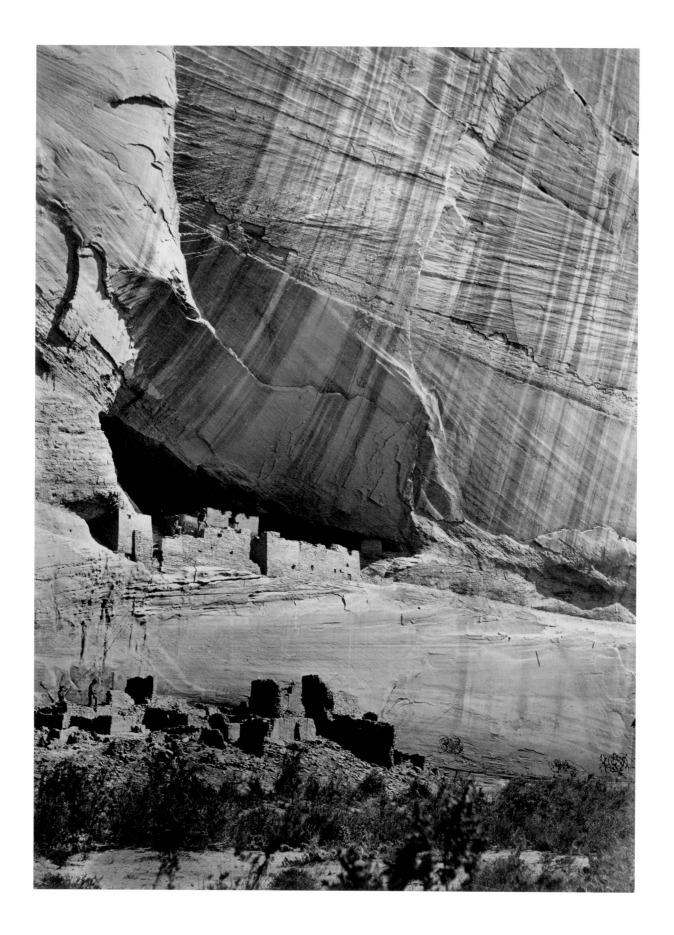

25. **Timothy O'Sullivan**. Ancient Ruins in the Cañon de Chelle. 1873

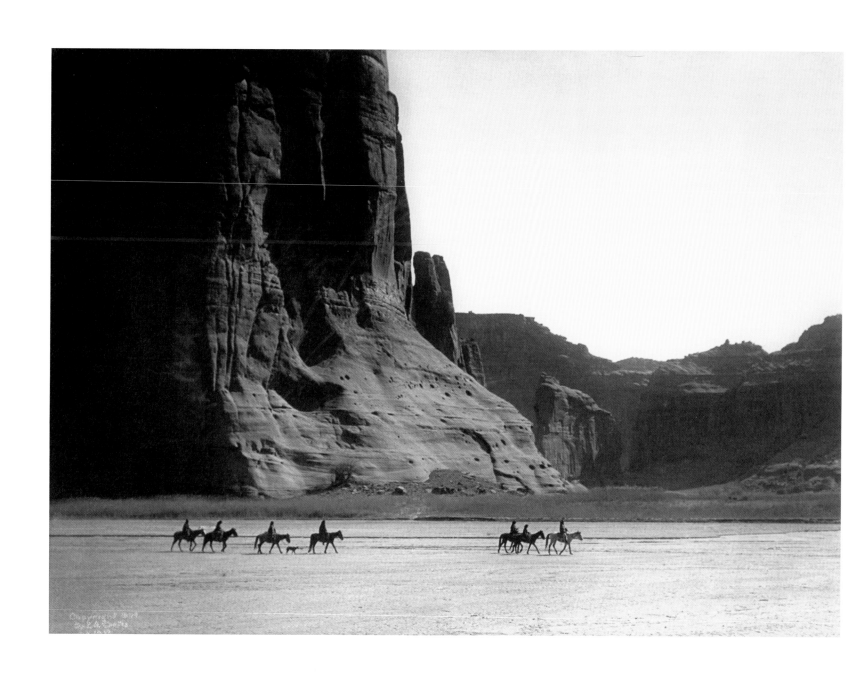

26. **Edward Sheriff Curtis**. Cañon de Chelly. 1904

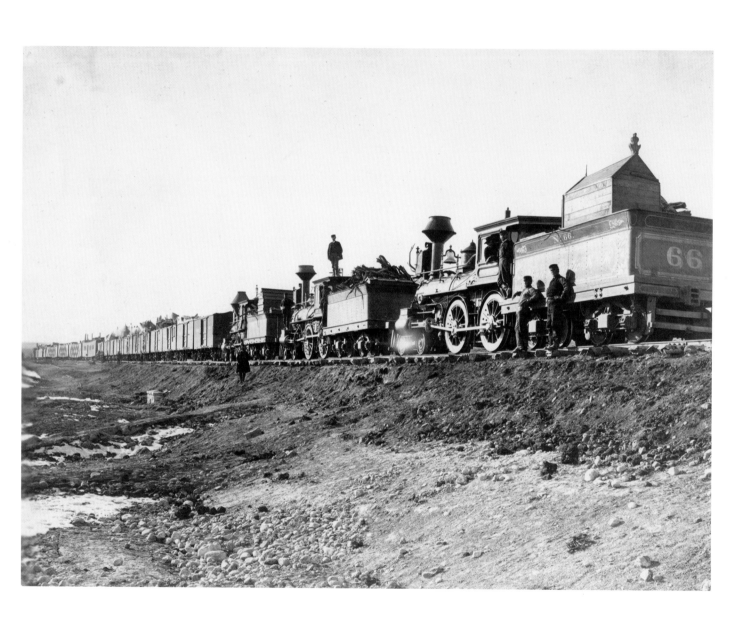

27. **Andrew J. Russell**. Construction Train, Bear River. 1868

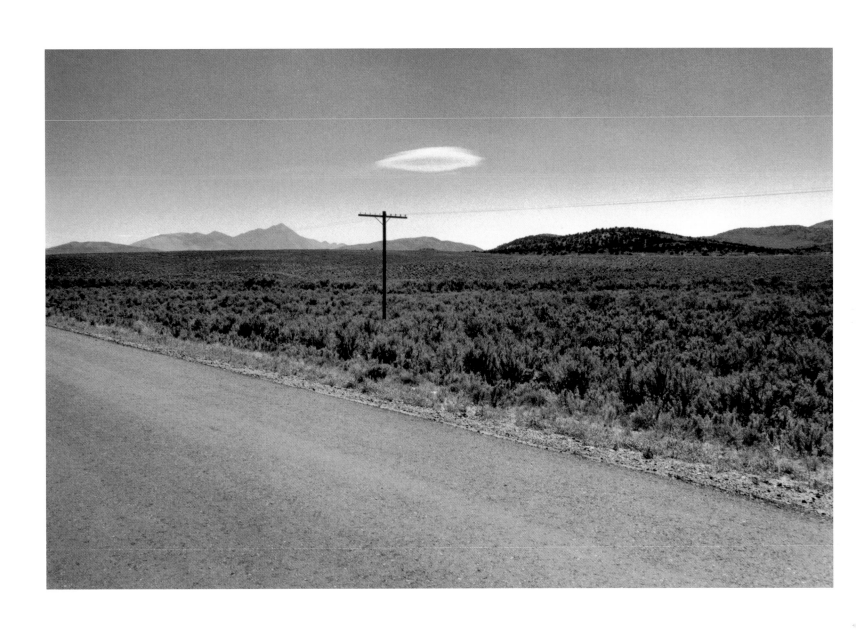

28. Henry Wessel, Jr. Untitled. 1968

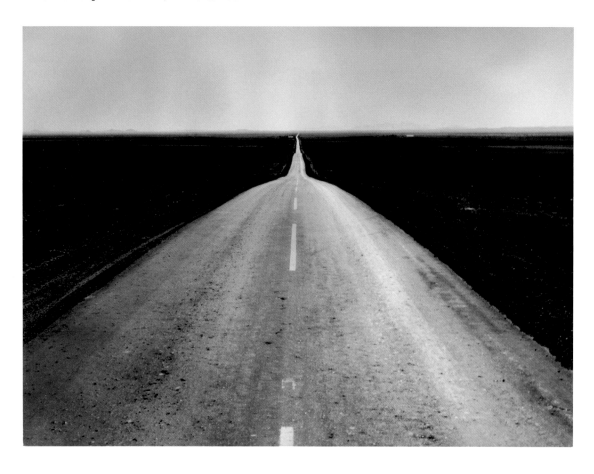

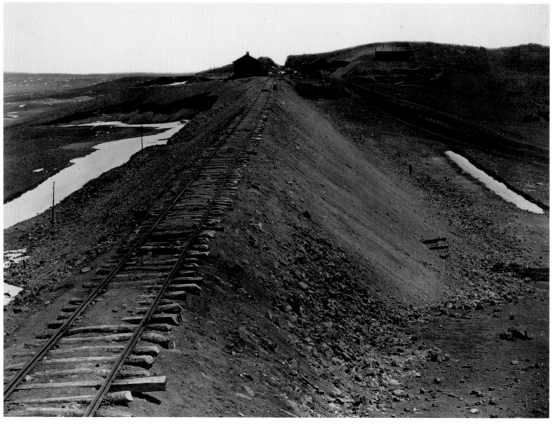

30. **Andrew J. Russell**. Granite Cañon, from the Water Tank. 1869

31. **David Hockney**. Pearblossom Hwy., 11–18th April, 1986, #1. 1986

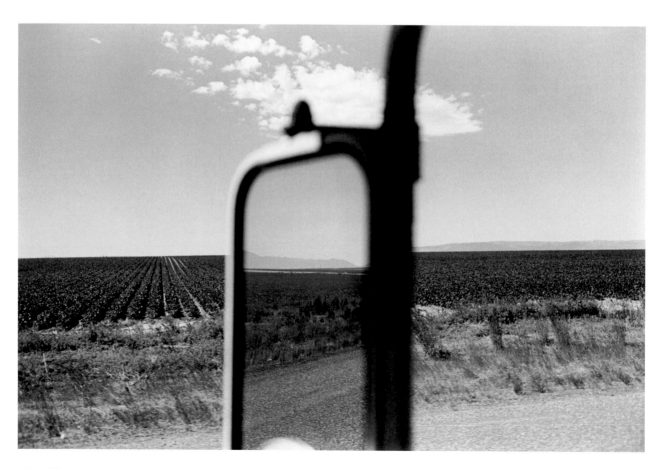

33. **Lee Friedlander**. Idaho. 1972

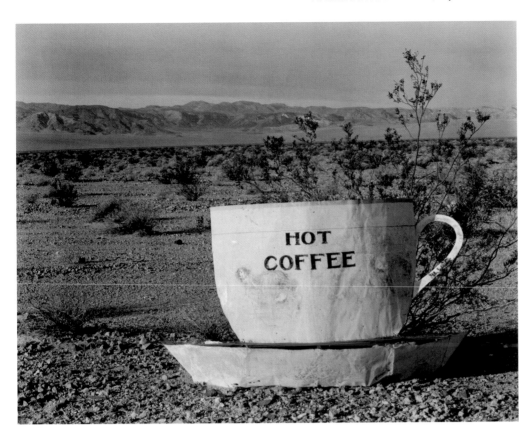

36. **Robert Frank**. Santa Fe, New Mexico. 1955

37. **Robert Frank**. Covered car—Long Beach, California. 1955

38. **Dennis Hopper**. Double Standard. 1961

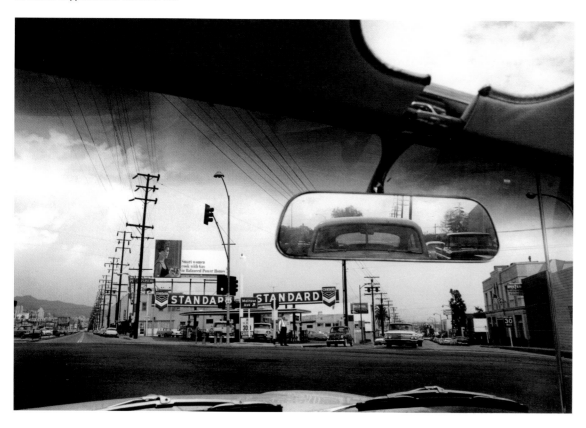

39. **Stephen Shore**. Beverly Boulevard and La Brea Avenue, Los Angeles, California. July 21, 1975

40 **Adam Bartos**. Los Angeles. 1978

Edward Ruscha

41. Sears Roebuck & Co., Bellingham & Hamlin, North Hollywood. 1967
44. Century City, 1800 Avenue of the Stars. 1967

42. Zurich-American Insurance, 4465 Wilshire Blvd. 1967
45. Church of Christ, 14655 Sherman Way, Van Nuys. 1967

43. Unidentified Lot, Reseda. 1967
46. 7133 Kester, Van Nuys. 1967

William A. Garnett

47. Grading, Lakewood, California. 1950
50. Framing, Lakewood, California. 1950

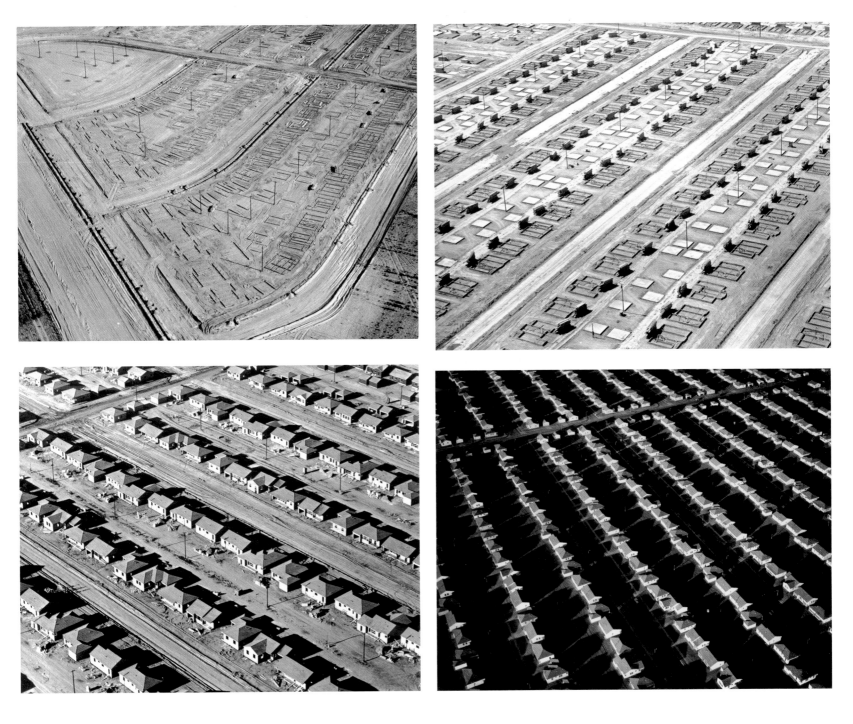

48. Trenching, Lakewood, California. 1950
51. Plaster and Roofing, Lakewood, California. 1950

49. Foundation and Slabs, Lakewood, California. 1950
52. Finished Housing, Lakewood, California. 1950

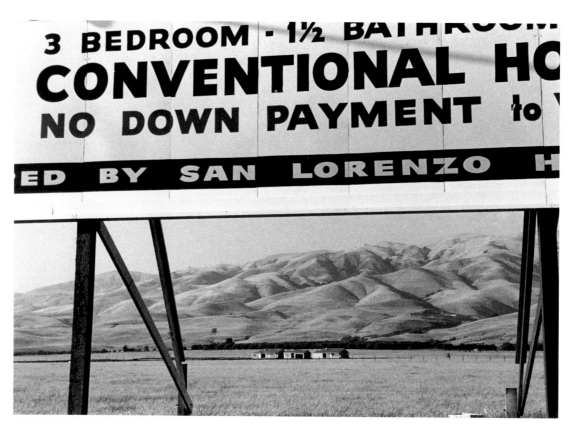

54 **Dorothea Lange**. Near Milpitas, California. 1956

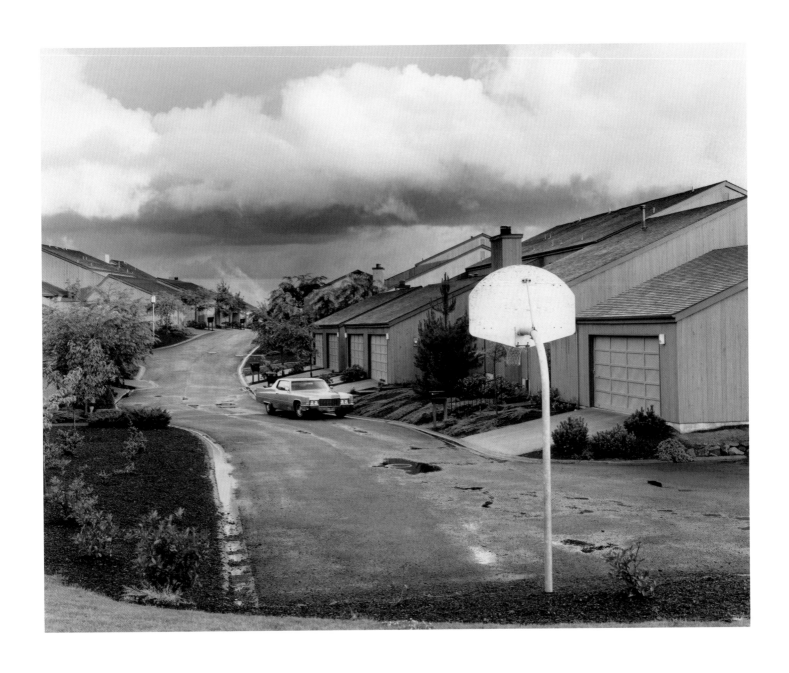

55. **Joel Sternfeld**. *Lake Oswego, Oregon.* 1979

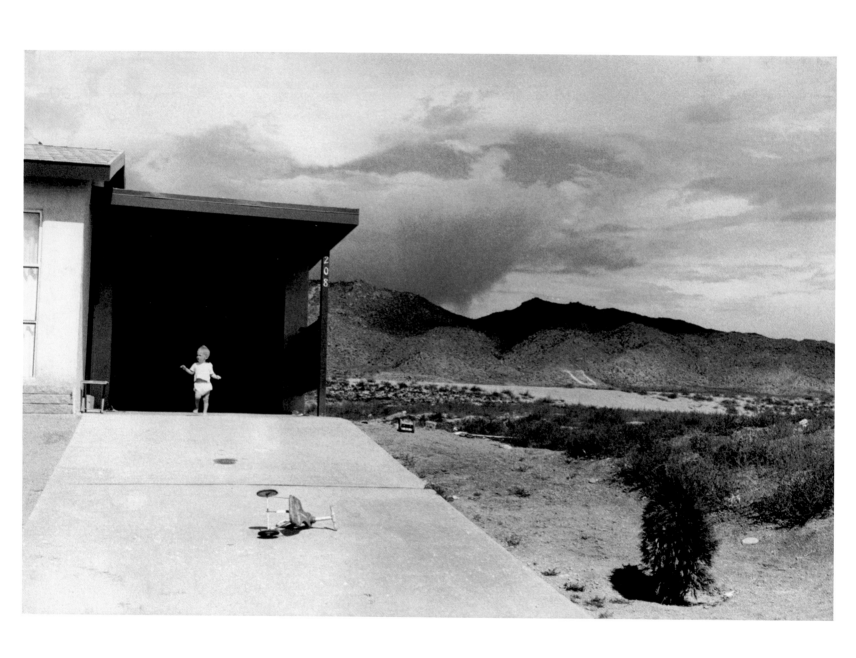

56 **Garry Winogrand**. New Mexico. 1957

57. **Robert Adams**. Colorado Springs, Colorado. 1968

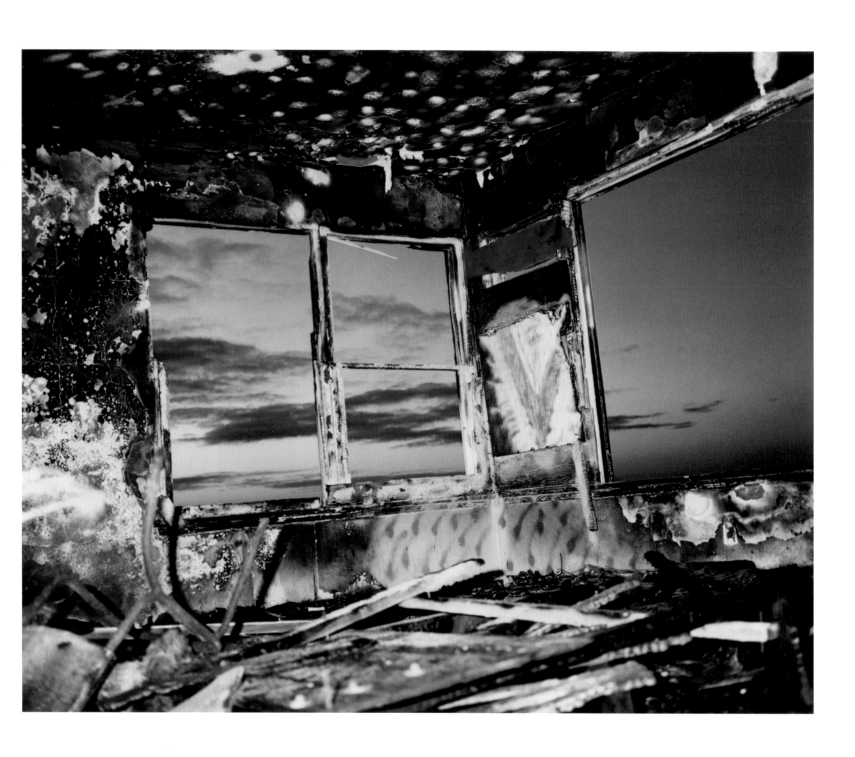

58. **John Divola**. Zuma #29. 1978

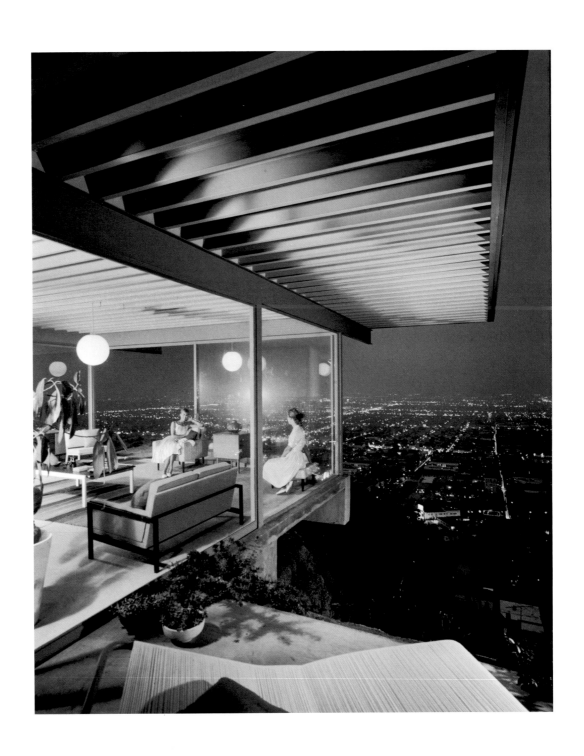

59. **Julius Shulman**. Case Study House #22. 1960

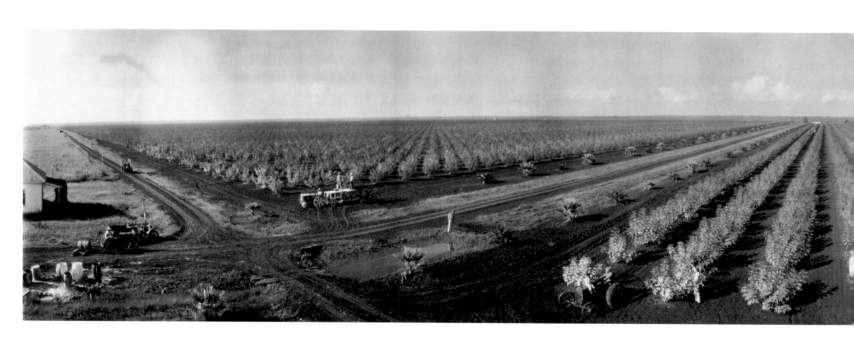

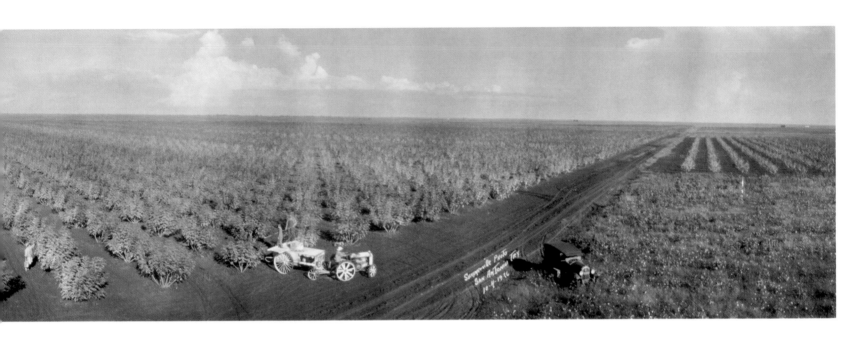

60. **Hugo Summerville**. Gaines Fig Farm. 1926

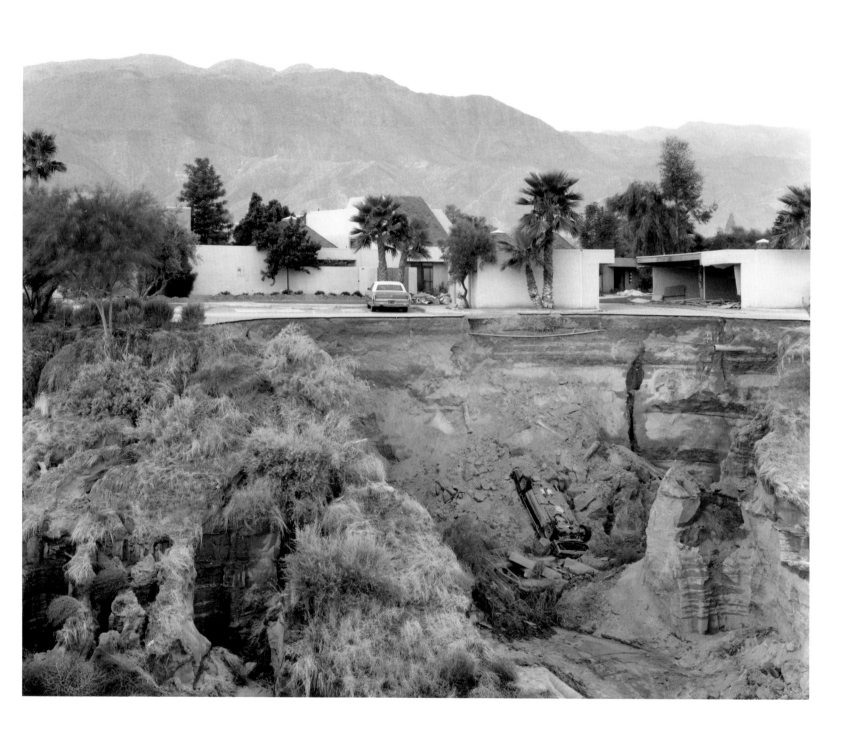

61. **Joel Sternfeld**. After a Flash Flood, Rancho Mirage, California. July 1979

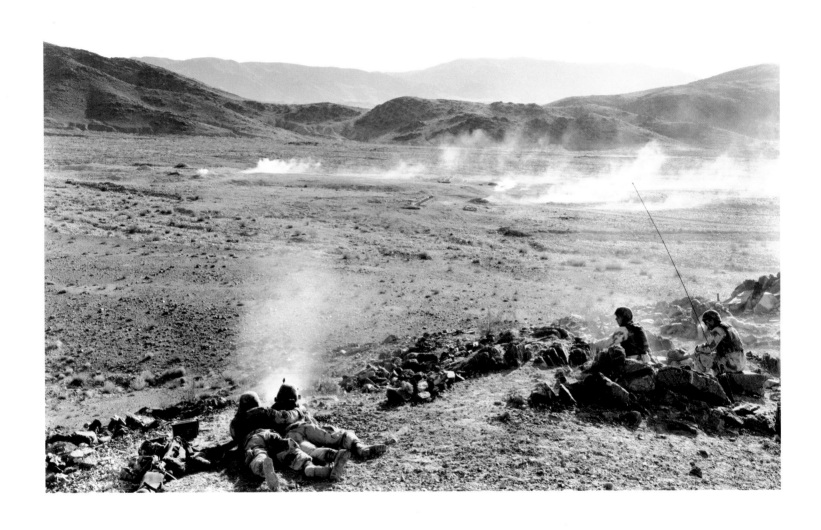

62. **An-My Lê**. 29 Palms: Infantry Platoon. 2003–04

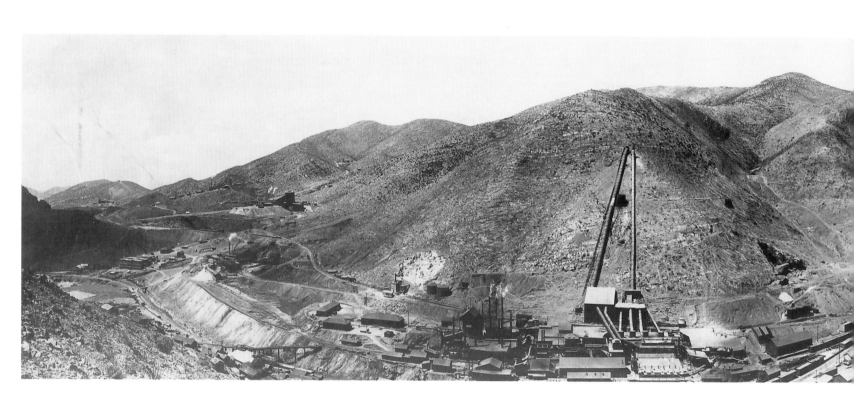

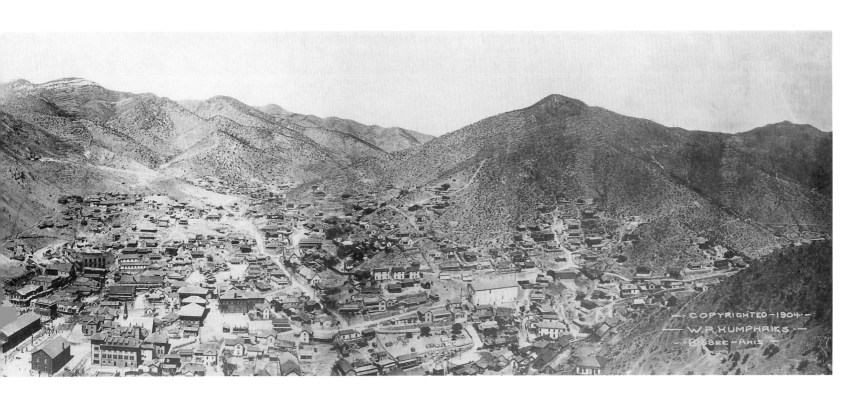

63. **Wilfred R. Humphries**. Bisbee. 1904

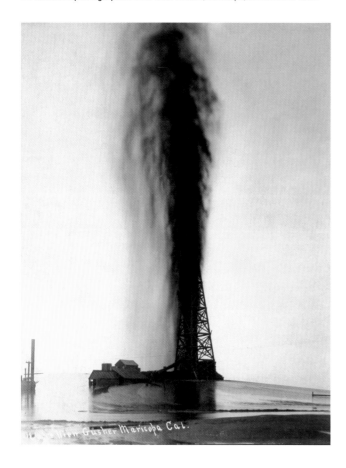

65. **Robert Adams**. Burning Oil Sludge North of Denver, Colorado. 1973

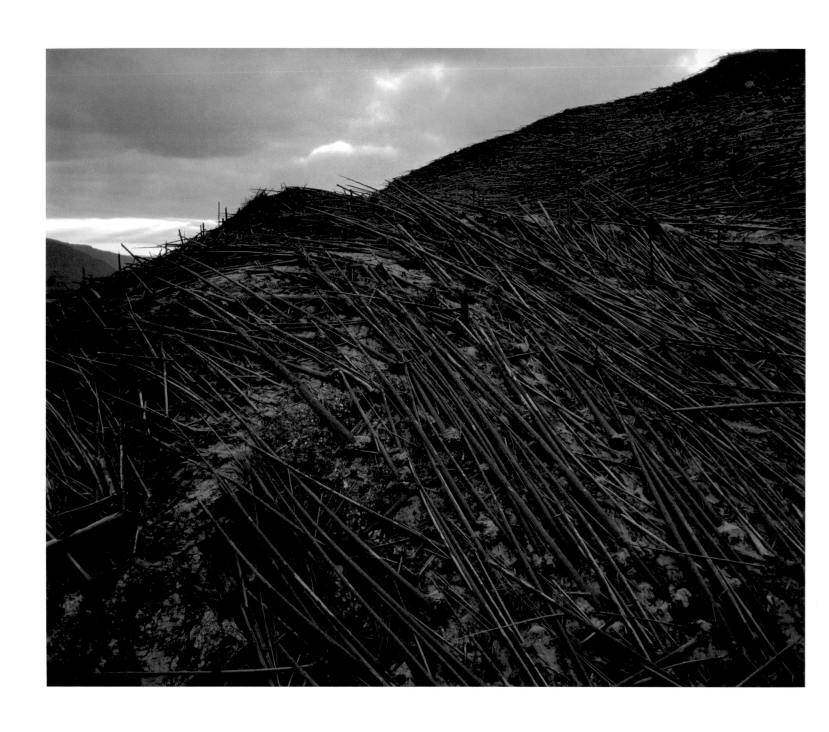

66. **Frank Gohlke**. Aerial view: downed forest near Elk Rock. Approximately ten miles northwest of Mount St. Helens. 1981

67. **Lewis Baltz**. San Quentin Point. 1985

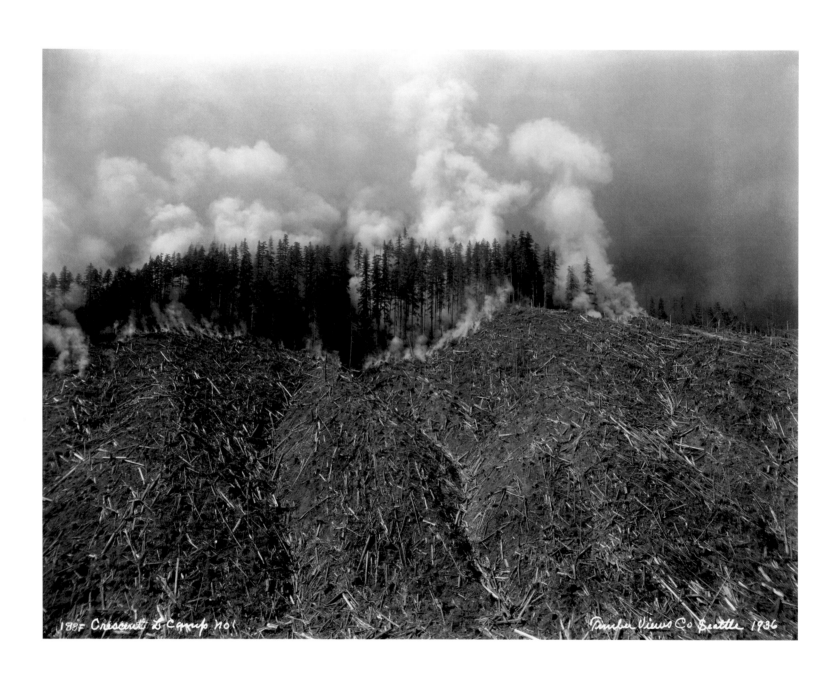

68. **Darius Kinsey**. Crescent Camp No. 1. 1936

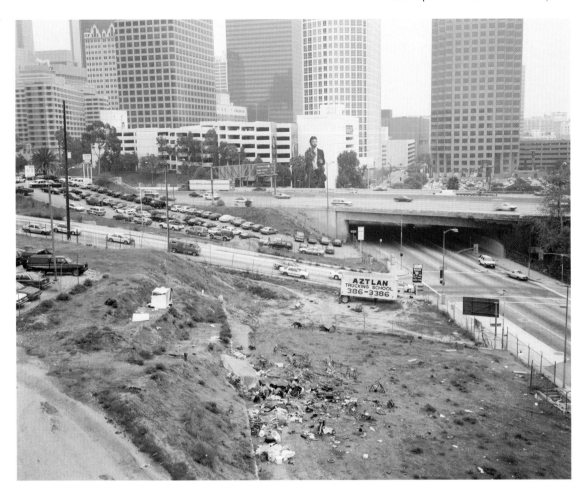

70. **David T Hanson**. Wasteland: California Gulch, Leadville, Colorado. 1986

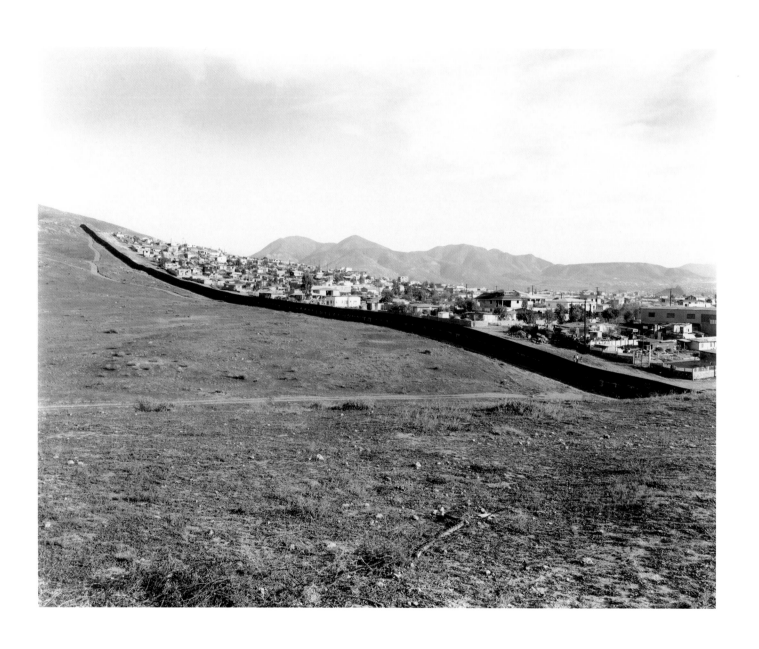

71 **Geoffrey James**. Looking Towards Mexico, Otay Mesa. 1997

73. **Robert Dawson**. Ground Water Pump Near Allensworth, California. 1984

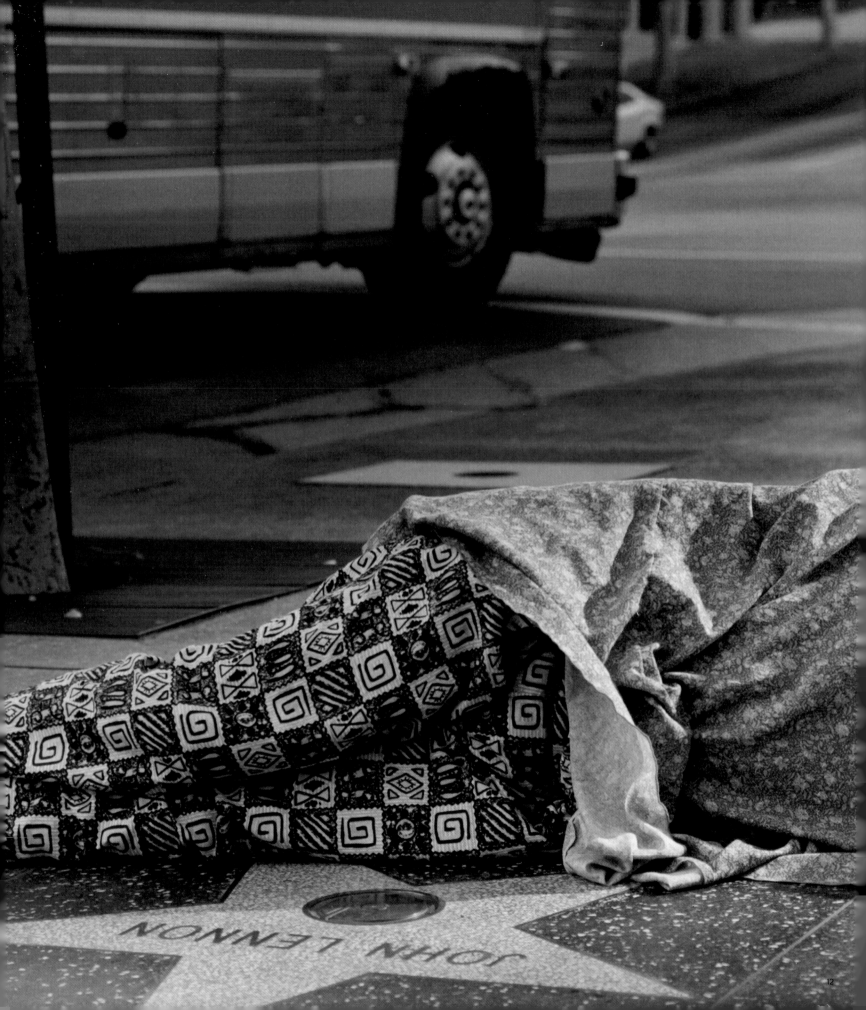

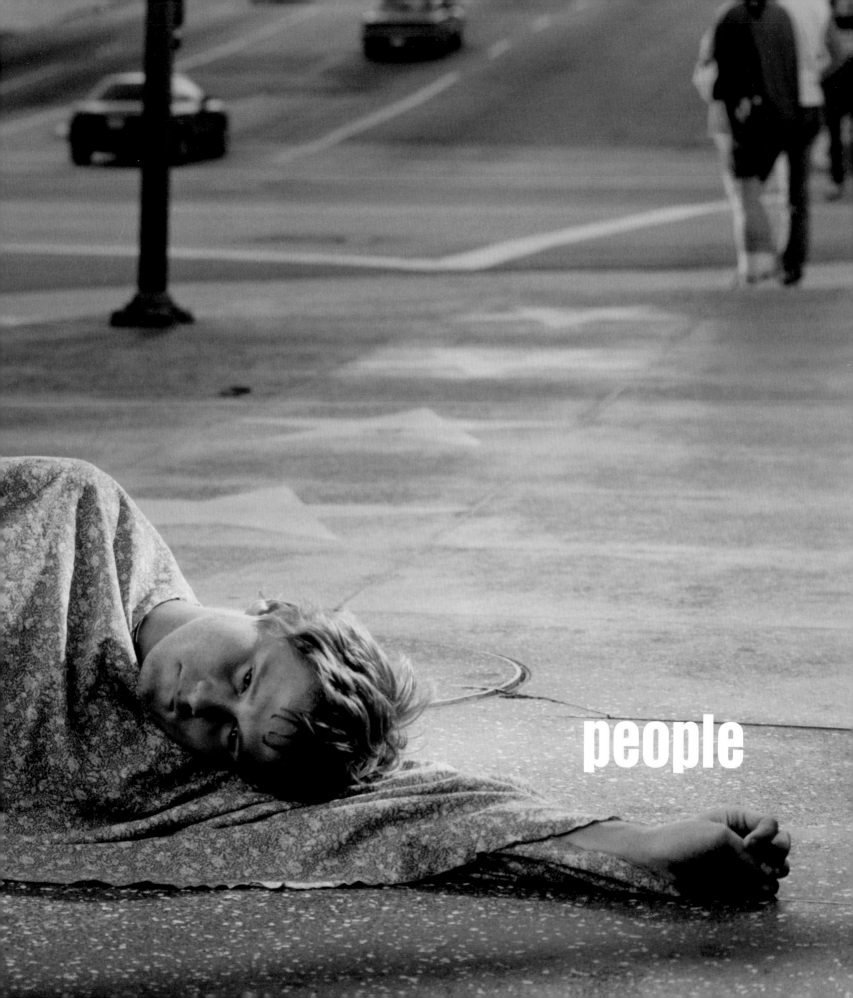

people

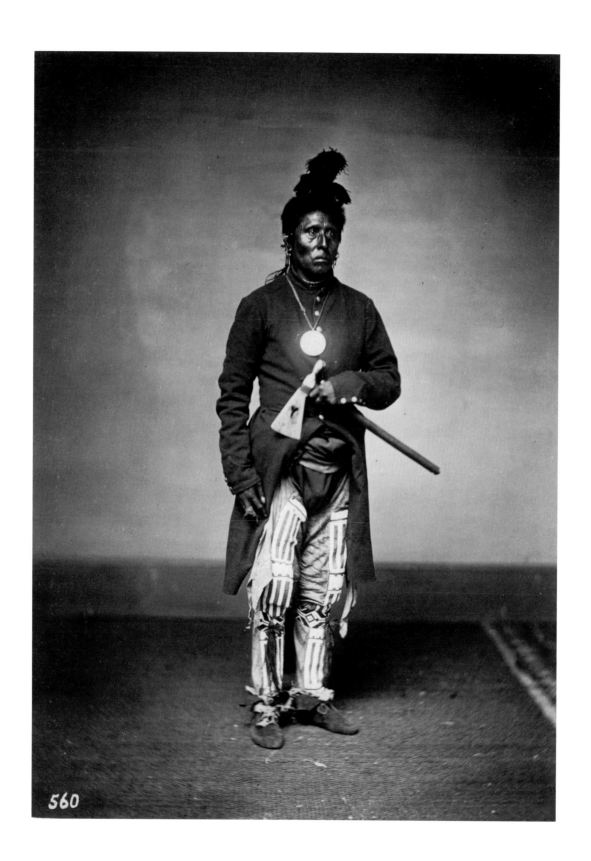

74. Attributed to **Edric L. Eaton**. Sky Chief (Tirawahut Resaru). c. 1867

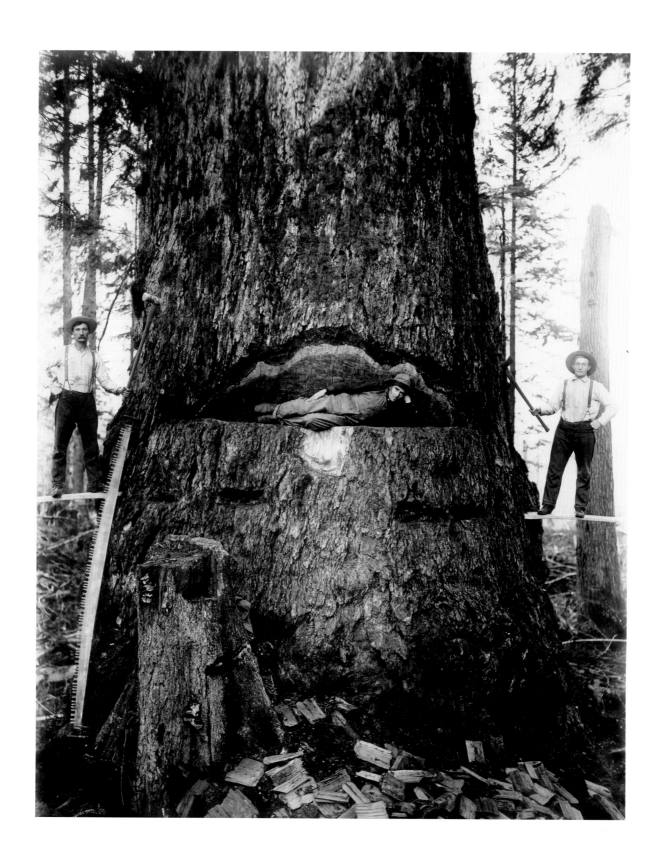

75. **Darius Kinsey**. Felling a Fir Tree, 51 Feet in Circumference. 1906

76. **William Gedney**. San Francisco. 1966–67

77. **Joel Sternfeld**. A Woman at Home After Exercising, Malibu, California. August 1988

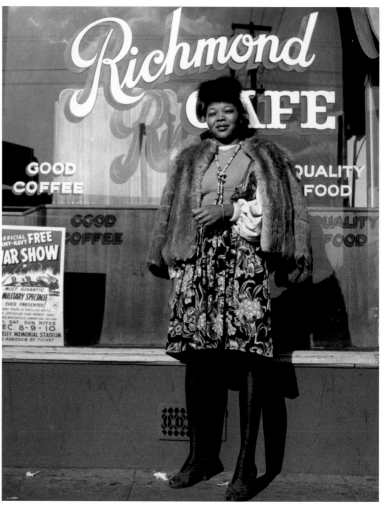

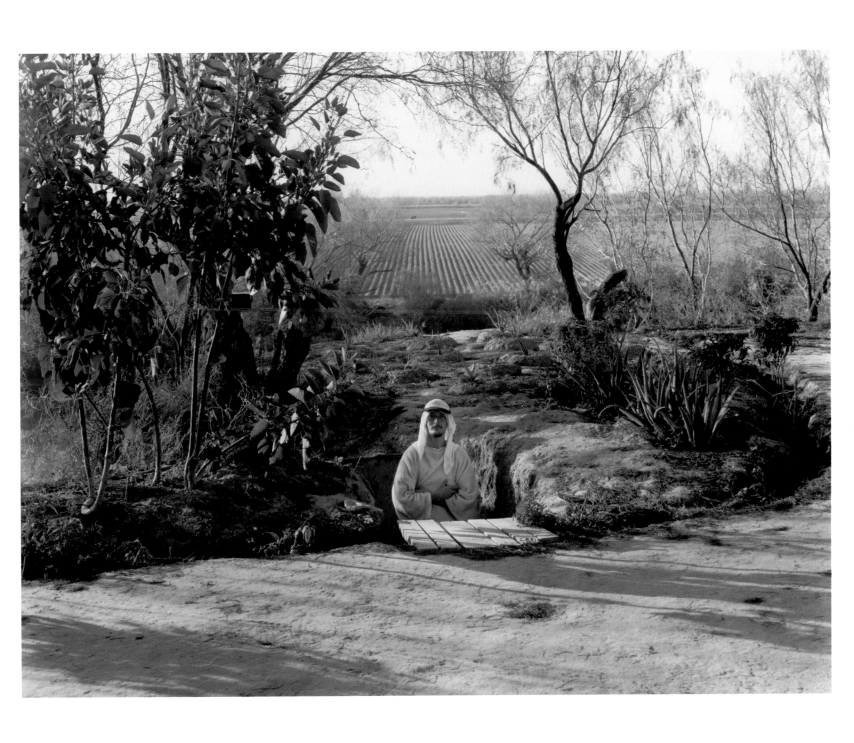

80. **Joel Sternfeld**. Member of the Christ Family Religious Sect, Hidalgo County, Texas. January 1983

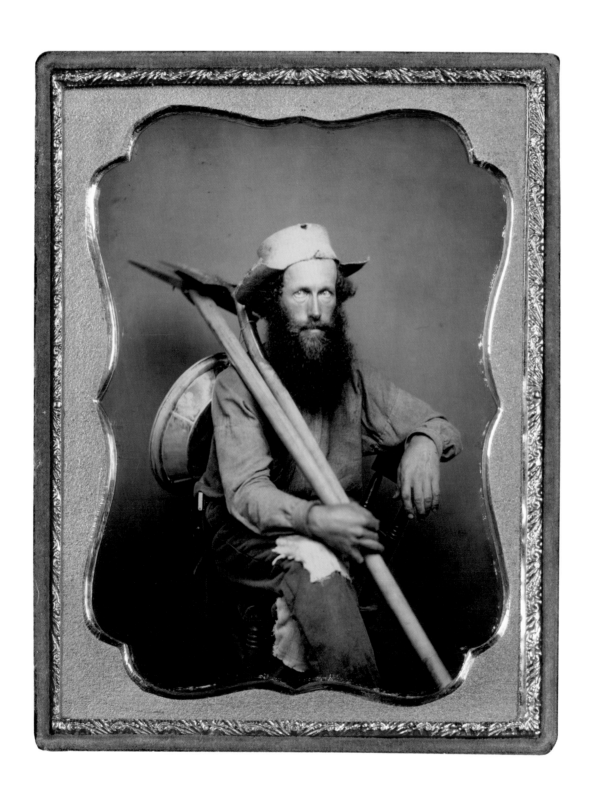

81. **Unknown photographer**. Gold Miner. c. 1850

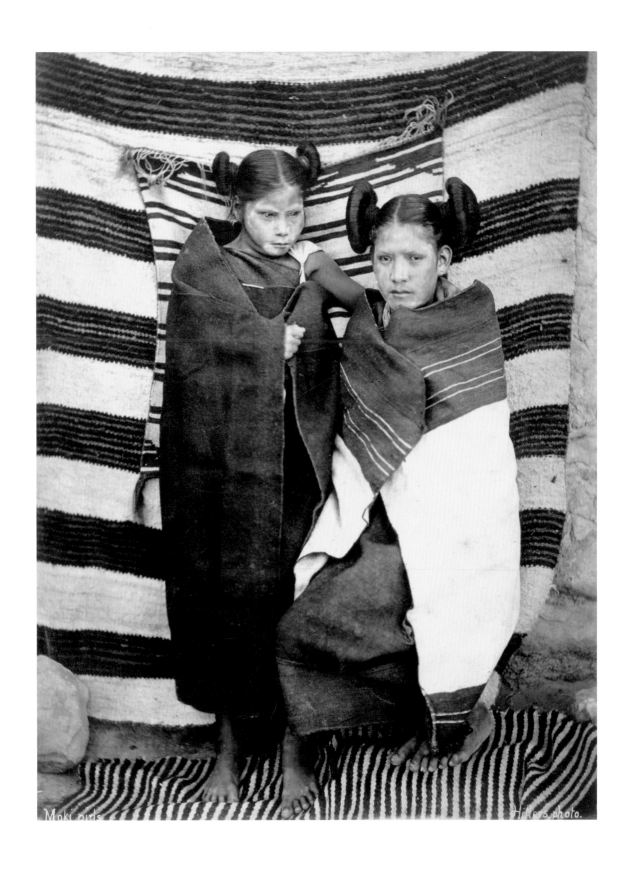

82. **John K. Hillers**. Moki Girls. 1879

83. **Carleton E. Watkins**. Chinese Actor. 1876–80

84. **Philip-Lorca diCorcia**. Marilyn; 28 Years Old; Las Vegas, Nevada; $30. 1990–92

85. **Robert Frank**. Movie premiere–Hollywood. 1955

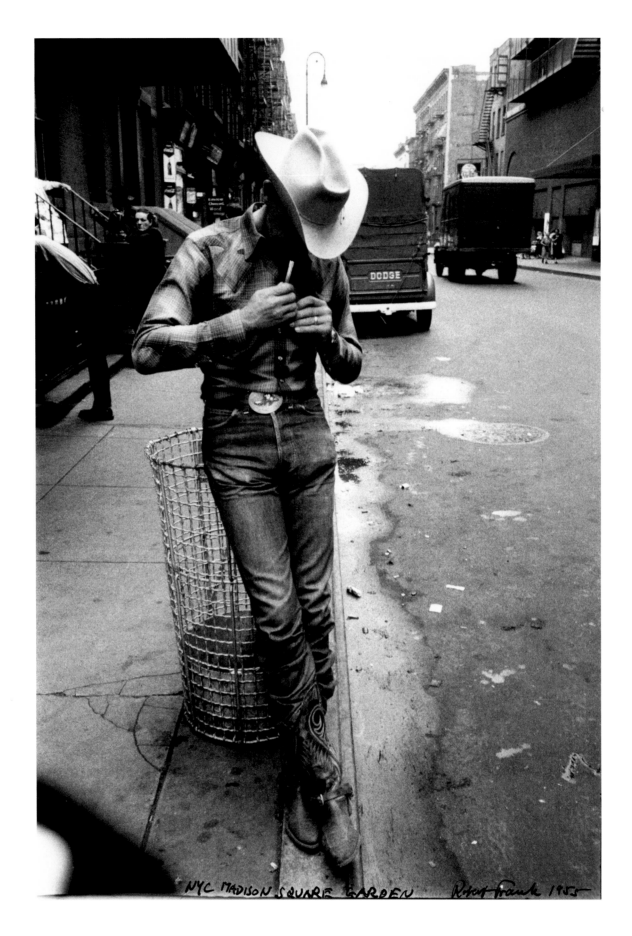

NYC MADISON SQUARE GARDEN Robert Frank 1955

86. **Robert Frank**. Rodeo–New York City. 1954

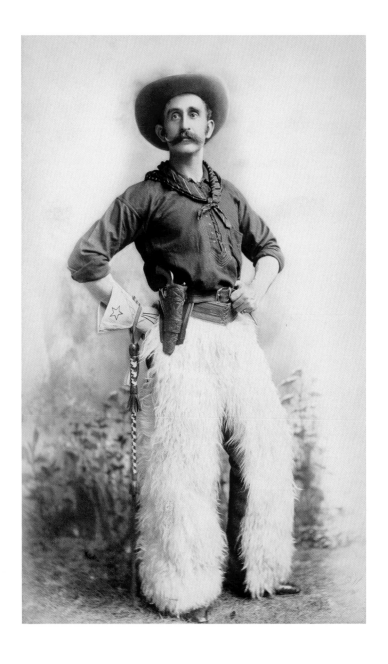

87. **Charles D. Kirkland**. Wyoming Cow-boy. c. 1877–95

89. **Timothy O'Sullivan**. Savage Mine, Curtis Shaft, Virginia City, Nevada. 1868

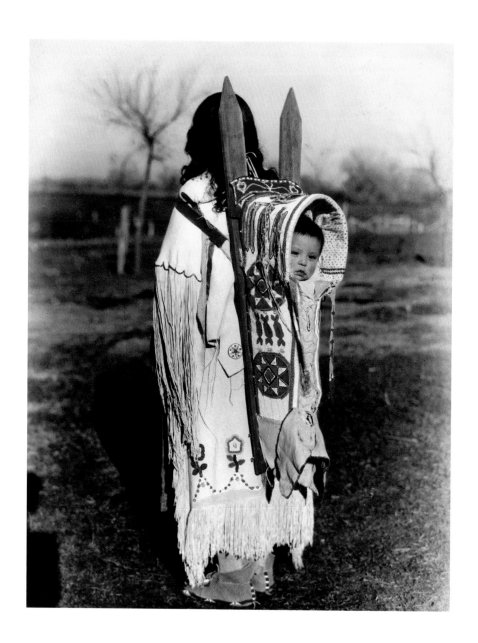

90. **Horace Poolaw**. Dorothy Poolaw Ware with Her Son Justin Lee Ware. c. 1920

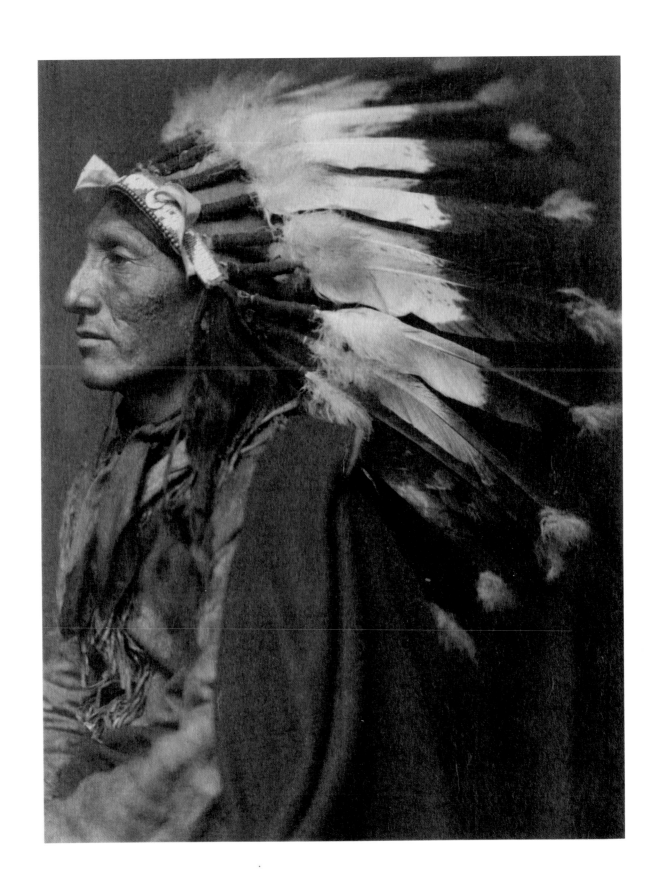

91. **Gertrude Käsebier**. American Indian Portrait. c. 1899

92. **James Luna**. Half Indian/Half Mexican. 1991

93. **Henry Wessel, Jr.** Southern California. 1985

94. **Tod Papageorge**. Hermosa Beach, California. August 1978

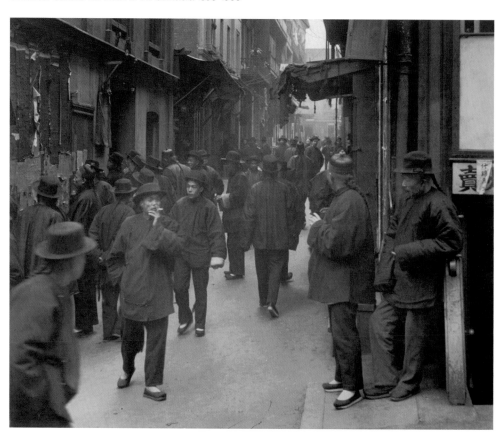

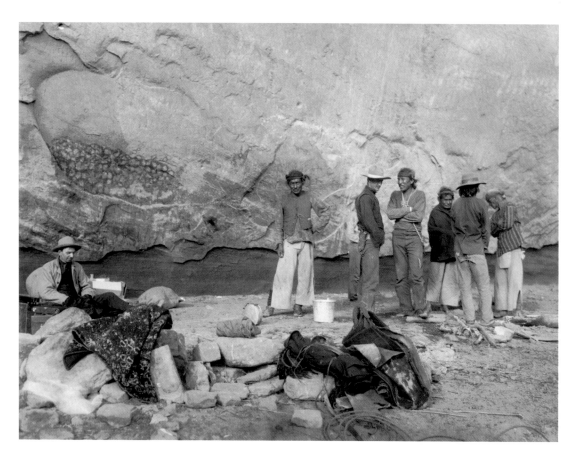

95. **Adam Clark Vroman**. Untitled. 1895–1904

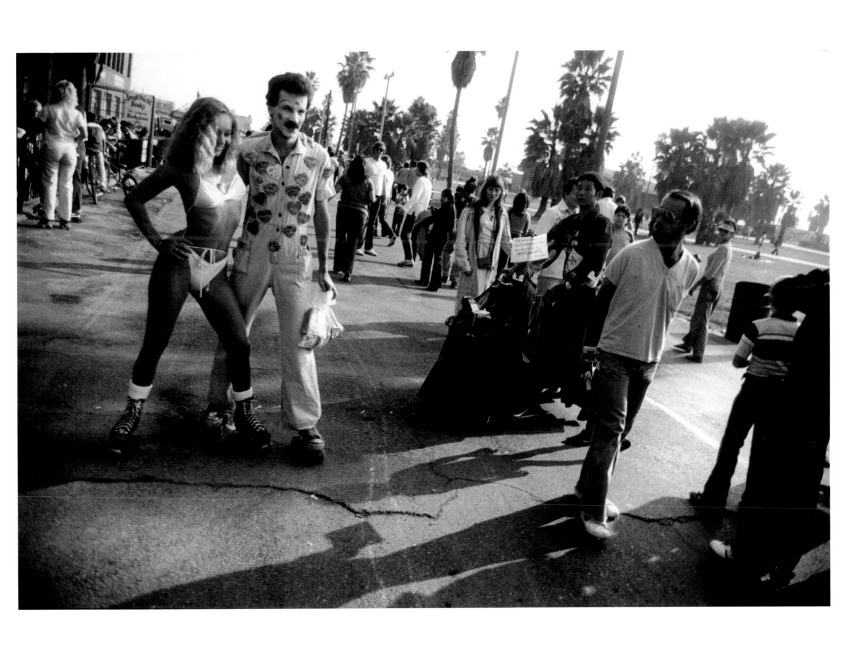

97. **Garry Winogrand**. Los Angeles. 1982

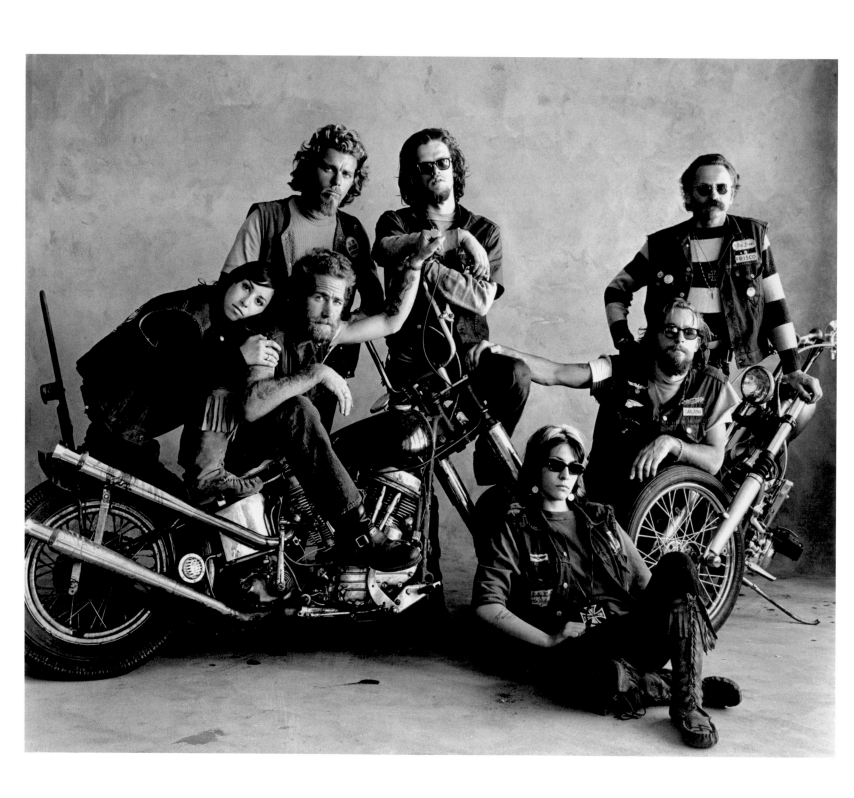

98. **Irving Penn**. Hell's Angels, San Francisco. 1967

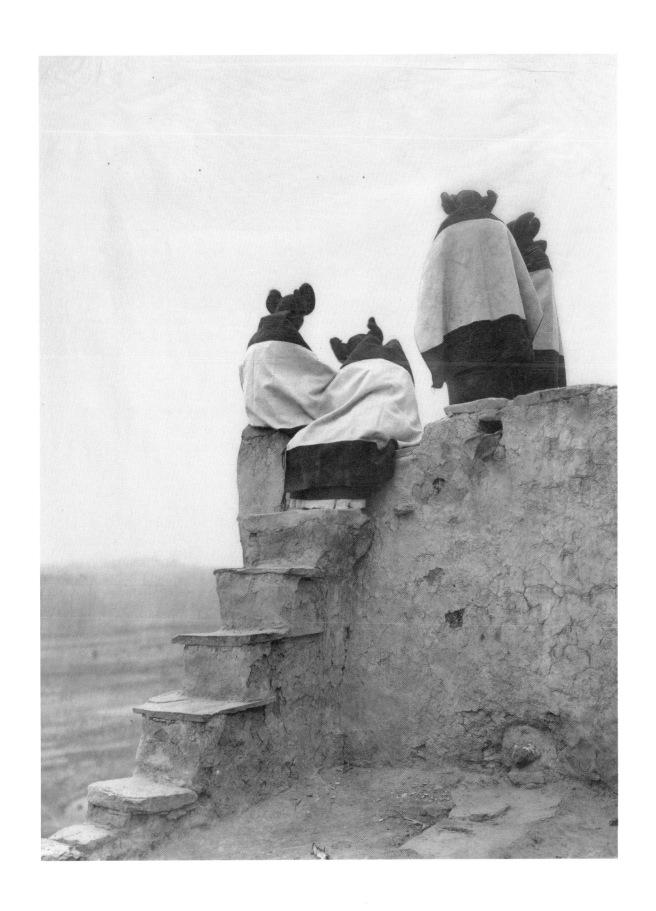

99. **Edward Sheriff Curtis**. Watching the Dancers. 1906

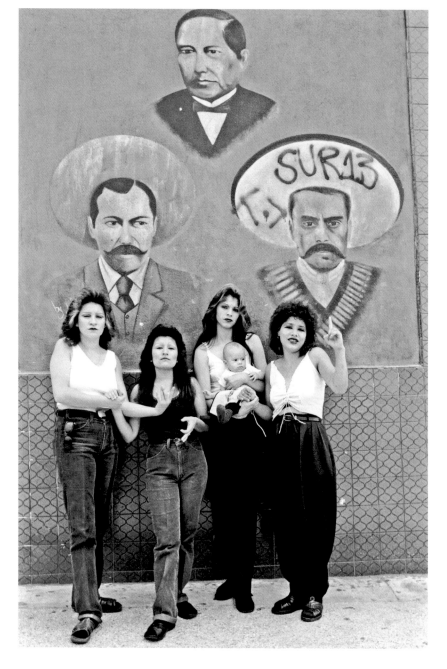

101. **Graciela Iturbide**. Cholas I, White Fence, East Los Angeles. 1986

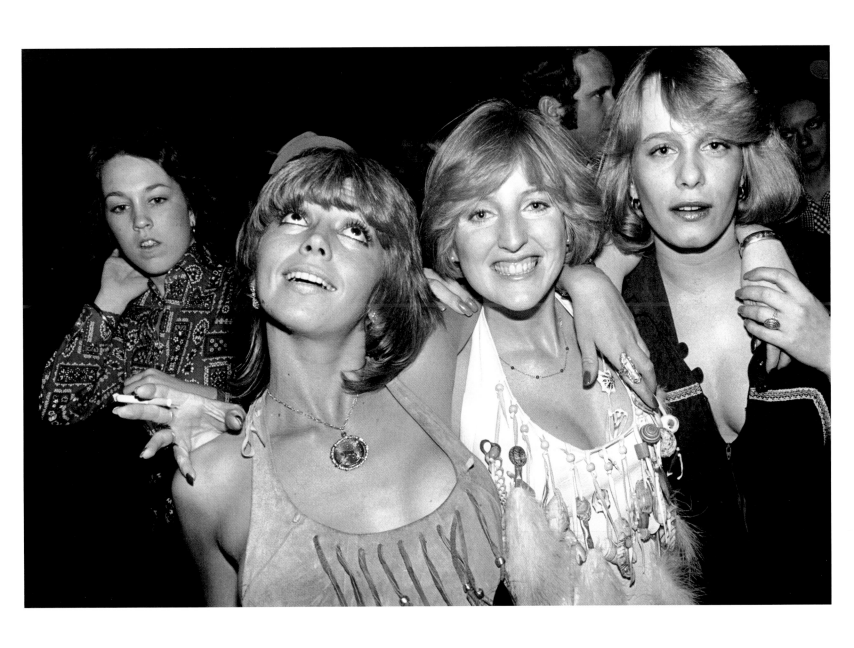

102 **Garry Winogrand**. Fort Worth, Texas. 1974–77

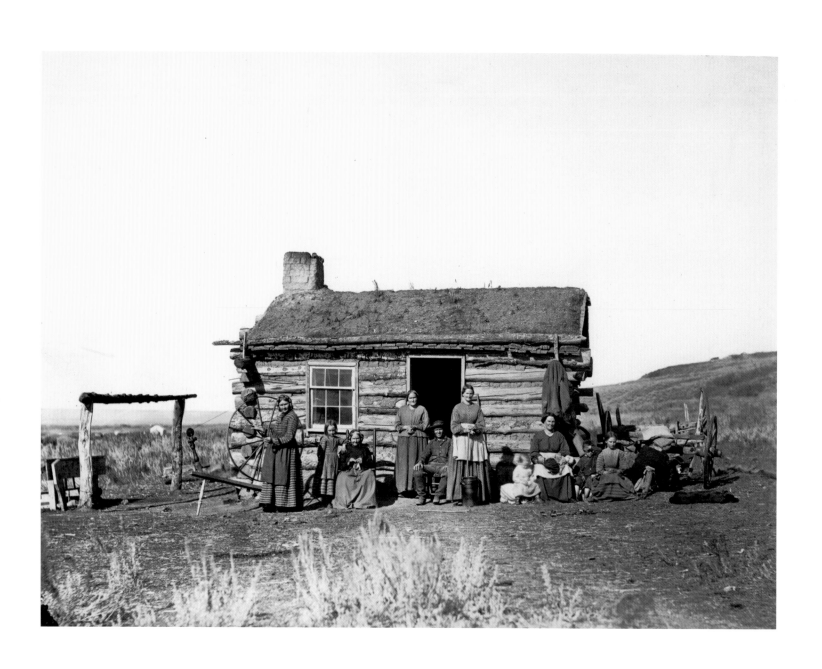

103. **Andrew J. Russell**. Mormon Family, Great Salt Lake Valley. 1869

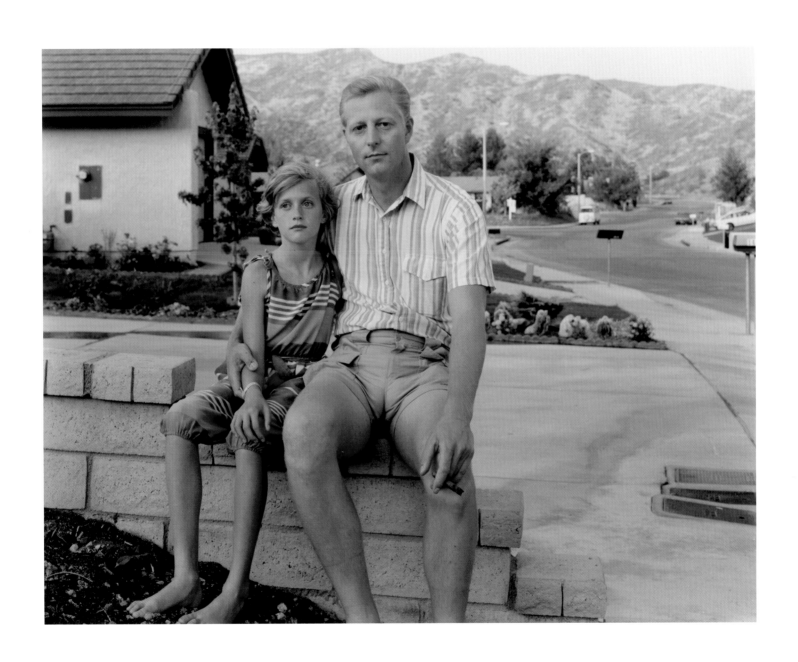

104. **Joel Sternfeld**. Canyon Country, California. June 1983

105. **Joel Meyerowitz**. Los Angeles. 1964

107. **Solomon D. Butcher**. James McCrea Sod Home. c. 1888

108. **Bill Owens**. We Are Really Happy. 1972

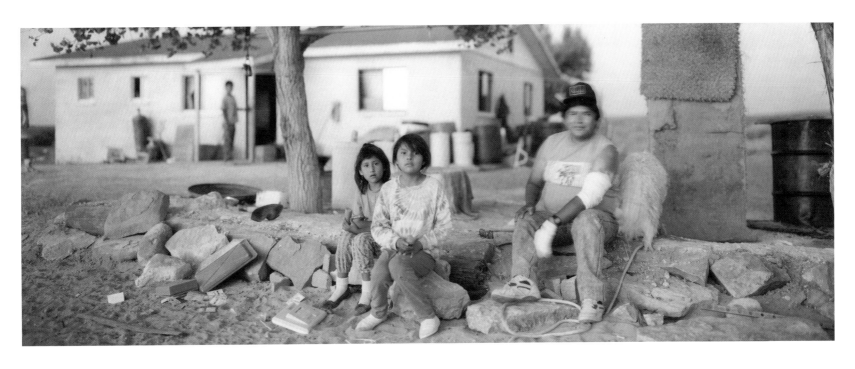

109. **Lois Conner**. Bluff, Utah. *1992*

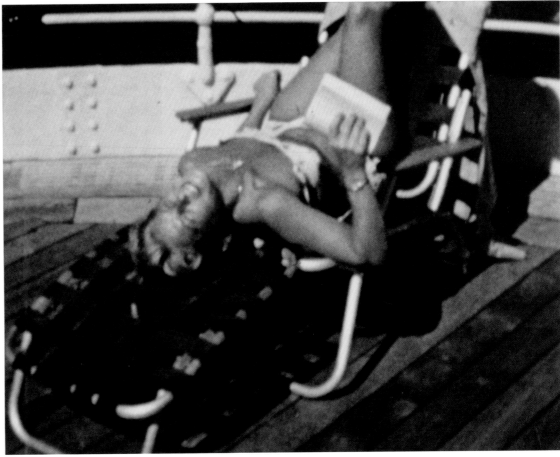

110. **Larry Sultan**. Film Stills from the Sultan Family Home Movies. 1943–72

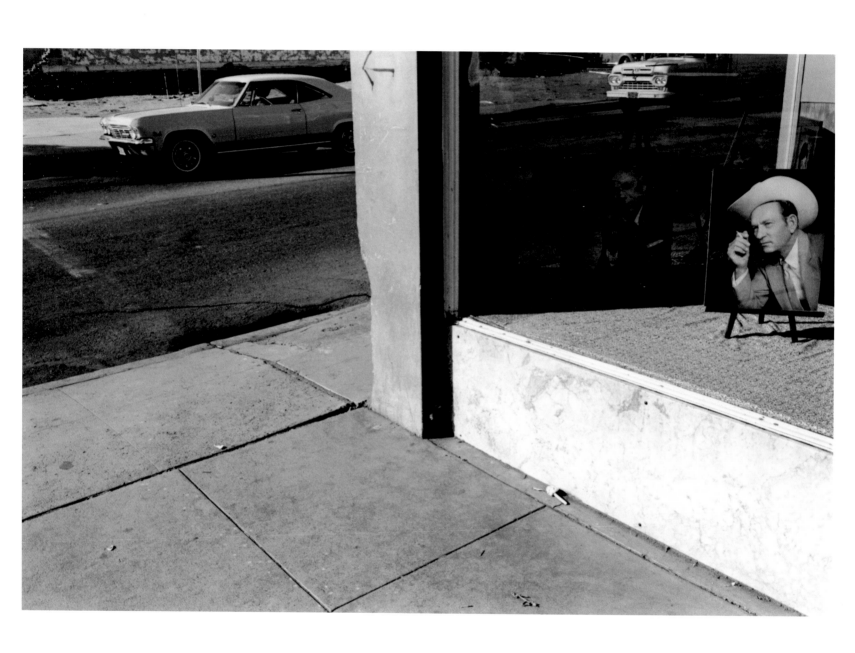

111 **Lee Friedlander**. California. 1965

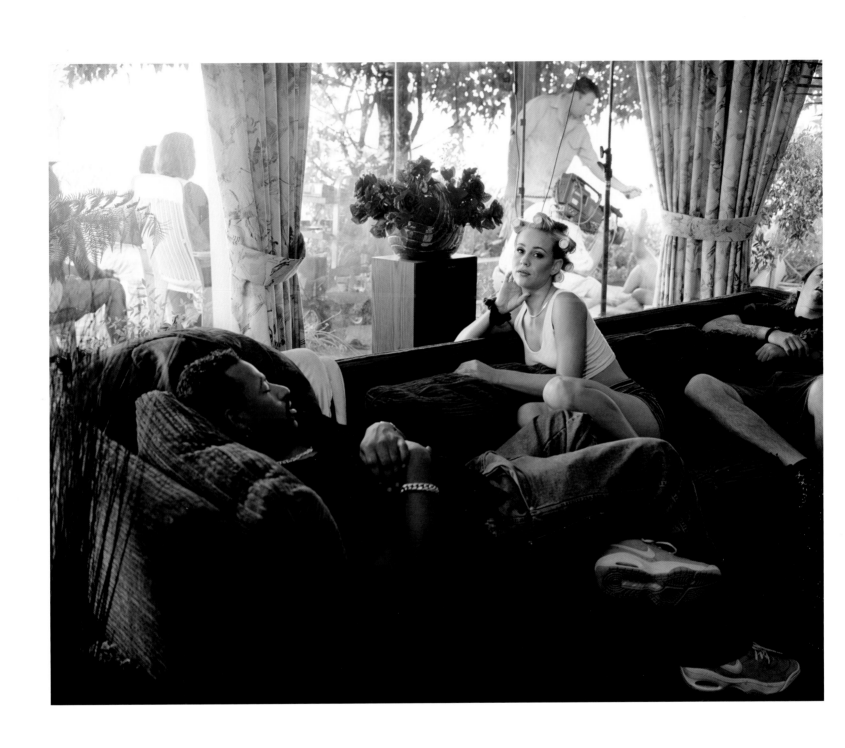

112. **Larry Sultan**. Tasha's Third Film. 1998

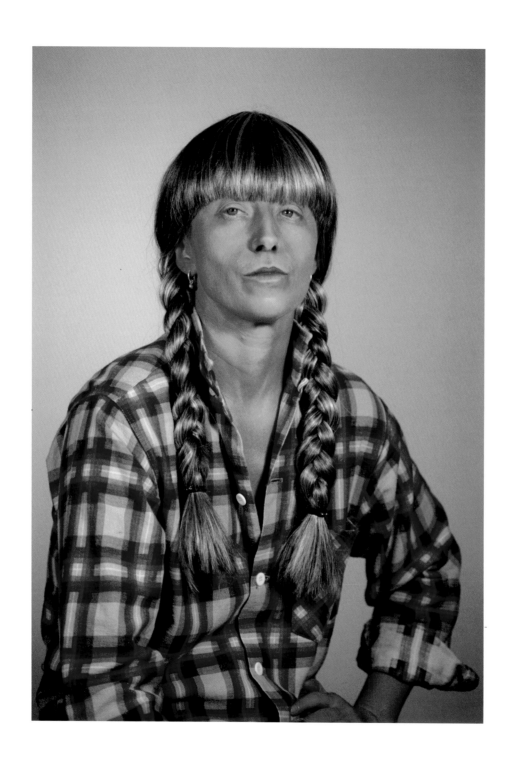

113. **Cindy Sherman**. Untitled #398. 2000

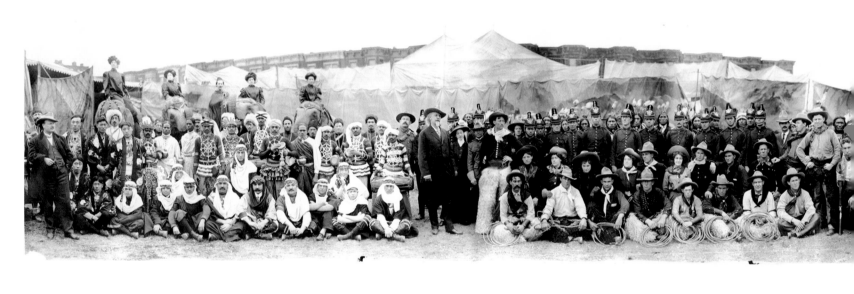

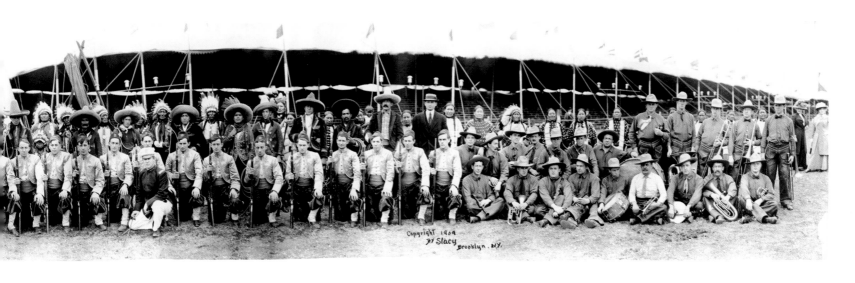

115. **Stacy Studio**. Buffalo Bill, Pawnee Bill and entire Wild West Show and Far East troupe, in front of tents. 1909

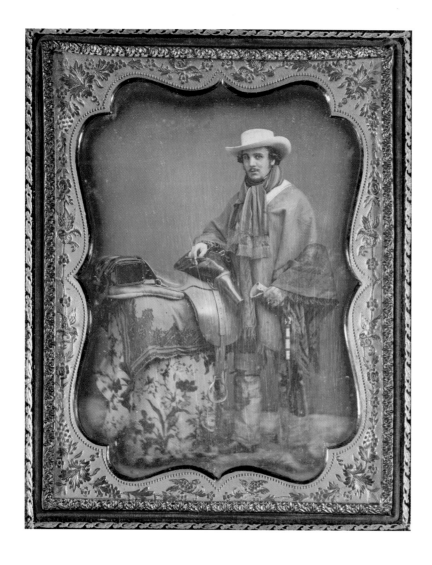

117. **David Levinthal**. Untitled. 1989

118. **Richard Prince**. Untitled (Cowboy). 2003

119. **James Casebere**. Covered Wagons. 1985

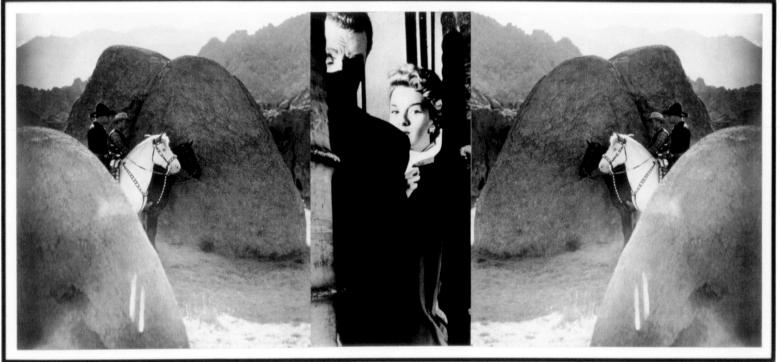

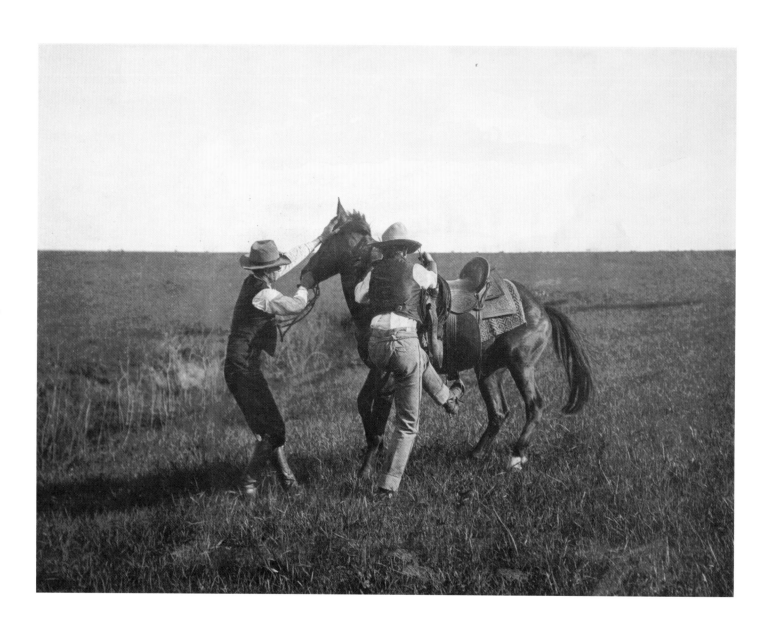

121. **Erwin E. Smith**. Mounting a Bronc. c. 1910

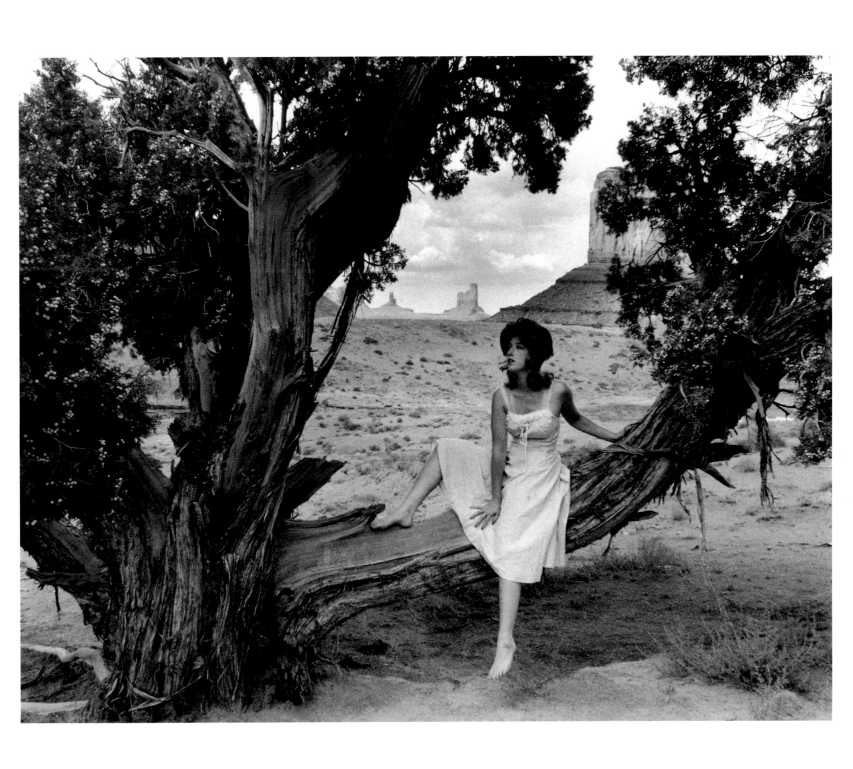

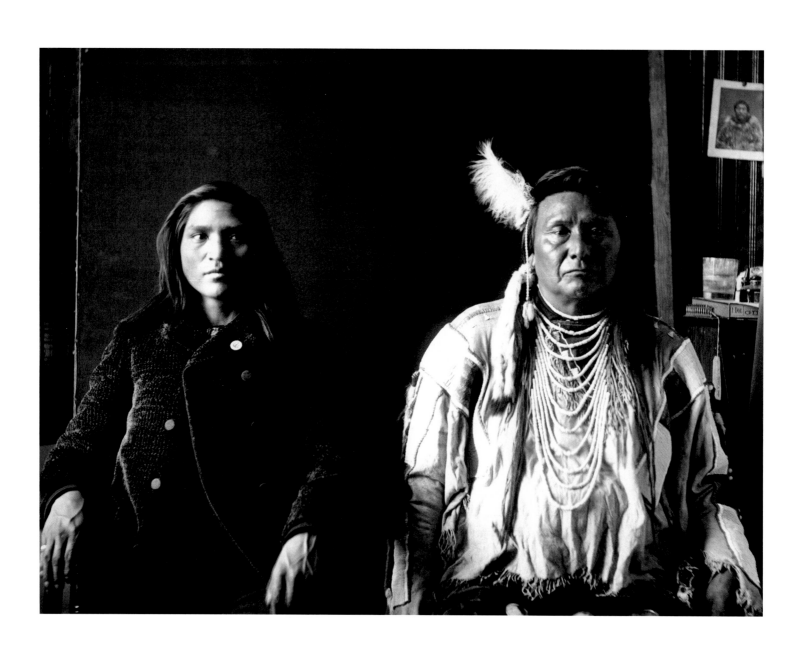

123. **Wells Moses Sawyer**. Chief Joseph and Nephew (Hinmaton-Yalakit, also Hin-Ma-Toe-Ya-Lut-Kiht; or Thunder Coming from the Water Up Over the Land, and his nephew, Amos F. Wilkinson). 1897

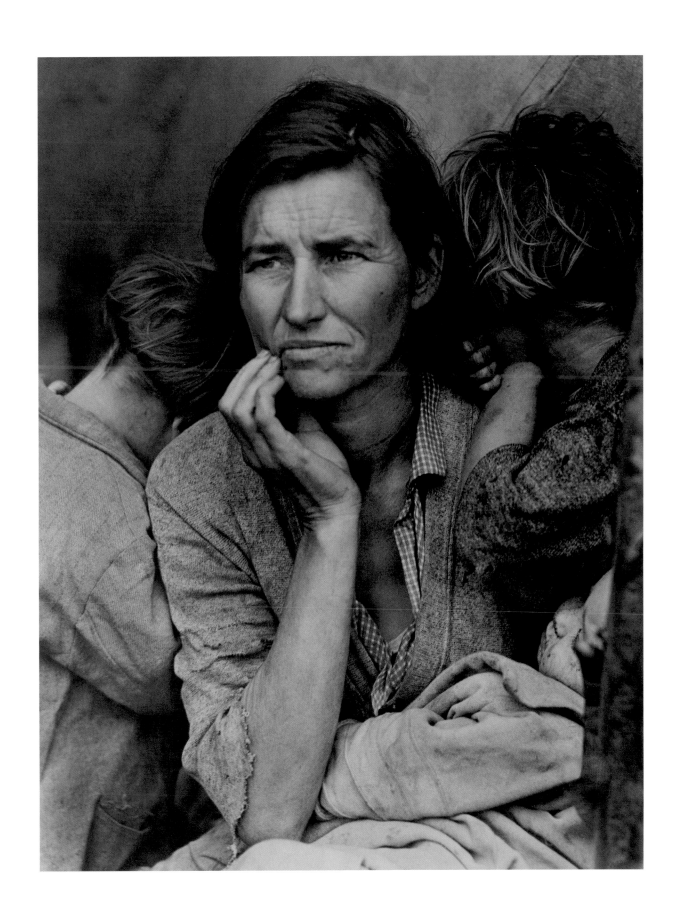

124. **Dorothea Lange**. Migrant Mother, Nipomo, California. 1936.

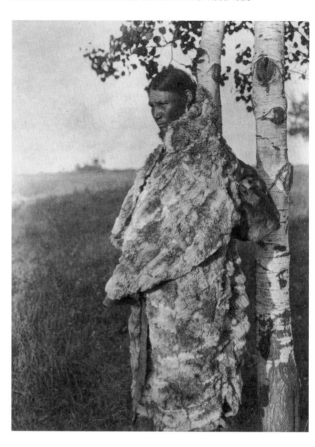

125. **Larry Sultan**. Antioch Creek. 2008

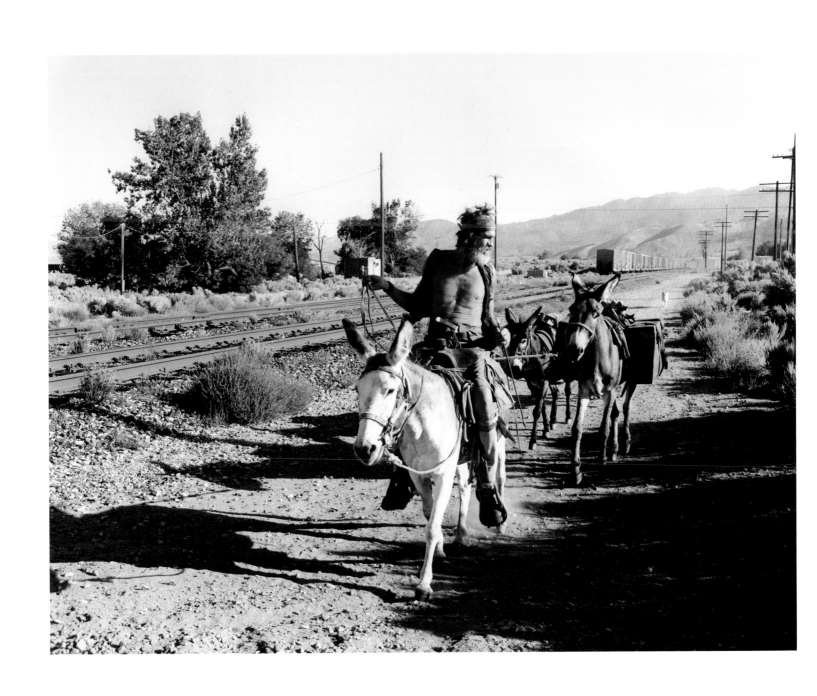

127. **Justine Kurland**. Astride Mama Burro, Now Dead. 2007

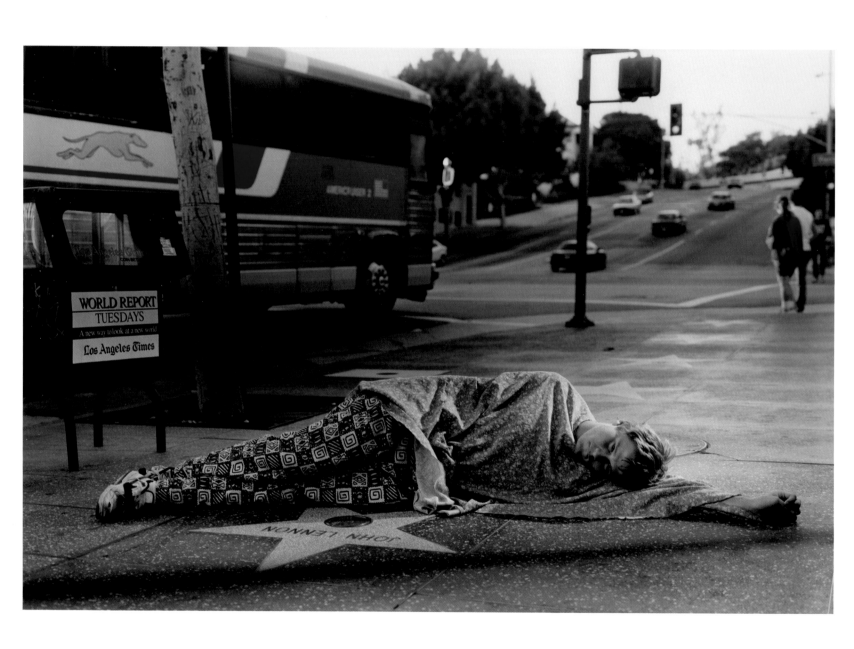

128. **Philip-Lorca diCorcia**. Major Tom; Kansas City, Kansas; $20. 1990–92

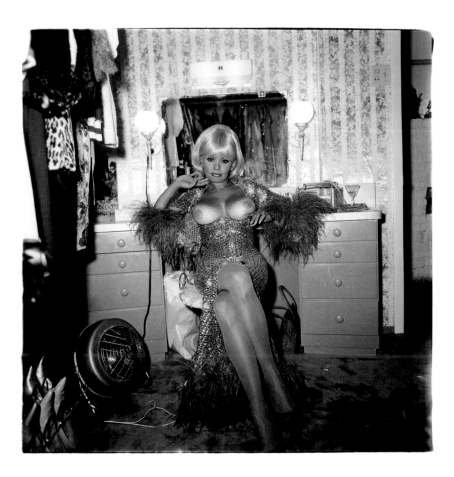

130. **Larry Clark**. Dead. 1970

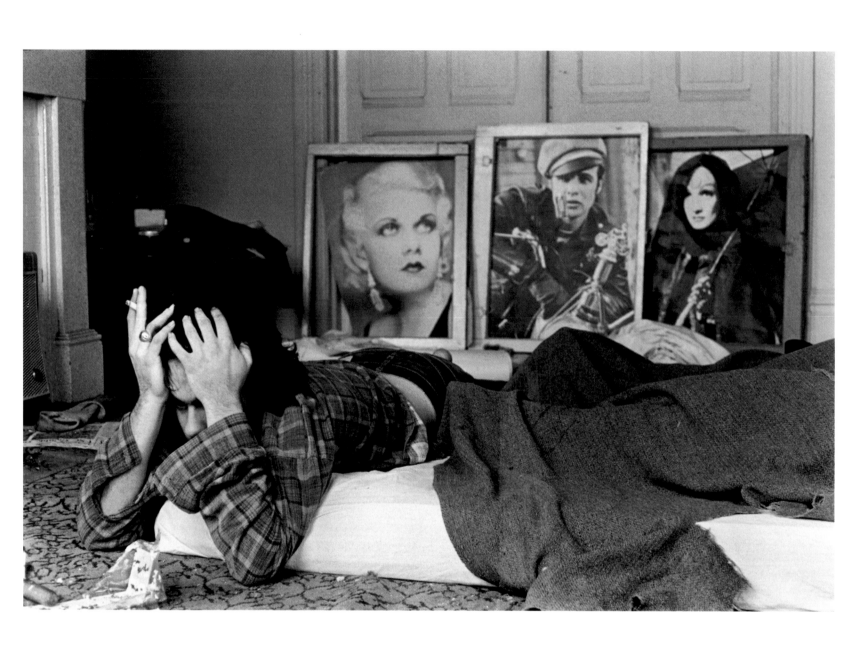

131. **William Gedney**. Untitled. January 1967

132. **Katy Grannan**. Nicole, Crissy Field Parking Lot (I). 2006

133. **Richard Avedon**. Carl Hoefert, unemployed black jack dealer, Reno, Nevada, August 30, 1983. 1983

list of plates

The works are listed first in alphabetical order by artist, then in the order in which they appear in the book. In the dimensions, height precedes width.

Ansel Adams. American, 1902–1984

Mount Williamson, Sierra Nevada, from Manzanar, California. c. 1944
Gelatin silver print (printed c. 1978), 15 ½ x 18 ½" (39.3 x 47 cm)
The Museum of Modern Art, New York. Gift of the photographer
Plate 2

Moonrise, Hernandez, New Mexico. 1941
Gelatin silver print, 14 ⅞ x 19" (37.8 x 48.3 cm)
The Museum of Modern Art, New York. Gift of the photographer
Plate 11

Robert Adams. American, born 1937

East from Flagstaff Mountain, Boulder County, Colorado. 1976
Gelatin silver print, 8 ¹⁵/₁₆ x 11 ¼" (22.7 x 28.5 cm)
The Museum of Modern Art, New York. Purchase
Plate 22

Colorado Springs, Colorado. 1968
Gelatin silver print, 5 ¹⁵/₁₆ x 5 ¹⁵/₁₆" (15.2 x 15.2 cm)
The Museum of Modern Art, New York. Acquired through the generosity of Lily Auchincloss
Plate 57

Burning Oil Sludge North of Denver, Colorado. 1973
Gelatin silver print, 6 x 7 ⅝" (15.2 x 19.4 cm)
The J. Paul Getty Museum, Los Angeles
Plate 65

Diane Arbus. American, 1923–1971

Topless Dancer in Her Dressing Room, San Francisco, California. 1968
Gelatin silver print (printed by Neil Selkirk), 14 ⁵/₁₆ x 14 ⅜" (36.4 x 36.5 cm)
The Museum of Modern Art, New York. Purchase
Plate 129

Richard Avedon. American, 1923–2004

Carl Hoefert, unemployed black jack dealer, Reno, Nevada, August 30, 1983. 1983
Gelatin silver print, 47 ½ x 37 ½" (120.6 x 95.2 cm)
The Museum of Modern Art, New York. Gift of the photographer
Plate 133

John Baldessari. American, born 1931

Black and White Decision. 1984
Black-and-white photographs (gelatin silver prints), overall: 64 x 70 ¾" (162.6 x 179.7 cm)
The Broad Art Foundation, Santa Monica
Plate 120

Lewis Baltz. American, born 1945

San Quentin Point. 1985
Twenty-five gelatin silver prints, each: 7 ⅜ x 9 ¹/₁₆" (18.7 x 23 cm)
The Museum of Modern Art, New York. Gift of Robert L. Smith
Plate 67

Adam Bartos. American, born 1953

Los Angeles. 1978
Chromogenic color print (printed 2006), 24 ¹⁵/₁₆ x 36 ¼" (63.4 x 92.1 cm)
The Museum of Modern Art, New York. Acquired through the generosity of Edgar Wachenheim III
Plate 40

Solomon D. Butcher. American, 1856–1927

James McCrea Sod Home. c. 1888
Gelatin silver print (printed 1964), 10 ¾ x 13 ½" (27.3 x 34.3 cm)
The Museum of Modern Art, New York. Courtesy Nebraska State Historical Society
Plate 107

James Casebere. American, born 1953

Subdivision with Spotlight. 1982
Gelatin silver print, 14 ¹³/₁₆ x 18 ¹⁵/₁₆" (37.6 x 48.1 cm)
The Museum of Modern Art, New York. Purchase
Plate 53

Covered Wagons. 1985
Gelatin silver print, 29 ½ x 22 ¾" (75 x 57.8 cm)
The Museum of Modern Art, New York. Purchase
Plate 119

Larry Clark. American, born 1943

Dead from the portfolio **Tulsa.** 1970
Gelatin silver print, 11 ⅞ x 8" (30.1 x 20.3 cm)
The Museum of Modern Art, New York. Extended loan from Mr. Jack Yogman
Plate 130

Alvin Langdon Coburn. American, 1882–1966

Yosemite Valley, California. c. 1911
Platinum print, 16 x 12 1/4" (40.6 x 31.2 cm)
The Museum of Modern Art, New York. David H. McAlpin Fund
Plate 10

Lois Conner. American, born 1951

Bluff, Utah from the series **Dineh–People of the Earth's Surface.** 1992
Platinum print, 6 15/16 x 16 13/16" (17.6 x 42.7 cm)
The Museum of Modern Art, New York. Gift of Barbara Foshay
Plate 109

Edward Sheriff Curtis. American, 1868–1954

Cañon de Chelly. 1904
Gelatin silver print, 5 5/8 x 7 3/4" (14.3 x 19.7 cm)
Amon Carter Museum, Fort Worth, Texas
Plate 26

Watching the Dancers. 1906
Photogravure, 15 1/8 x 11 5/16" (38.4 x 28.7 cm)
The Museum of Modern Art, New York. Gift of Jean-Antony du Lac
Plate 99

Cree Woman with Fur Robe. 1926
Photogravure, 7 1/2 x 5 1/2" (19 x 14 cm)
The Museum of Modern Art, New York. Purchase
Plate 126

Robert Dawson. American, born 1950

Ground Water Pump Near Allensworth, California. 1984
Gelatin silver print, 17 9/16 x 13 11/16" (44.6 x 34.7 cm)
The Museum of Modern Art, New York. The Family of Man Fund
Plate 73

Philip-Lorca diCorcia. American, born 1953

Marilyn; 28 Years Old; Las Vegas, Nevada; $30. 1990–92
Chromogenic color print, 24 x 35 15/16" (61 x 91.4 cm)
The Museum of Modern Art, New York. E.T. Harmax Foundation Fund
Plate 84

Major Tom; Kansas City, Kansas; $20. 1990–92
Chromogenic color print, 15 1/8 x 22 3/4" (38.4 x 57.8 cm)
The Museum of Modern Art, New York. E.T. Harmax Foundation Fund
Plate 128

John Divola. American, born 1949

N34°10.744'W116°07.973' from the series **Isolated Houses.** 1995–98
Chromogenic color print, 19 x 19" (48.3 x 48.3 cm)
The Museum of Modern Art, New York. E.T. Harmax Foundation Fund
Plate 14

Zuma #29. 1978
Dye transfer print, 14 1/2 x 17 15/16" (36.7 x 45.6 cm)
The Museum of Modern Art, New York. Purchase
Plate 58

Attributed to **Edric L. Eaton**. American, 1836–1890

Sky Chief (Tirawahut Resaru). c. 1867
Albumen silver print (printed by William Henry Jackson),
7 15/16 x 5 1/4" (18.6 x 13.3 cm)
The Metropolitan Museum of Art. Gilman Collection, purchase,
Sam Salz Foundation Gift, 2005 (2005.100.111)
Plate 74

Robert Frank. American, born Switzerland 1924

Santa Fe, New Mexico. 1955
Gelatin silver print, 8 15/16 x 13 1/4" (22.7 x 33.7 cm)
The Museum of Modern Art, New York. Gift of Robert and Gayle Greenhill
Plate 36

Covered car–Long Beach, California. 1955
Gelatin silver print, 13 1/8 x 19 3/16" (33.3 x 48.8 cm)
The Museum of Modern Art, New York. John Spencer Fund
Plate 37

Movie premiere–Hollywood. 1955
Gelatin silver print, 13 1/8 x 9 3/16" (33.4 x 23.3 cm)
The Metropolitan Museum of Art. Purchase, anonymous gifts, 1986
(1986.1198.10)
Plate 85

Rodeo–New York City. 1954 (dated 1955 by the artist)
Gelatin silver print, 13 x 9 1/16" (33 x 23 cm)
The Metropolitan Museum of Art. Gift of Barbara and Eugene Schwartz, 1992
(1992.5162.3)
Plate 86

Lee Friedlander. American, born 1934

Idaho. 1972
Gelatin silver print, 6 5/16 x 9 1/2" (16 x 24.1 cm)
Collection Stephanie and Tim Ingrassia, New York
Plate 33

California. 1965
Gelatin silver print, 5 3/8 x 7 15/16" (13.6 x 20.2 cm)
The Museum of Modern Art, New York. Purchase
Plate 111

Los Angeles, California. 1965
Gelatin silver print, 11 x 14" (27.9 x 35.6 cm)
Courtesy the artist and Janet Borden, Inc.
Plate 114

William A. Garnett. American, 1916–2006
Grading, Lakewood, California. 1950
Gelatin silver print, 7 7/16 x 9 7/16" (18.9 x 24 cm)
The J. Paul Getty Museum, Los Angeles
Plate 47

Trenching, Lakewood, California. 1950
Gelatin silver print, 7 5/16 x 9 7/16" (18.6 x 24 cm)
The J. Paul Getty Museum, Los Angeles
Plate 48

Foundation and Slabs, Lakewood, California. 1950
Gelatin silver print, 7 7/16 x 9 3/8" (18.9 x 23.8 cm)
The J. Paul Getty Museum, Los Angeles
Plate 49

Framing, Lakewood, California. 1950
Gelatin silver print, 7 1/4 x 9 1/2" (18.4 x 24.1 cm)
The J. Paul Getty Museum, Los Angeles
Plate 50

Plaster and Roofing, Lakewood, California. 1950
Gelatin silver print, 7 11/16 x 9 9/16" (19.5 x 24.3 cm)
The J. Paul Getty Museum, Los Angeles
Plate 51

Finished Housing, Lakewood, California. 1950
Gelatin silver print, 7 3/8 x 9 7/16" (18.7 x 24 cm)
The J. Paul Getty Museum, Los Angeles
Plate 52

William Gedney. American, 1932–1989
San Francisco. 1966–67
Gelatin silver print, 12 x 8 1/16" (30.5 x 20.5 cm)
The Museum of Modern Art, New York. Gift of the Duke University
Rare Book, Manuscript, and Special Collections Library
Plate 76

Untitled. January 1967
Gelatin silver print, 8 1/4 x 12" (20.9 x 30.5 cm)
The Museum of Modern Art, New York. Mr. and Mrs. John Spencer Fund
Plate 131

Arnold Genthe. American, born Germany. 1869–1942
The Street of the Gamblers. 1896–1906
Gelatin silver print, 9 3/4 x 11 7/8" (24.8 x 30.2 cm)
The Museum of Modern Art, New York. Gift of Albert M. Bender
Plate 96

Laura Gilpin. American, 1881–1979
Sunrise on the Desert. 1921
Platinum print, 7 1/2 x 9 1/4" (19.1 x 23.6 cm)
The Museum of Modern Art, New York. Gift of Miss Mina Turner
Plate 16

Frank Gohlke. American, born 1942
Aerial view: downed forest near Elk Rock. Approximately
ten miles northwest of Mount St. Helens. 1981
Gelatin silver print, 17 7/8 x 21 7/8" (45.7 x 55.8 cm)
The Museum of Modern Art, New York. Acquired through the
generosity of Shirley C. Burden
Plate 66

Katy Grannan. American, born 1969
Nicole, Crissy Field Parking Lot (I). 2006
Pigmented inkjet print, 40 x 50" (101.6 x 127 cm)
The Museum of Modern Art, New York. Acquired through
the generosity of the Cornelius N. Bliss Memorial Fund
Plate 132

David T Hanson. American, born 1948
Wasteland: California Gulch, Leadville, Colorado. 1986
Chromogenic color print, 17 5/16 x 21 15/16" (44 x 55.8 cm)
The Museum of Modern Art, New York. Gift of the photographer
Plate 70

Chauncey Hare. American, born 1934
Southern Pacific Station, Oakland. 1967
Gelatin silver print, 7 7/8 x 9 7/8" (20 x 25.1 cm)
The Museum of Modern Art, New York. Purchase
Plate 35

Alfred A. Hart. American, 1816–1908
Rounding Cape Horn. Road to Iowa Hill from the River,
in the Distance. c. 1869
Two albumen silver prints, each: 2 15/16 x 3 1/16" (7.6 x 7.8 cm)
The Museum of Modern Art, New York. Purchase
Plate 32

John K. Hillers. American, 1843–1925
Hopi Pueblos of Mishongnovi and Shipaulovi, Arizona. 1879 or 1881
Albumen silver print, 9 3/4 x 12 3/4" (24.8 x 32.4 cm)
Collection of the Sack Photographic Trust of the San Francisco Museum
of Modern Art (ST1998.0226)
Plate 21

Moki Girls. 1879
Albumen silver print, 9 5/16 x 7 1/16" (23.7 x 17.9 cm)
The J. Paul Getty Museum, Los Angeles
Plate 82

David Hockney. British, born 1937
Pearblossom Hwy., 11–18th April, 1986, #1. 1986
Chromogenic color prints, overall: 47 x 46 1/2" (119.4 x 118.1 cm)
The J. Paul Getty Museum, Los Angeles. Gift of David Hockney
Plate 31

Dennis Hopper. American, born 1936
Double Standard. 1961
Gelatin silver print (printed later), 16 x 24″ (40.6 x 61 cm)
The Museum of Modern Art, New York. Samuel J. Wagstaff, Jr., Fund
Plate 38

Wilfred R. Humphries. American, 1876–c. 1910
Bisbee. 1904
Gelatin silver print, 4 1/2 x 23 1/4″ (11.4 x 59.1 cm)
Amon Carter Museum, Fort Worth, Texas
Plate 63

Graciela Iturbide. Mexican, born 1943
Cholas I, White Fence, East Los Angeles. 1986
Gelatin silver print, 18 1/4 x 12 1/4″ (46.4 x 31.1 cm)
Courtesy the artist and RoseGallery, Santa Monica
Plate 101

William Henry Jackson. American, 1843–1942
Grand Canyon of the Colorado River. 1883
Albumen silver print, 21 x 17 1/16″ (53.3 x 43.3 cm)
The J. Paul Getty Museum, Los Angeles
Plate 4

Upper Twin Lake, Colorado from **The Rocky Mountains, Scenes along the Line of the Denver and Rio Grande Railway.** 1875
Albumen silver print, 17 x 21″ (43.2 x 53.3 cm)
The Museum of Modern Art, New York. David H. McAlpin Fund
Plate 8

Geoffrey James. Canadian, born Wales 1942
Looking Towards Mexico, Otay Mesa from the series **Running Fence.** 1997
Gelatin silver print, 28 7/16 x 35 11/16″ (72.3 x 90.7 cm)
The Museum of Modern Art, New York. Gift of the photographer
Plate 71

Gertrude Käsebier. American, 1852–1934
American Indian Portrait. c. 1899
Platinum print, 7 3/4 x 7″ (19.7 x 17.8 cm)
The Museum of Modern Art, New York. Gift of Miss Mina Turner
Plate 91

Darius Kinsey. American, 1869–1945
Crescent Camp No. 1. 1936
Gelatin silver print, 10 3/16 x 13 7/16″ (25.8 x 34.2 cm)
The Museum of Modern Art, New York. Courtesy of Jesse E. Ebert
Plate 68

Felling a Fir Tree, 51 Feet in Circumference. 1906
Gelatin silver print, 13 3/8 x 10 3/8″ (34 x 26.4 cm)
The Museum of Modern Art, New York. Anonymous gift
Plate 75

Charles D. Kirkland. American, 1857–1926
Wyoming Cow-boy. c. 1877–95
Albumen silver print, 7 7/16 x 4 1/2″ (18.9 x 11.4 cm)
Amon Carter Museum, Fort Worth, Texas
Plate 87

Justine Kurland. American, born 1969
Astride Mama Burro, Now Dead. 2007
Chromogenic color print, 40 x 50″ (101.6 x 127 cm)
Courtesy the artist and Mitchell-Innes & Nash, New York
Plate 127

Dorothea Lange. American, 1895–1965
The Road West, New Mexico. 1938
Gelatin silver print, 9 5/8 x 13 1/16″ (24.5 x 33.2 cm)
The Museum of Modern Art, New York. Purchase
Plate 29

Near Milpitas, California. 1956
Gelatin silver print, 9 7/16 x 13 7/16″ (24 x 34.1 cm)
The Museum of Modern Art, New York. Purchase
Plate 54

Richmond, California. 1942
Gelatin silver print, 9 3/4 x 7 11/16″ (24.7 x 19.5 cm)
The Museum of Modern Art, New York. Purchase
Plate 79

Migrant Mother, Nipomo, California. 1936
Gelatin silver print, 11 1/8 x 8 9/16″ (28.3 x 21.8 cm)
The Museum of Modern Art, New York. Purchase
Plate 124

An-My Lê. American, born Vietnam 1960
29 Palms: Infantry Platoon. 2003–04
Gelatin silver print, 26 1/2 x 38 1/16″ (67.3 x 96.7 cm)
The Museum of Modern Art, New York. Robert B. Menschel Fund
Plate 62

David Levinthal. American, born 1949
Untitled from the series **The Wild West.** 1989
Color instant print, 24 x 19 1/2″ (61 x 49.6 cm)
The Museum of Modern Art, New York. The Fellows of Photography Fund and Horace W. Goldsmith Fund through Robert B. Menschel
Plate 117

James Luna. Native American (Pooyukitchum/Luiseño), born 1950
Half Indian/Half Mexican. 1991
Three gelatin silver prints, each: 30 x 24″ (76.2 x 61 cm)
The Museum of Contemporary Art, San Diego. Gift of the Peter Norton Family Foundation
Plate 92

Elaine Mayes. American, born 1938
Kenneth Williams, Age 22 from the series **We Are the
Haight-Ashbury.** August 30, 1968
Gelatin silver print, 9 x 8 3/4" (22.8 x 22.2 cm)
The Museum of Modern Art, New York. Purchase
Plate 78

Joel Meyerowitz. American, born 1938
Los Angeles. 1964
Gelatin silver print, 9 x 13 1/2" (22.9 x 34.3 cm)
The Museum of Modern Art, New York. Purchase
Plate 105

Richard Misrach. American, born 1949
Desert Fire Number 43. 1983
Chromogenic color print, 18 3/16 x 23" (46.2 x 58.4 cm)
The Museum of Modern Art, New York. Joseph G. Mayer Fund
Plate 9

Karin Apollonia Müller. German, born 1963
Civitas from the series **Angels in Fall.** February 1997
Chromogenic color print, 19 3/4 x 24 1/2" (50.1 x 62.2 cm)
The Museum of Modern Art, New York. Gift of Howard Stein
Plate 69

Eadweard J. Muybridge. British, 1830–1904
Valley of the Yosemite from Mosquito Camp. 1872
Albumen silver print, 16 15/16 x 21 9/16" (43.1 x 54.8 cm)
The Museum of Modern Art, New York. Gift of Paul F. Walter
Plate 7

Panorama of San Francisco, from California-St. Hill. 1877
Eleven albumen silver prints, bound, overall: 7 5/16" x 7' (18.5 x 219 cm)
Amon Carter Museum, Fort Worth, Texas
Plate 23

Timothy O'Sullivan. American, born Ireland. 1840–1882
Desert Sand Hills near Sink of Carson, Nevada. 1867
Albumen silver print, 8 13/16 x 11 7/16" (22.4 x 29.1 cm)
The J. Paul Getty Museum, Los Angeles
Plate 15

Ancient Ruins in the Cañon de Chelle from **Geographical
and Geological Explorations and Surveys West of the 100th
Meridian.** 1873
Albumen silver print, 10 13/16 x 7 15/16" (27.5 x 20.2 cm)
The Museum of Modern Art, New York. Gift of Ansel Adams
in memory of Albert M. Bender
Plate 25

Savage Mine, Curtis Shaft, Virginia City, Nevada. 1868
Albumen silver print, 5 11/16 x 7 15/16" (14.4 x 20.2 cm)
Amon Carter Museum, Fort Worth, Texas
Plate 89

Bill Owens. American, born 1938
We Are Really Happy. 1972
Gelatin silver print, 8 1/16 x 9 15/16" (20.4 x 25.3 cm)
The Museum of Modern Art, New York. Gift of the photographer
Plate 108

Tod Papageorge. American, born 1940
Hermosa Beach, California. August 1978
Gelatin silver print, 10 5/8 x 15 9/16" (27 x 39.6 cm)
The Museum of Modern Art, New York. Purchase
Plate 94

Irving Penn. American, born 1917
Hell's Angels, San Francisco. 1967
Platinum-palladium print, 18 5/8 x 22 1/2" (47.3 x 57.2 cm)
National Gallery of Art, Washington, D.C. Gift of Irving Penn (2002.119.65)
Plate 98

Horace Poolaw. American Indian (Kiowa), 1906–1984
Dorothy Poolaw Ware with Her Son Justin Lee Ware. c. 1920
Hand-colored gelatin silver print, 10 1/2 x 13" (26.7 x 33 cm)
Collection of Tom Jones
Plate 90

Richard Prince. American, born 1949
Untitled (Cowboy). 2003
Chromogenic color print, 40 x 30" (101.6 x 76.2 cm)
Collection of Douglas S. Cramer
Plate 118

Edward Ruscha. American, born 1937
Every Building on the Sunset Strip. 1966
Photolithographic halftone book in foil-covered slipcase, closed: 7 x 5 1/2"
(17.9 x 14 cm); unfolded: 27' (823 cm) long
The Museum of Modern Art Library
Plate 24

Sears Roebuck & Co., Bellingham & Hamlin, North Hollywood. 1967
Gelatin silver print, 7 1/8 x 7 3/8" (18.1 x 18.7 cm)
Whitney Museum of American Art, New York. Purchase, with funds from
The Leonard and Evelyn Lauder Foundation, and Diane and Thomas Tuft
Plate 41

Zurich-American Insurance, 4465 Wilshire Blvd. 1967
Gelatin silver print, 5 1/4 x 6 1/4" (13.3 x 15.9 cm)
Whitney Museum of American Art, New York. Purchase, with funds from
The Leonard and Evelyn Lauder Foundation, and Diane and Thomas Tuft
Plate 42

Unidentified Lot, Reseda. 1967
Gelatin silver print, 7 3/4 x 7 3/4" (19.7 x 19.7 cm)
Whitney Museum of American Art, New York. Purchase, with funds from
The Leonard and Evelyn Lauder Foundation, and Diane and Thomas Tuft
Plate 43

Century City, 1800 Avenue of the Stars. 1967
Gelatin silver print, 4 3/4 x 7 5/16" (12.1 x 18.6 cm)
Whitney Museum of American Art, New York. Purchase, with funds from
The Leonard and Evelyn Lauder Foundation, and Diane and Thomas Tuft
Plate 44

Church of Christ, 14655 Sherman Way, Van Nuys. 1967
Gelatin silver print, 6 x 7 1/2" (15.2 x 19.1 cm)
Whitney Museum of American Art, New York. Purchase, with funds from
The Leonard and Evelyn Lauder Foundation, and Diane and Thomas Tuft
Plate 45

7133 Kester, Van Nuys. 1967
Gelatin silver print, 7 3/4 x 7 3/4" (19.7 x 19.7 cm)
Whitney Museum of American Art, New York. Purchase, with funds from
The Leonard and Evelyn Lauder Foundation, and Diane and Thomas Tuft
Plate 46

Andrew J. Russell. American, 1830–1902
Construction Train, Bear River. 1868
Albumen silver print, 8 3/4 x 11 1/2" (22.2 x 29.2 cm)
The Museum of Modern Art, New York. Gift of Union Pacific Railroad Company
Plate 27

Granite Cañon, from the Water Tank from The Great West illustrated in
a series of photographic views across the continent taken along the
line of the Union Pacific Railroad west from Omaha, Nebraska. 1869
Albumen silver print, 9 x 11 3/4" (22.9 x 29.8 cm)
Photography Collection, Miriam and Ira D. Wallach Division of Art, Prints and
Photographs, The New York Public Library, Astor, Lenox and Tilden Foundations
Plate 30

Mormon Family, Great Salt Lake Valley from The Great West illustrated
in a series of photographic views across the continent taken along the
line of the Union Pacific Railroad west from Omaha, Nebraska. 1869
Albumen silver print, 9 x 11 3/4" (22.9 x 29.8 cm)
Photography Collection, Miriam and Ira D. Wallach Division of Art, Prints and
Photographs, The New York Public Library, Astor, Lenox and Tilden Foundations
Plate 103

Wells Moses Sawyer. American, 1863–1961
Chief Joseph and Nephew (Hinmaton-Yalakit, also Hin-Ma-Toe-Ya-Lut-
Kiht; or Thunder Coming from the Water Up Over the Land, and his
nephew, Amos F. Wilkinson). 1897
Gelatin silver print, 7 1/2 x 9 1/2" (19.1 x 24.1 cm)
Amon Carter Museum, Fort Worth, Texas
Plate 123

Cindy Sherman. American, born 1954
Untitled #398. 2000
Chromogenic color print, 34 1/4 x 24" (87 x 61 cm)
Collection of Ellen and Richard Levine
Plate 113

Untitled Film Still #43. 1979
Gelatin silver print, 7 9/16 x 9 7/16" (19.2 x 24 cm)
The Museum of Modern Art, New York. Acquired through the
generosity of Sid R. Bass
Plate 122

Stephen Shore. American, born 1947
U.S. 97, South of Klamath Falls, Oregon. July 21, 1973
Chromogenic color print (printed 2005), 17 1/4 x 21 1/2" (43.8 x 54.6 cm)
Courtesy the artist and 303 Gallery, New York
Plate 3

Beverly Boulevard and La Brea Avenue, Los Angeles, California.
July 21, 1975
Chromogenic color print (printed 2005), 17 1/4 x 21 1/2" (43.8 x 54.6 cm)
Courtesy the artist and 303 Gallery, New York
Plate 39

Julius Shulman. American, born 1910
Case Study House #22. 1960
Gelatin silver print (printed later), 20 X 16" (50.8 X 40.6 cm)
Courtesy the artist and Yancey Richardson Gallery, New York
Plate 59

Erwin E. Smith. American, 1886–1947
Mounting a Bronc. c. 1910
Gelatin silver print, 11 1/8 x 14 9/16" (28.3 x 37 cm)
The Museum of Modern Art, New York. The Family of Man Fund
Plate 121

Frederick Sommer. American, born Italy. 1905–1999
Arizona Landscape. 1943
Gelatin silver print, 7 5/8 x 9 9/16" (19.4 x 24.3 cm)
The Museum of Modern Art, New York. Purchase
Plate 18

Stacy Studio. U.S.A, active early 1900s
Buffalo Bill, Pawnee Bill and entire Wild West Show and
Far East troupe, in front of tents. 1909
Gelatin silver print, 9 1/8 x 70" (35.6 x 177.8 cm)
Buffalo Bill Historical Center, Cody, Wyoming; Museum Purchase.
William Cody Boal Collection (P.69.1230.1)
Plate 115

Joel Sternfeld. American, born 1944
Abandoned Uranium Refinery near Tuba City, Arizona,
Navajo Nation. 1982
Chromogenic color print (printed 1996), 16 x 20 3/16" (40.6 x 51.2 cm)
The Museum of Modern Art, New York. Gift of Beth Goldberg Nash and
Joshua Nash
Plate 13

Lake Oswego, Oregon. 1979
Chromogenic color print, 13 1/2 x 16 3/4" (34.2 x 42.6 cm)
The Museum of Modern Art, New York. Gift of the photographer
Plate 55

After a Flash Flood, Rancho Mirage, California. July 1979
Chromogenic color print, 13 1/2 x 17" (34.4 x 43.3 cm)
The Museum of Modern Art, New York. Acquired with matching funds
from Shirley C. Burden and The National Endowment for the Arts
Plate 61

A Woman at Home After Exercising, Malibu, California. August 1988
Chromogenic color print, 46 1/2 x 38" (118.1 x 96.5 cm)
Courtesy the artist and Luhring Augustine, New York
Plate 77

Member of the Christ Family Religious Sect, Hidalgo County, Texas.
January 1983
Chromogenic color print (printed 1995), 13 9/16 x 17 1/8" (34.5 x 43.5 cm)
The Museum of Modern Art, New York. Gift of Beth Goldberg Nash and
Joshua Nash
Plate 80

Canyon Country, California. June 1983
Chromogenic color print, 13 9/16 x 17 1/8" (34.4 x 43.5 cm)
The Museum of Modern Art, New York. Gift of Beth Goldberg Nash and
Joshua Nash
Plate 104

Larry Sultan. American, born 1946
Film Stills from the Sultan Family Home Movies. 1943–72
Six chromogenic color prints (printed 1985), each: 16 1/2 x 21 1/4" (42 x 54 cm)
The Museum of Modern Art, New York. Gift of Lewis Baltz
Plate 110

Tasha's Third Film from the series The Valley. 1998
Chromogenic color print, 40 x 50" (101.6 x 127 cm)
Whitney Museum of American Art, New York.
Gift of Jeanne and Richard S. Press
Plate 112

Antioch Creek from the series Homeland. 2008
Chromogenic color print, 30 x 40" (76.2 x 101.6 cm)
Courtesy the artist and Janet Borden, Inc.
Plate 125

Hugo Summerville. American, 1885–1948
Gaines Fig Farm. 1926
Gelatin silver print (printed 1988), 9 3/8 x 57" (23.8 x 144.8 cm)
The Museum of Modern Art, New York. Purchase
Plate 60

Unknown photographers
Lake View Gusher, Maricopa, California. c. 1905
Gelatin silver print, 8 x 6 1/8" (20.3 x 15.6 cm)
San Francisco Museum of Modern Art. Gift of Stephen White (96.121)
Plate 64

Gold Miner. c. 1850
Daguerreotype, 3 5/8 x 2 5/8" (9.2 x 6.7 cm)
The Nelson-Atkins Museum of Art, Kansas City, Missouri. Gift of Hallmark
Cards, Inc. (2005.27.115)
Plate 81

The Frontiersman. c. 1856
Ambrotype, 5 1/2 x 4 1/2" (14 x 11.4 cm)
The Nelson-Atkins Museum of Art, Kansas City, Missouri. Gift of Hallmark
Cards, Inc. (2005.27.110)
Plate 88

Five Members of the Wild Bunch. c. 1892
Tintype, 3 5/16 x 2 7/16" (8.4 x 6.2 cm)
The Metropolitan Museum of Art. Gilman Collection, Gift of the
Howard Gilman Foundation, 2005 (2005.100.111)
Plate 100

El Dorado Country, California. c. 1855
Daguerreotype, 4 1/2 x 5 1/2" (11.4 x 14 cm)
The Nelson-Atkins Museum of Art, Kansas City, Missouri. Gift of Hallmark
Cards, Inc. (2005.27.117)
Plate 106

Portrait of a Man with a Saddle. 1850–54
Daguerreotype, 4 3/4 x 3 7/16" (12.1 x 8.7 cm)
The J. Paul Getty Museum, Los Angeles
Plate 116

Adam Clark Vroman. American, 1856–1916
Untitled. 1895–1904
Platinum print, 6 x 8" (15.3 x 20.4 cm)
The Museum of Modern Art, New York. John Parkinson III Fund
Plate 95

Carleton E. Watkins. American, 1829–1916
Grizzly Giant, Mariposa Grove. 1861
Albumen silver print, 20 9/16 x 15 11/16" (52.2 x 39.9 cm)
The Museum of Modern Art, New York. The Fellows of Photography Fund
Plate 6

View from the Sentinel Dome, Yosemite. 1865–66
Three albumen silver prints, overall: 15 3/4 x 61 7/8" (40 x 157.1 cm)
Department of Special Collections, Stanford University Libraries
Plate 12

The Town on the Hill, New Almaden. 1863
Albumen silver print, 15 ⁵/₈ x 20 ⁹/₁₆″ (39.7 x 52.3 cm)
Department of Special Collections, Stanford University Libraries
Plate 20

Chinese Actor. 1876–80
Albumen silver print, 4 ³/₈ x 6 ³/₄″ (11.1 x 17.1 cm)
The J. Paul Getty Museum, Los Angeles
Plate 83

Henry Wessel, Jr. American, born 1942
Untitled. 1968
Gelatin silver print, 9 x 13 ¹/₂″ (22.9 x 34.3 cm)
The Museum of Modern Art, New York. Purchase
Plate 28

Southern California. 1985
Gelatin silver print, 16 x 20″ (40.6 x 50.8 cm)
Courtesy the artist, Charles Cowles Gallery, and Robert Mann Gallery,
New York
Plate 93

Edward Weston. American, 1886–1958
Quaker State Oil, Arizona. 1941
Gelatin silver print, 7 ⁵/₈ x 9 ⁵/₈″ (19.4 x 24.5 cm)
The Museum of Modern Art, New York. Acquired through the
generosity of Celeste Bartos
Plate 17

Hot Coffee, Mojave Desert. 1937
Gelatin silver print, 7 ¹/₂ x 9 ⁹/₁₆″ (19 x 24.3 cm)
The Museum of Modern Art, New York. Purchase
Plate 34

Boulder Dam. 1941
Gelatin silver print, 7 ⁹/₁₆ x 9 ⁵/₈″ (19.3 x 24.5 cm)
The Museum of Modern Art, New York. Acquired by exchange
Plate 72

Minor White. American, 1908–1976
Grand Tetons. 1959
Gelatin silver print, 9 ¹/₂ x 12 ¹/₈″ (24.1 x 30.8 cm)
The Museum of Modern Art, New York. Gift of Robert M. Doty
Plate 1

Devil's Slide, San Mateo County, California. 1948
Gelatin silver print, 6 ⁵/₈ x 8 ¹/₂″ (16.8 x 20.8 cm)
The Museum of Modern Art, New York. Gift of David H. McAlpin
Plate 19

Garry Winogrand. American, 1928–1984
Castle Rock, Colorado. 1959
Gelatin silver print (printed 1978), 8 ⁷/₈ x 13 ³/₈″ (22.5 x 34 cm)
The Museum of Modern Art, New York. Gift of Mr. and Mrs. James Hunter
Plate 5

New Mexico. 1957
Gelatin silver print, 8 ¹⁵/₁₆ x 13 ¹/₈″ (22.8 x 33.3 cm)
The Museum of Modern Art, New York. Purchase
Plate 56

Los Angeles. 1982
Gelatin silver print, 8 ¹³/₁₆ x 13 ³/₁₆″ (22.4 x 33.5 cm)
The Museum of Modern Art, New York. Purchase and gift of
Barbara Schwartz in memory of Eugene M. Schwartz
Plate 97

Fort Worth, Texas. 1974–77
Gelatin silver print (printed 1987–88 by Tom Consilvio), 14 ⁷/₈ x 22 ¹/₄″
(37.8 x 56.5 cm)
The Museum of Modern Art, New York. Purchase
Plate 102

bibliography

The following titles are recommended as introductions to topics relating to photography and the American West. Additional books by and about individual photographers featured in the exhibition are included after the list of general works.

General works

Adams, Celeste Marie, Franklin Kelly, and Ron Tyler. *America: Art and the West*. Sydney, Australia: American-Australian Foundation for the Arts/International Cultural Corporation of Australia, 1986. Exh. cat.

Adams, Robert. *Beauty in Photography: Essays in Defense of Traditional Values*. New York: Aperture, 1981.

Armstrong, Elizabeth. *Birth of the Cool: California Art, Design, and Culture at Mid-century*. Newport Beach, Calif.: Orange County Museum of Art, and New York: Prestel Publishing, 2007. Exh. cat.

Athearn, Robert G. *The Mythic West in Twentieth-Century America*. Lawrence, Kans.: University Press of Kansas, 1986.

Barron, Stephanie, Sheri Bernstein, and Ilene Susan Fort. *Made in California: Art, Image, and Identity, 1900–2000*. Berkeley, Calif.: University of California Press, and Los Angeles: Los Angeles County Museum of Art, 2000. Exh. cat.

Bartlett, Richard A. *Great Surveys of the American West*. Norman, Okla.: University of Oklahoma Press, 1962.

Baudrillard, Jean. *America*. Translated by Chris Turner. London: Verso, 1994.

Bayles, David. *Notes on a Shared Landscape: Making Sense of the American West*. Eugene, Oreg.: Image Continuum Press, 2005.

Beardsley, John. *Earthworks and Beyond: Contemporary Art in the Landscape*. New York: Abbeville Press, 1998.

Blake, Peter. *God's Own Junkyard: The Planned Deterioration of America's Landscape*. New York: Holt, Rinehart, and Winston, 1964.

Blauvelt, Andrew, ed. *Worlds Away: New Suburban Landscapes*. Minneapolis: Walker Art Center, 2008. Exh. cat.

Broder, Patricia Janis. *The American West: The Modern Vision*. Boston: Little, Brown, 1984.

Brougher, Kerry, and Russell Ferguson, eds. *Art and Film Since 1945: Hall of Mirrors*. Los Angeles: Museum of Contemporary Art, 1996. Exh. cat.

Bruce, Chris, Brian W. Dippie, Paul Fees, Mark Klett, and Kathleen Murphy. *Myth of the West*. New York: Rizzoli, and Seattle: Henry Art Gallery, University of Washington, 1990. Exh. cat.

Bush, Alfred L., and Lee Clark Mitchell. *The Photograph and the American Indian*. Princeton, N.J.: Princeton University Press, 1994. Exh. cat.

Cahn, Robert, and Robert Glenn Ketchum. *American Photographers and the National Parks*. New York: Viking Press, and Washington, D.C.: National Park Foundation, 1981. Exh. cat.

Castleberry, May, ed. *The New World's Old World: Photographic Views of Ancient America*. Albuquerque, N.Mex.: University of New Mexico Press, 2003. Exh. cat.

——. *Perpetual Mirage: Photographic Narratives of the Desert West*. New York: Whitney Museum of American Art, 1996. Exh. cat.

Current, Karen, and William Current. *Photography and the Old West*. Fort Worth, Tex.: Amon Carter Museum, and New York: Harry N. Abrams, 1978. Exh. cat.

Davis, Keith F. *An American Century of Photography: From Dry-Plate to Digital. The Hallmark Photographic Collection*. Kansas City, Mo.: Hallmark Cards, and New York: Harry N. Abrams, 1995.

——. *The Origins of American Photography: From Daguerreotype to Dry-Plate, 1839–1885*. Kansas City, Mo.: Hall Family Foundation/The Nelson-Atkins Museum of Art, 2007. Exh. cat.

Duany, Andres, Elizabeth Plater-Zyberk, and Jeff Speck. *Suburban Nation: The Rise of Sprawl and the Decline of the American Dream*. New York: North Point Press, 2000.

Fleming, Paula Richardson. *Native American Photography at the Smithsonian: The Shiner Catalogue*. Washington, D.C.: Smithsonian Institution Press, 2003.

Fleming, Paula Richardson, and Judith Lynn Luskey. *Grand Endeavors of American Indian Photography*. Washington, D.C.: Smithsonian Institution Press, 1993.

Foresta, Merry A. *American Photographs: The First Century*. Washington, D.C.: Smithsonian Institution Press, 1996. Exh. cat.

Friedman, Martin, John Beardsley, Lucinda Furlong, Neil Harris, Rebecca Solnit, and John R. Stilgoe. *Visions of America: Landscape as Metaphor in the Late Twentieth Century*. Columbus, Ohio: Columbus Museum of Art, and Denver: Denver Art Museum, 1994. Exh. cat.

Galassi, Peter. *American Photography 1890–1965 from The Museum of Modern Art*. New York: The Museum of Modern Art, 1995. Exh. cat.

Goetzmann, William H., and William N. Goetzmann. *The West of the Imagination*. New York: W. W. Norton & Company, 1986.

Goetzmann, William H., and Joseph C. Porter. *The West as Romantic Horizon: Selections from the Collection of the InterNorth Art Foundation*. Omaha, Nebr.: Center for Western Studies, Joslyn Art Museum: InterNorth Art Foundation, 1981. Exh. cat.

Hambourg, Maria Morris, Pierre Apraxine, Malcolm Daniel, Jeff L. Rosenheim, and Virginia Heckert. *The Waking Dream: Photography's First Century. Selections from the Gilman Paper Company Collection*. New York: The Metropolitan Museum of Art, 1993. Exh. cat.

Heyman, Therese, ed. *Picturing California: A Century of Photographic Genius*. Oakland, Calif.: Oakland Museum, 1989. Exh. cat.

Higgs, Matthew, and Ralph Rugoff, eds. *Baja to Vancouver: The West Coast and Contemporary Art*. San Francisco: CCA, Wattis Institute for Contemporary Arts; San Diego: Museum of Contemporary Art; Seattle: Seattle Art Museum; and Vancouver, Canada: Vancouver Art Gallery, 2003. Exh. cat.

Hume, Sandy, Ellen Manchester, and Gary Metz, eds. *The Great West: Real/Ideal*.

Boulder, Colo.: The Department of Fine Arts, University of Colorado at Boulder, 1977. Exh. cat.

Jenkins, William. *New Topographics: Photographs of a Man-Altered Landscape*. Rochester, N.Y.: International Museum of Photography at George Eastman House, 1975. Exh. cat.

Johnson, Tim. ed. *Spirit Capture: Photographs from the National Museum of the American Indian*. Washington, D.C.: Smithsonian Institution Press, 1998. Exh. cat.

Jones, Peter C. *The Changing Face of America*. New York: Prentice Hall Press, 1991.

Jussim, Estelle, and Elizabeth Lindquist-Cock. *Landscape as Photograph*. New Haven, Conn.: Yale University Press, 1985.

Kass, Emily. *The American West: Visions and Revisions*. Fort Wayne, Ind.: Fort Wayne Museum of Art, 1985. Exh. cat.

Klett, Mark, Ellen Manchester, JoAnn Verburg, Gordon Bunshaw, and Rick Dingus. *Second View: The Rephotographic Survey Project*. With an essay by Rick Berger. Albuquerque, N.Mex.: University of New Mexico Press, 1984.

Kort, Pamela, and Max Hollein, eds. *I like America: Fictions of the Wild West*. Frankfurt, Germany: Schirn Kunsthalle Frankfurt, and New York: Prestel Publishing, 2006. Exh. cat.

Lippard, Lucy R., ed. *Partial Recall: With Essays on Photographs of Native North Americans*. New York: The New Press, 1992.

Margolis, David. *To Delight the Eye: Original Photographic Book Illustrations of the American West*. Dallas, Tex.: DeGolyer Library, Southern Methodist University, 1994. Exh. cat.

Michaels, Leonard, David Reid, and Raquel Scherr, eds. *West of the West: Imagining California*. San Francisco: North Point Press, 1989.

Naef, Weston J., and James N. Wood. *Era of Exploration: The Rise of Landscape Photography in the American West, 1860–1885*. Buffalo, N.Y.: Albright-Knox Art Gallery, and New York: The Metropolitan Museum of Art, 1975. Exh. cat.

Neff, Emily Ballew. *The Modern West: American Landscapes, 1890–1950*. Houston, Tex.: Museum of Fine Arts, and New Haven, Conn.: Yale University Press, 2006. Exh. cat.

Østerby, Anette, Nancy Bloomberg, Blake Milteer, and Nancy Tieken. *The Wild West: Painting, Photography, Sculpture, and Native American Art from the American West*. Ishøj, Denmark: Arken Museum of Modern Art, 2001. Exh. cat.

Palmquist, Peter E., Thomas R. Kailbourn, and Martha A. Sandweiss. *Pioneer Photographers of the Far West: A Biographical Dictionary, 1840–1865*. Palo Alto, Calif.: Stanford University Press, 2000.

Phillips, Sandra S., Richard Rodriguez, Aaron Betsky, and Eldridge M. Moores. *Crossing the Frontier: Photographs of the Developing West, 1849 to the Present*. San Francisco: San Francisco Museum of Modern Art, 1996. Exh. cat.

Pitts, Terence. *Western American Photography: The First 100 Years. Selections from the Amon Carter Museum*. Phoenix, Ariz.: Phoenix Art Museum, 1987. Exh. cat.

Pomeroy, Earl. *In Search of the Golden West: The Tourist in Western America*. Lincoln, Nebr.: University of Nebraska Press, 1957.

Prown, Jules David, Nancy K. Anderson, William Cronon, Brian W. Dippie, Martha A. Sandweiss, Susan P. Schoelwer, and Howard R. Lamar. *Discovered Lands, Invented Pasts: Transforming Visions of the American West*. New Haven, Conn.: Yale University Press, 1992. Exh. cat.

Sandweiss, Martha A. *Photography in Nineteenth-Century America*. Fort Worth, Tex.: Amon Carter Museum, and New York: Harry N. Abrams, 1991. Exh. cat.

——. *Print the Legend: Photography and the American West*. New Haven, Conn.: Yale University Press, 2002.

Schama, Simon. *Landscape and Memory*. New York: Alfred A. Knopf, 1995.

Scott, Amy, ed. *Yosemite: Art of an American Icon*. Los Angeles: Autry National Center, and Berkeley, Calif.: University of California Press, 2006. Exh. cat.

Sichel, Kim. *Mapping the West: Nineteenth-Century American Landscape Photographs from the Boston Public Library*. Boston: Boston University Art Gallery, 1992. Exh. cat.

Smith, Henry Nash. *Virgin Land: The American West as Symbol and Myth*. Cambridge, Mass.: Harvard University Press, 1970.

Stewart, Rick. *A Century of Western Art: Selections from the Amon Carter Museum*. Fort Worth, Tex.: Amon Carter Museum, 1998.

Strong Hearts: Native American Visions and Voices. New York: Aperture, 1995.

Szarkowski, John. *The Photographer and the American Landscape*. New York: The Museum of Modern Art, 1963. Exh. cat.

——. *American Landscapes: Photographs from the Collection of The Museum of Modern Art*. New York: The Museum of Modern Art, 1981. Exh. cat.

Taylor, Joshua Charles. *America as Art*. Washington, D.C.: Smithsonian Institution Press, 1976. Exh. cat.

Trachtenberg, Alan. *Reading American Photographs: Images as History, Mathew Brady to Walker Evans*. New York: Hill and Wang, 1989.

Truettner, William H., ed. *The West as America: Reinterpreting Images of the Frontier, 1820–1920*. Washington, D.C.: Smithsonian Institution Press, 1991. Exh. cat.

Venturi, Robert, Denise Scott Brown, and Steven Izenour. *Learning from Las Vegas: The Forgotten Symbolism of Architectural Form*. Cambridge, Mass.: MIT Press, 1972.

Watts, Jennifer A., and Claudia Bohn-Spector. *The Great Wide Open: Panoramic Photographs of the American West*. London: Merrell, 2001. Exh. cat.

——. *This Side of Paradise: Body and Landscape in Los Angeles Photographs*. London: Merrell, and San Marino, Calif.: The Huntington Library, Art Collections, and Botanical Gardens, 2008. Exh. cat.

Whiting, Cécile. *Pop L.A.: Art and the City in the 1960s*. Berkeley, Calif.: University of California Press, 2006.

Wolf, Daniel, ed. *The American Space: Meaning in Nineteenth-Century Landscape Photography*. Middletown, Conn.: Wesleyan University Press, 1983.

Wolfe, Ann M. *Suburban Escape: The Art of California Sprawl*. Santa Fe, N.Mex.: Center for American Places, and San Jose, Calif.: San Jose Museum of Art, 2006. Exh. cat.

Selected monographs

The following monographs have been selected to accompany the photographs in this volume and are not necessarily comprehensive resources about each photographer.

Ansel Adams
Szarkowski, John. *Ansel Adams at 100*. Boston: Little, Brown, and San Francisco: San Francisco Museum of Modern Art, 2001. Exh. cat.

Robert Adams
Adams, Robert. *The New West: Landscapes along the Colorado Front Range*. Foreword by John Szarkowski. Boulder, Colo.: The Colorado Associated University Press, 1974.

——. *Robert Adams: To Make It Home. Photographs of the American West, 1965–1986*. New York: Aperture, 1989. Exh. cat.

Diane Arbus

Phillips, Sandra S. *Diane Arbus: Revelations*. New York: Random House, 2003. Exh. cat.

Richard Avedon

Avedon, Richard. *In the American West*. New York: Harry N. Abrams, 1985.

John Baldessari

Van Bruggen, Coosje. *John Baldessari*. New York: Rizzoli, 1990. Exh. cat.

Lewis Baltz

Baltz, Lewis. *San Quentin Point*. Introduction by Mark Haworth-Booth. Berlin: Verlag Zwölftes Hause, and Millerton, N.Y.: Aperture, 1986.

Adam Bartos

Bartos, Adam. *Boulevard*. Essay by Geoff Dyer. Göttingen, Germany: Steidl/Dangin, 2005.

Solomon D. Butcher

Carter, John. *Solomon D. Butcher: Photographing the American Dream*. Lincoln, Nebr.: University of Nebraska Press, 1985.

James Casebere

Berger, Maurice. *James Casebere, Model Culture: Photographs 1975–1996*. San Francisco: Friends of Photography, 1996. Exh. cat.

Larry Clark

Clark, Larry. *Tulsa*. New York: Larry Clark, 1971.

Alvin Langdon Coburn

Steinorth, Karl, ed. *Alvin Langdon Coburn: Photographs 1900–1924*. Zurich, Switzerland: Edition Stemmle, 1998. Exh. cat.

Lois Conner

Conner, Lois. *Out West: 30 Panoramic Views of the American Landscape*. New York: Stewart, Tabori & Chang, 1996.

Edward Sheriff Curtis

Curtis, Edward S. *The North American Indian: The Complete Portfolios*. Cologne, Germany: Taschen, 1997.

Robert Dawson

Dawson, Robert, and Gray Brechin. *Farewell, Promised Land: Waking from the California Dream*. Berkeley, Calif.: University of California Press, 1999.

Philip-Lorca diCorcia

Galassi, Peter. *Philip-Lorca diCorcia*. New York: The Museum of Modern Art, 1995.

John Divola

Divola, John. *Three Acts*. Essay by David Campany. New York: Aperture, 2006.

Robert Frank

Frank, Robert. *The Americans*. Introduction by Jack Kerouac. New York: Pantheon Books, 1986.

Lee Friedlander

Galassi, Peter. *Friedlander*. New York: The Museum of Modern Art, 2005. Exh. cat.

William A. Garnett

Sandweiss, Martha A. *William Garnett: Aerial Photographs*. Berkeley, Calif.: University of California Press, 1994.

William Gedney

Sartor, Margaret, and Geoff Dyer, eds. *What Was True: The Photographs and Notebooks of William Gedney*. Durham, N.C.: Center for Documentary Studies, and New York: W. W. Norton, 2000. Exh. cat.

Arnold Genthe

Genthe, Arnold. *Genthe's Photographs of San Francisco's Chinatown*. Text by John Kuo Wei Tchen. New York: Dover, 1984.

Laura Gilpin

Sandweiss, Martha A. *Laura Gilpin: An Enduring Grace*. Fort Worth, Tex.: Amon Carter Museum, 1986. Exh. cat.

Frank Gohlke

Gohlke, Frank. *Mount St. Helens: Photographs by Frank Gohlke*. Essay by Simon LeVay and Kerry Sieh. New York: The Museum of Modern Art, 2005. Exh. cat.

Katy Grannan

Grannan, Katy. *The Westerns*. San Francisco: Fraenkel Gallery, and New York, Greenberg Van Doren Gallery, Salon 94 Freemans, 2007. Exh. cat.

David T Hanson

Hanson, David T. *Waste Land: Meditations on a Ravaged Landscape*. New York: Aperture, 1997.

Chauncey Hare

Hare, Chauncey. *Interior America*. Millerton, N.Y.: Aperture, 1978.

Alfred A. Hart

Kibbey, Mead B. *The Railroad Photographs of Alfred A. Hart*. Sacramento, Calif.: California State Library Foundation, 1995.

John K. Hillers

Fowler, Don D. *The Western Photographs of John K. Hillers: Myself in the Water*. Washington, D.C.: Smithsonian Institution Press, 1989.

David Hockney

Hockney, David. *Cameraworks*. Essay by Lawrence Weschler. New York: Alfred A. Knopf, 1984.

Dennis Hopper

Noever, Peter, ed. *Dennis Hopper: A System of Moments*. Ostfildern-Ruit, Germany: Hatje Cantz, 2001. Exh. cat.

Graciela Iturbide

Iturbide, Graciela. *Eyes to Fly With: Portraits, Self-Portraits, and Other Photographs*. Essay by Alejandro Castellanos. Austin, Tex.: University of Texas Press, 2006.

William Henry Jackson

Hales, Peter B. *William Henry Jackson and the Transformation of the American Landscape*. Philadelphia: Temple University Press, 1988.

Geoffrey James

James, Geoffrey. *Running Fence*. Essays by Elizabeth Armstrong, Sebastian Rotella, and Dot Tuer. Vancouver, Canada: Presentation House Gallery, 1999. Exh. cat.

Gertrude Käsebier

Delaney, Michelle. *Buffalo Bill's Wild West Warriors: A Photographic History by Gertrude Käsebier*. Washington, D.C.: Smithsonian Institution Press, and New York: HarperCollins, 2007.

Darius Kinsey

Bohn, Dave, and Rodolfo Petschek. *Kinsey, Photographer: A Half Century of Negatives by Darius and Tabitha May Kinsey*. San Francisco: Prism Editions, 1978.

Justine Kurland

Kurland, Justine. *Spirit West*. Paris: Coromandel Design, 2001.

Dorothea Lange

Heyman, Therese Thau, Sandra S. Phillips, and John Szarkowski. *Dorothea Lange: American Photographs*. San Francisco: San Francisco Museum of Modern Art, 1994. Exh. cat.

Lange, Dorothea, and Paul Schuster Taylor. *An American Exodus: A Record of Human Erosion*. New York: Reynal & Hitchcock, 1939.

An-My Lê

Lê, An-My. *Small Wars*. Essay by Richard B. Woodward. New York: Aperture, 2005.

David Levinthal

Stainback, Charles, and Richard B. Woodward. *David Levinthal: Work from 1975–1996*. New York: International Center of Photography, 1997. Exh. cat.

James Luna

Lowe, Truman T., and Paul Chaat Smith. *James Luna: Emendatio*. Washington, D.C.: Smithsonian Institution Press, 2005. Exh. cat.

Elaine Mayes

Mayes, Elaine. *It Happened in Monterey*. Culver City, Calif.: Britannia Press, 2002.

Joel Meyerowitz

Sullivan, Constance, and Susan Weiley, eds. *Creating a Sense of Place: Photographs by Joel Meyerowitz*. Washington, D.C.: Smithsonian Institution Press/Constance Sullivan Editions, 1990.

Richard Misrach

Tucker, Anne Wilkes, and Rebecca Solnit. *Crimes and Splendors: The Desert Cantos of Richard Misrach*. Boston: Bulfinch Press, and Houston: Museum of Fine Arts, Houston, 1996. Exh. cat.

Karin Apollonia Müller

Müller, Karin Apollonia. *Angels in Fall*. Essay by Rodney Sappington. Hamburg, Germany: Kruse Verlag, 2001.

Eadweard J. Muybridge

Harris, David, and Eric Sandweiss. *Eadweard Muybridge and the Photographic Panorama of San Francisco, 1850–1880*. Montreal: Canadian Centre for Architecture, 1993. Exh. cat.

Solnit, Rebecca. *River of Shadows: Eadweard Muybridge and the Technological Wild West*. New York: Viking, 2003.

Timothy O'Sullivan

Dingus, Rick. *The Photographic Artifacts of Timothy O'Sullivan*. Albuquerque, N.Mex.: University of New Mexico Press, 1982.

Snyder, Joel. *American Frontiers: The Photographs of Timothy H. O'Sullivan, 1867–1874*. New York: Aperture, 1981. Exh. cat.

Bill Owens

Homes, A. M. *Bill Owens*. Bologna, Italy: Damiani, 2008.

Tod Papageorge

Papageorge, Tod. *Passing Through Eden: Photographs of Central Park*. Göttingen, Germany: Steidl, 2007.

Irving Penn

Szarkowski, John. *Irving Penn*. New York: The Museum of Modern Art, 1984. Exh. cat.

Horace Poolaw

Gustafson, Donna. *Kiowa Culture in Transition, 1925–1955: The Photographs of Horace Poolaw*. New York: The American Federation of Arts, 1990. Exh. cat.

Richard Prince

Spector, Nancy. *Richard Prince*. New York: Guggenheim Museum, 2007. Exh. cat.

Edward Ruscha

Rowell, Margit. *Ed Ruscha, Photographer*. Göttingen, Germany: Steidl, and New York: Whitney Museum of American Art, 2006. Exh. cat.

Andrew J. Russell

Van Haaften, Julia. *Tracking the West: A. J. Russell's Photographs of the Union Pacific Railroad*. New York: The New York Public Library, 1994. Exh. cat.

Cindy Sherman

Durand, Régis, Jean-Pierre Criqui, and Laura Mulvey. *Cindy Sherman*. Paris: Flammarion/Éditions Jeu de Paume, 2006. Exh. cat.

Sherman, Cindy. *Cindy Sherman: The Complete Untitled Film Stills*. New York: The Museum of Modern Art, 2003.

Stephen Shore

Shore, Stephen. *Uncommon Places: The Complete Works*. Essay by Stephan Schmidt-Wulffen. New York: Aperture, 2004.

Julius Shulman

Gössel, Peter, ed. *Julius Shulman: Architecture and Its Photography*. Cologne, Germany: Taschen, 1998.

Erwin E. Smith

Smith, Erwin E. *Life on the Texas Range*. Text by J. Evetts Haley. Austin, Tex.: University of Texas Press, 1952.

Frederick Sommer

Davis, Keith F. *The Art of Frederick Sommer: Photography, Drawing, Collage*. Prescott, Ariz.: Frederick and Frances Sommer Foundation, 2005.

Joel Sternfeld

Sternfeld, Joel. *American Prospects*. Essays by Kerry Brougher, Andy Grundberg, and Anne W. Tucker. New York: D.A.P./Distributed Art Publishers, 2003.

———. *Stranger Passing*. Essays by Douglas R. Nickel and Ian Frazer. Boston: Bulfinch Press, and San Francisco: Melcher Media/San Francisco Museum of Modern Art, 2001. Exh. cat.

Larry Sultan

Sultan, Larry. *Pictures From Home*. New York: Harry N. Abrams, 1992. Exh. cat.

———. *The Valley*. Zurich, Switzerland: Scalo, 2004

Adam Clark Vroman

Watts, Jennifer A., and Andrew Smith. *Adam Clark Vroman: Platinum Prints, 1895–1904*. Los Angeles: Michael Dawson Gallery, and Santa Fe, N.Mex.: Michael Dawson/Andrew Smith Galleries, 2005. Exh. cat.

Carleton E. Watkins

Nickel, Douglas R. *Carleton Watkins: The Art of Perception*. San Francisco: San Francisco Museum of Modern Art, 1999. Exh. cat.

Palmquist, Peter E. *Carleton E. Watkins: Photographer of the American West*. Albuquerque, N.Mex.: University of New Mexico Press, and Fort Worth, Tex.: Amon Carter Museum, 1983. Exh. cat.

Henry Wessel, Jr.

Zander, Thomas, ed. *Henry Wessel*. Göttingen, Germany: Steidl, 2007. Exh. cat.

Edward Weston

Enyeart, James L. *Edward Weston's California Landscapes*. Boston: Little, Brown, 1984.

Watts, Jennifer A., ed. *Edward Weston: A Legacy*. London: Merrell, and San Marino, Calif.: The Huntington Library, Art Collections, and Botanical Gardens, 2003. Exh. cat.

Minor White

Bunnell, Peter C. *Minor White: The Eye That Shapes*. Princeton, N.J.: The Art Museum, Princeton University, and Boston: Bulfinch Press/Little, Brown, 1989. Exh. cat.

Garry Winogrand

Szarkowski, John. *Garry Winogrand: Figments from the Real World*. New York: The Museum of Modern Art, 1988. Exh. cat.

Winogrand, Garry. *Stock Photographs: The Fort Worth Fat Stock Show and Rodeo*. Essay by Ron Tyler. Austin, Tex.: University of Texas Press, 1980.

index

credits

© 2009 The Ansel Adams Publishing Rights Trust, courtesy Collection Center for Creative Photography, University of Arizona: 34 (top), 41; © 2009 Robert Adams: 51 (bottom), 73, 82 (bottom); © 1972 The Estate of Diane Arbus, LLC: 143 (top); © 1981 Arizona Board of Regents, courtesy Collection Center for Creative Photography: 47, 61 (top), 89 (top); © 2009 The Richard Avedon Foundation: 147; © 2009 John Baldessari, courtesy Marian Goodman Gallery, New York. Photograph by Douglas M. Parker Studio, Los Angeles: 135; © 2009 Lewis Baltz: 84, 85; © 2009 Adam Bartos: 65; © 2009 James Casebere: 70 (top), 134; © 1976 Christo: 19; © 2009 Larry Clark: 143 (bottom); © 2009 Lois Conner: 123; © 2009 Robert Dawson: 89 (bottom); © 2009 Philip-Lorca diCorcia: 101, 142; © 2009 John Divola: 45, 74; © Robert Frank, from *The Americans:* 62, 63, 102, 103; © 2009 Lee Friedlander: 60 (bottom), 126, 129; © William A. & Eula Beal Garnett Trust: 68, 69; © J. Paul Getty Trust. Used with permission. Courtesy Julius Shulman Photography Archive Research Library at the Getty Research Institute: 75; © 2009 Frank Gohlke: 83; © 2009 Katy Grannan, courtesy Greenberg Van Doren Gallery, New York, Fraenkel Gallery, San Francisco, and Salon94, New York: 145; © 2009 David T Hanson: 87 (bottom); © 2009 Chauncey Hare: 61 (bottom); © 2009 David Hockney: 59; © 2009 Dennis Hopper: 64 (top); © 2009 Graciela Iturbide: 116 (right); © 2009 Geoffrey James: 88; © 2009 Justine Kurland: 141; © 2009 An-My Lê: 79; © 2009 David Levinthal: 132 (right); © 2009 James Luna. Photograph by Richard Lou: 108-9; © 1972 Massachusetts Institute of Technology, by permission of The MIT Press: 16; © 2009 Elaine Mayes: 96 (top); © 2009 Joel Meyerowitz: 120; © 2009 Richard Misrach: 40 (bottom); © 2009 Karin Apollonia Müller: 87 (top); © 2009 Bill Owens: 122; © 2009 Tod Papageorge: 111; © 1967 Irving Penn, courtesy the Board of Trustees, National Gallery of Art, Washington, D.C., 1967:

114; Used by permission of the Horace Poolaw Family, Robert William Poolaw, Sr., Linda Poolaw, and Bryce M. Poolaw: 106; © Richard Prince, courtesy Gladstone Gallery, New York. Photograph by David Regen: 133; © 2009 Edward Ruscha, courtesy Gagosian Gallery: 15 (right), 52-53 (bottom), 66-67; Courtesy SFMOMA: 51 (top), 82 (top); © 2009 Cindy Sherman: 137; © 2009 Cindy Sherman, courtesy Cindy Sherman and Metro Pictures: 128; © 2009 Stephen Shore, courtesy 303 Gallery, New York: 35, 64 (bottom); © Erwin E. Smith Foundation: 136; © Estate of Robert Smithson/Licensed by VAGA, New York, courtesy James Cohan Gallery, New York: 18; © 2009 Joel Sternfeld: 44, 71, 78, 97, 119; © 2009 Joel Sternfeld, courtesy Joel Sternfeld and Luhring Augustine, New York: 95; © 2009 Larry Sultan: 124-25; © 2009 Larry Sultan, courtesy Janet Borden, Inc.: 127, 140 (bottom); © 2009 Henry Wessel, Jr.: 57; © 2009 Henry Wessel, Jr., courtesy Henry Wessel, Jr., Charles Cowles Gallery, and Robert Mann Gallery, New York: 110; © The Estate of Garry Winogrand, courtesy Fraenkel Gallery, San Francisco: 37, 72, 113, 117

Certain photographs reproduced in this volume appear courtesy the Department of Imaging Services, The Museum of Modern Art, New York: 34 (top), 37, 40 (top), 41, 44, 48, 51 (bottom), 52-53 (bottom), 57, 58 (top), 63, 72, 73, 83, 96 (bottom), 97, 112 (both), 113, 119, 120, 126, 132 (bottom), 136, 144, 145, Robert Gerhardt: 86, 94, Thomas Griesel: 34 (bottom), 39 (top), 46 (bottom), 49, 65, 70 (bottom), 79, 88, 93, 96 (top), 101, 122, 123, 134, 137, 139, 140 (top), 147, Erik Landsberg: 45, 61 (top), 89 (top), Jonathan Muzikar: 38, 39 (bottom), 40 (bottom), 45, 54, 56, 60 (top), 61 (bottom), 62, 70 (top), 71, 74, 78, 82, 83, 87 (bottom), 89 (bottom), 107, 111, 115, 117, 121, 124-25, 142, 143 (top and bottom), John Wronn: 76-77

acknowledgments

This publication and the exhibition it accompanies would not have been possible without the hard work of many dedicated and talented people. First and foremost, I am deeply grateful to the photographers whose work is included herein for their extraordinary pictures and their cooperation.

At the Museum, my heartfelt appreciation is extended to Glenn D. Lowry, Director, for his support of the exhibition. In the Department of Photography, I am most indebted to Peter Galassi, Chief Curator, for his intellectual engagement and sage guidance throughout the project. Very warm thanks are due to Dan Leers, Beaumont and Nancy Newhall Curatorial Fellow, for his exceptional assistance and his good cheer. I also appreciate the advice of my colleagues Roxana Marcoci, Curator, Susan Kismaric, Curator, and Sarah Hermanson Meister, Associate Curator; the contributions of Whitney Gaylord, Cataloguer, and Megan Feingold, Departmental Assistant; and the assistance of interns Susanna Berger, Andrea Hackman, Suleyman Okam, and Yuko Teshima.

In the Department of Publications, I am grateful to Christopher Hudson, Publisher, and Kara Kirk, Associate Publisher. I appreciated the guidance of David Frankel, Editorial Director, and the editorial expertise of Rebecca Roberts, Senior Assistant Editor. Christina Grillo, Production Manager, has done a superb job of overseeing the book's production. Thanks are also due to interns Natalia Good and Merav Lahr. In Imaging Services, I am grateful to Erik Landsberg, Head of Collections Imaging, Robert Kastler, Production Manager, and Roberto Rivera, Production Assistant, who met our imaging needs under extremely tight deadlines. My praise also goes to Pascale Willi for her imaginative and elegant design for this book.

The organization of an exhibition requires the help of many people in the Museum. Jennifer Russell, Senior Deputy Director for Exhibitions, Collections, and Programs; Maria DeMarco Beardsley, Coordinator of Exhibitions; and Jennifer Manno, Assistant Coordinator of Exhibitions, provided good counsel in terms of the logistics of organizing the show. Brandi Pomfret, Registrar Assistant, handled the transport and registration of the exhibition with professionalism. Jerome Neuner, Director of Exhibition Design and Production, and Betty Fisher, Production Manager, conceived an elegant exhibition design. I salute Rob Jung, Manager of Art Preparation and Handling, and all the preparators who helped me with the show's physical implementation. My special thanks go to Lee Ann Daffner, Photography Conservator, and Peter Perez, Framing Conservator.

A project of this scope would not have been possible without the assistance of many people outside the Museum. I benefited from the superb collections and resources of museums and libraries around the country. At The Metropolitan Museum of Art, New York, I was ably assisted by Mia Fineman, Senior Research Associate, and I wish to thank Malcolm Daniel, Chief Curator, and Jeff Rosenheim, Curator, for their contributions. At the J. Paul Getty Museum, Los Angeles, my sincere thanks go to Virginia Heckert, Associate Curator, Erin Garcia, Curatorial Assistant, and Karen Hellman, Assistant Curator, for their assistance. Sandra S. Phillips, Senior Curator, and Erin O'Toole, Associate Curator, at San Francisco's Museum of Modern Art graciously shared their time and expertise. I am indebted to John Rohrbach, Curator, and Jessica May, Assistant Curator, at the Amon Carter Museum in Fort Worth, Texas, for sharing their knowledge of Western photography. Keith F. Davis, Curator, and Jane Aspinwall, Assistant Curator, at the Nelson-Atkins Museum of Art in Kansas City deserve my gratitude. I thank Charlotte Cotton, Chief Curator, and Eve Schillo, Curatorial Assistant, at the Los Angeles County Museum of Art. I am especially indebted to Joanne Heyler, Director and

Chief Curator at the Broad Art Foundation, Los Angeles, for her facilitation of the loan. I thank Tina Kukielski, Senior Curatorial Assistant at the Whitney Museum of American Art in New York, and Megan Peacock, Archivist at the McCracken Research Library, Buffalo Bill Historical Center, in Cody, Wyoming. At the New York Public Library, David Lowe and Jean Mihich provided assistance. Thanks are also due to Polly Armstrong, Library Specialist, John Mustain, Rare Book Librarian and Classics Bibliographer, and Roberto Trujillo, Head and Frances and Charles Field Curator, Department of Special Collections, Stanford University Libraries. I am especially grateful to Nancy Mithlo, Assistant Professor of American Indian Studies and Art History, University of Wisconsin-Madison, for her time and expertise. I give special thanks to the staff of the galleries that represent the photographers included in the exhibition. They provided much-needed assistance throughout the development of this project.

I would like to extend my gratitude to the Seattle Art Museum, our tour partner, and to Zora Hutlova Foy, Senior Manager of Exhibitions and Curatorial Publications at the museum, and Marisa Sánchez, Assistant Curator of Modern and Contemporary Art there.

I am grateful to the following individuals for generously sharing with me their knowledge about the American West; their contributions facilitated and encouraged my efforts: Jeffrey Fraenkel, Katy Grannan, Milan Hughston, Sandra S. Phillips, Larry Sultan, and Daniel Wolf. I am indebted to the excellent books and writings of Alfred Bush, Keith F. Davis, Martha A. Sandweiss, Rebecca Solnit, John Szarkowski, and Jennifer A. Watts. My sincere thanks go to my colleagues and friends for their valuable suggestions on the catalogue essay: May Castleberry, Jacob Dyrenforth, Naomi Fry, and Alexsandra Lloyd.

Into the Sunset: Photography's Image of the American West would not have been possible without the generosity of the lenders to this exhibition. I would like to express my gratitude to each of them for their willingness to make such notable works available to a larger viewing public.

Eva Respini
Assistant Curator, Department of Photography,
The Museum of Modern Art, New York

lenders to the exhibition

Amon Carter Museum, Fort Worth, Texas

Janet Borden, Inc., New York

The Broad Art Foundation, Santa Monica, California

Buffalo Bill Historical Center, Cody, Wyoming

Charles Cowles Gallery and Robert Mann Gallery, New York

Douglas S. Cramer, Roxbury, Connecticut

Stephanie and Tim Ingrassia, New York

The J. Paul Getty Museum, Los Angeles

Tom Jones, Madison, Wisconsin

Ellen and Richard Levine, New York

Luhring Augustine, New York

The Metropolitan Museum of Art, New York

Mitchell-Innes & Nash, New York

Museum of Contemporary Art, San Diego

The Museum of Modern Art, New York

National Gallery of Art, Washington, D.C.

The Nelson-Atkins Museum of Art, Kansas City, Missouri

The New York Public Library

Yancey Richardson Gallery, New York

RoseGallery, Santa Monica, California

San Francisco Museum of Modern Art

Department of Special Collections, Stanford University Libraries, Palo Alto, California

Whitney Museum of American Art, New York

303 Gallery, New York

8824 8825 8828 8844 Larabee 8850 8852 8860

8831 8833 Larabee 8849 8851 8853 8855 8857 8863